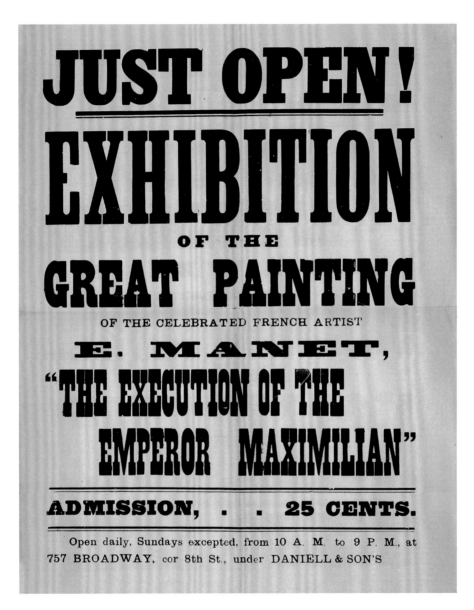

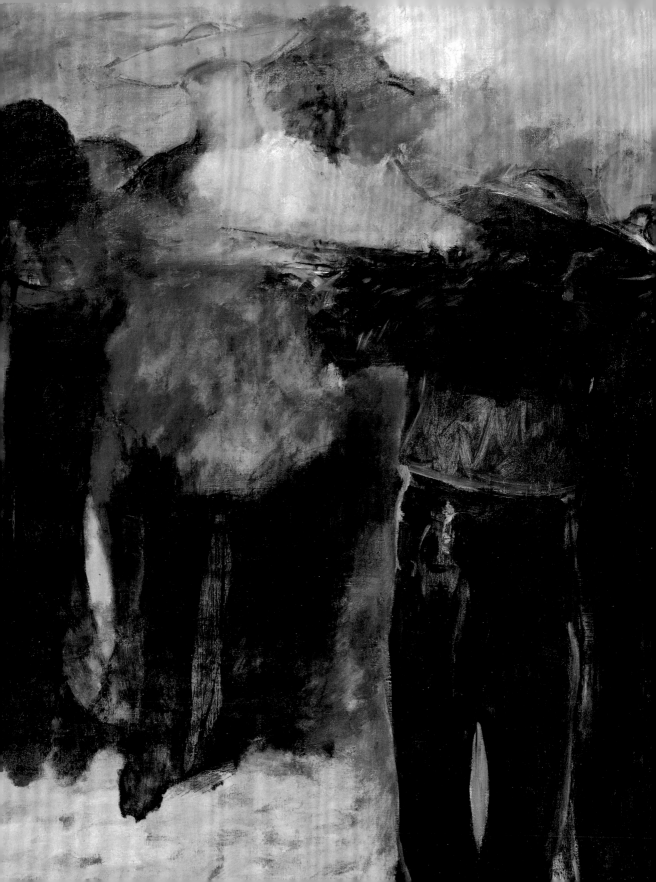

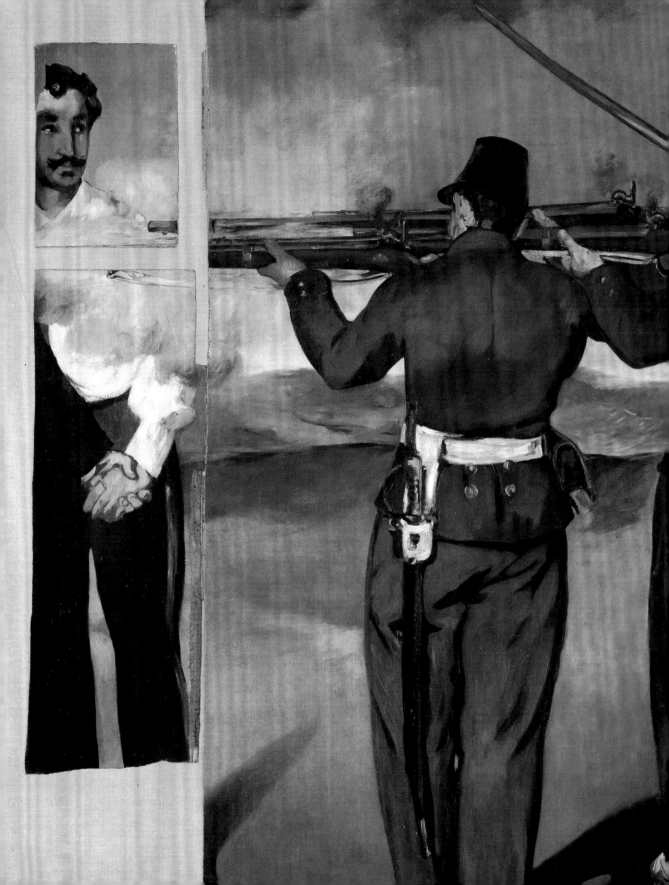

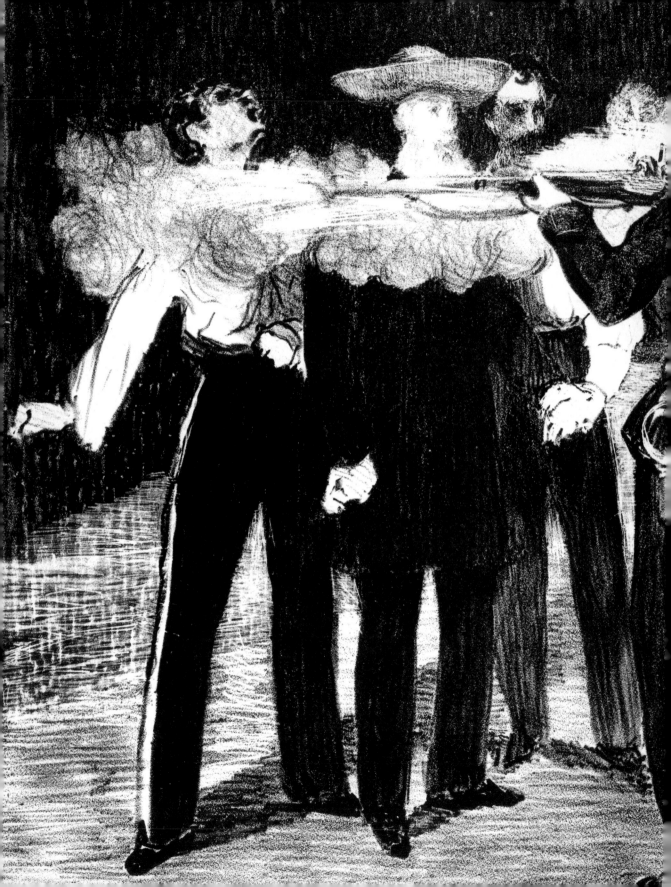

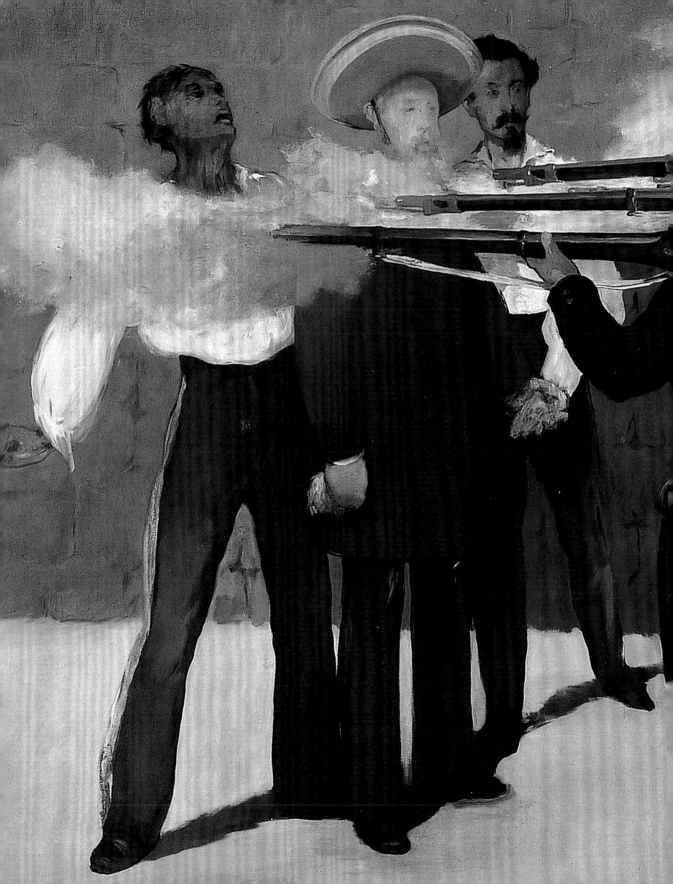

MANET

and the

EXECUTION

of

MAXIMILIAN

John Elderfield

THE MUSEUM OF MODERN ART

NEW YORK

Published on the occasion of the exhibition *Manet and the Execution of Maximilian* at The Museum of Modern Art, New York, November 5, 2006–January 29, 2007, organized by John Elderfield, The Marie-Josée and Henry Kravis Chief Curator of Painting and Sculpture, The Museum of Modern Art

Major support for the exhibition is provided by an indemnity from the Federal Council on the Arts and the Humanities.

Additional funding is provided by David Teiger.

This publication was made possible by the Nancy Lee and Perry Bass Publication Endowment Fund.

Produced by the Department of Publications,
The Museum of Modern Art, New York
Edited by Joanne Greenspun
Designed by Amanda Washburn
Production by Christina Grillo

Translation of pages 182–91 from the French by Jeanine Herman

Printed and bound by Conti Tipocolor, s.p.a., Florence, Italy

Published by The Museum of Modern Art,
11 West 53 Street, New York, New York 10019-5497
© 2006 The Museum of Modern Art, New York
second printing 2006
Copyright credits for certain illustrations are cited in the Photograph Credits on p. 194.
All rights reserved.

Library of Congress Control Number: 2006931860
ISBN: 978-0-87070-423-9

Distributed in the United States and Canada by D.A.P/Distributed Art Publishers, Inc., New York
Distributed outside the United States and Canada by Thames & Hudson Ltd., London

Printed in Italy

CONTENTS

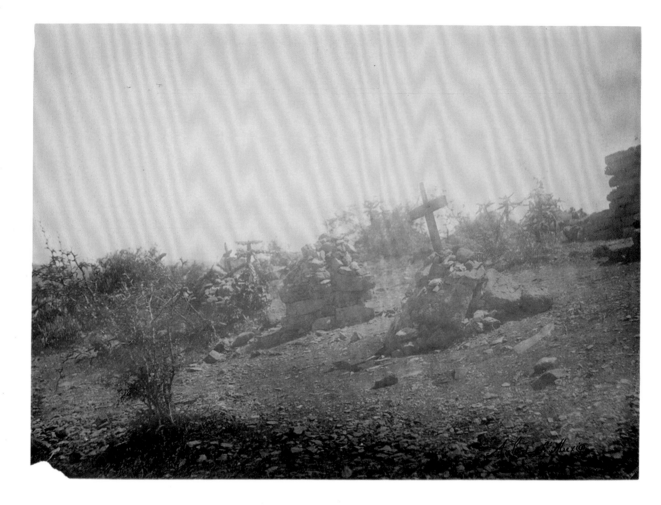

FOREWORD

In 1867, Edouard Manet chose to address one of the most controversial political events of his day: the disastrous end to the French intervention in Mexico. In doing so, he made three large paintings, an oil sketch, and a lithograph, depicting the execution of the French-installed emperor Maximilian, which are among the greatest achievements of early modern art.

Although the painting and sculpture collection of The Museum of Modern Art begins in the 1880s, exhibitions devoted to art previous to that date, sometimes a lot previous, took place from time to time in the early, pioneering years of the Museum's history. Their motivation was that an understanding of the art shown in the Museum's collection could usefully be aided by an understanding of the art that preceded it, just as an appreciation of the contemporary art shown by the Museum is informed by an appreciation of the modern art that it shows; and vice versa. Therefore, to present such historical exhibitions is not to turn away from the present but, rather, to seek to inform an understanding of the present by learning from the example of the past, and to reveal and clarify the challenges that the past continues to provide.

One of the exhibitions that we presented within the first year of the reopening of the Museum, in 2005, *Pioneering Modern Painting: Cézanne and Pissarro 1865–1885,* signaled the Museum's wish to reengage that pioneering idea by examining how Cézanne's mature art, which marks the beginning of the collection, was founded in the 1870s in collaboration with Pissarro, who is unrepresented in the collection. *Manet and the Execution of Maximilian* continues this initiative, and shows how an artist of the generation of the 1860s reinvented the then-defunct art of "history painting," the painting of significant public events, with such extraordinary, challenging results. It reveals how an artist of great stature can create important art based on a very unpromising subject, and how Manet thus found a vehicle to respond to a squalid political adventure that turned into the human tragedy of the abandoned Maximilian's execution.

It took seventy years before another major artist responded with comparable authority to a great public tragedy: until 1937, when Pablo Picasso painted *Guernica.*

FRANÇOIS AUBERT
Makeshift Memorial to
Maximilian and Generals
on the Hill of the Bells,
Querétaro. 1867
Albumen silver print, 6 1/4 x 8 3/4"
(15.9 x 22.2 cm)
The Museum of Modern Art,
New York. Purchase

In fact, the genesis of this exhibition came from discussions in Madrid in 2005 on the desire of the Prado and the Reina Sofia museums to create exhibitions in celebration of the twenty-fifth anniversary of the return of democracy to Spain and, therefore, of the arrival of *Guernica* in Spain after its long-term loan by Picasso to The Museum of Modern Art until democracy was restored. The Spanish museums wished to include in their exhibitions both Picasso's *Charnel House,* in the collection of The Museum of Modern Art, and the version of *The Execution of Emperor Maximilian* in the Städtische Kunsthalle, Mannheim; from this wish developed the proposal that New York and Mannheim, too, would create exhibitions on this occasion.

Present at our meetings in Madrid were, for the Prado, Rodrigo Uría, Miguel Zugaza, and Gabriele Finaldi; for the Reina Sofia, Ana Martinez de Aguilar and María García Yelo; for Mannheim, its director Rolf Lauter; and, for The Museum of Modern Art, John Elderfield, the Museum's Marie-Josée and Henry Kravis Chief Curator of Painting and Sculpture, and myself. We are deeply grateful to our four colleagues in Madrid for having initiated these discussions and to Rolf Lauter for having responded with enthusiasm to what did develop.

The Madrid exhibitions, which opened in June 2006, became a presentation of Picasso's work of all periods placed amid historical works in the galleries of the Prado, and a display around *Guernica* at the Reina Sofia, which included the unique opportunity to see in one room the Mannheim painting and its ultimate source, Francisco Goya's *The Third of May, 1808.* The exhibition in Mannheim, to open in February 2007, will present both modern and contemporary art devoted to the subject of war and violence. When we began to ponder what form the exhibition should assume in New York, John Elderfield urged that, although time would be short to do this, we should use the opportunity to attempt to bring together all of Manet's Maximilian compositions, since they had only once before been assembled, for an exhibition that took place in London and Mannheim in 1992–93. He immediately contacted the custodians of the other three paintings, whose agreement allowed the project to move ahead. We are profoundly grateful for their generous support, as we are to the other lenders to the exhibition, whose names appear in John Elderfield's Acknowledgments. But I should like to add my own thanks to Malcolm Rogers, director of the Museum of Fine Arts, Boston; Charles Saumarez Smith, director of The National Gallery, London; and Flemming Friborg, director of the Ny Carlsberg Glyptotek, Copenhagen. And I should add that

The Metropolitan Museum of Art, New York, has shown especial goodwill toward our project, and I thank its director, Philippe de Montebello, most sincerely.

The exhibition of Manet's *Execution of Maximilian* series in London and Mannheim in 1992–93 placed these compositions in the context of nineteenth-century art and included more than a dozen other works by Manet, several paintings by his contemporaries, popular prints, and photographs. The present exhibition includes, thanks to the great generosity of a number of institutions, a few important additional Manets together with some critical prints and photographs. However, it is intended to speak in a more focused way of Manet's practice, and asks us to ponder what this serial development of an image in five iterations tells us about his process of pictorial imagination, and the relationship of his painting to his photographic sources, and why this extraordinary body of work should have attracted the admiration of contemporary artists from R. B. Kitaj to Jasper Johns. In short, the exhibition invites us to consider these most political images by the pivotal figure in the history of modern painting from a contemporary point of view.

The conception of the exhibition, and the determination to realize it, belong to John Elderfield, whose insightful essay on Manet and the execution of Maximilian is a model of art history, and whose keen intelligence permeates this project. The many other people who contributed to this project, both inside and outside the Museum, are thanked in his own acknowledgments. Let me here simply record my own gratitude for all that they have done to realize the exhibition and this publication, and only mention that Anna Swinbourne and Jennifer Field, in the Department of Painting and Sculpture, were always striving for excellence, and dealt with extremely pressing deadlines with grace.

Finally, we would like to acknowledge an indemnity from the Federal Council on the Arts and the Humanities which helped to make possible this exhibition.

Glenn D. Lowry
Director, The Museum of Modern Art

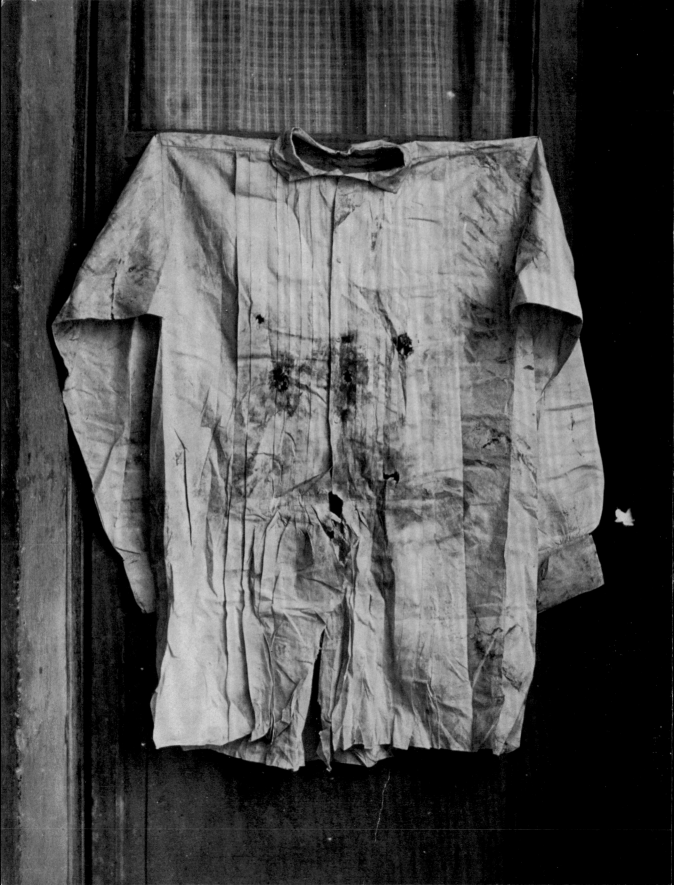

Introduction

REMEMBERING QUERÉTARO

On July 1,1867, Napoleon III of France (fig. 2) was about to open the prize-giving ceremony of the great Exposition Universelle in Paris, when he received an urgent message: Emperor Maximilian of Mexico (fig. 4), together with two of his generals, had been executed by firing squad outside the town of Querétaro, north of Mexico City.[1] Three years earlier, Napoleon had persuaded Maximilian, the idealistic arch-duke of Austria, to take the throne of Mexico in order to validate a French invasion that sought imperialist expansion and domestic prestige—only to pull out the troops when neither seemed capable of being secured. Predictably, the army of Benito Juárez (fig. 3), whom the French had deposed as president of Mexico, soon regained control. This ignominious foray into an unrealistic colonization not only doomed Maximilian and his wife Charlotte, who was driven insane in her futile attempts to rally support in Europe for her callously abandoned husband; it also proved the greatest blow to French prestige since their defeat at Waterloo in 1815, thus hastening the collapse of the Second Empire. And it occasioned one of the greatest achievements of early modern painting, namely, Edouard Manet's com-positions depicting Maximilian's execution.

 Manet (fig. 5) made five such compositions in the period from early to mid-July of 1867 through early 1869: the three large paintings that are now, in their order of creation, in the Museum of Fine Arts, Boston (fig. 21); in The National Gallery, London (fig. 40); and in the Städtische Kunsthalle, Mannheim (fig. 43); a small painting, now in the Ny Carlsberg Glyptotek, Copenhagen, which served as a study for the Mannheim painting (fig. 42); and a lithograph that was made in the same period as the Copenhagen painting (fig. 41). This book is published on the occasion of an exhibition devoted to these five works, related compositions by Manet, and works by photographers and other artists who also documented the event or whose pictures were likely sources for what Manet produced. The exhibi-tion brings together the Maximilian compositions for the first time in the United States, and is only the second exhibition that has ever been able to assemble all five of them. (The previous such exhibition took place in London and Mannheim in 1992–93.[2]) This book offers a new account of the genesis, the development, and

1 FRANÇOIS AUBERT
Maximilian's Shirt. June 1867
Albumen silver print,
8 $^{11}/_{16}$ x 6 $^{3}/_{8}$" (22 x 16.2 cm)
Research Library, The Getty
Research Institute, Los Angeles

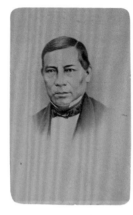

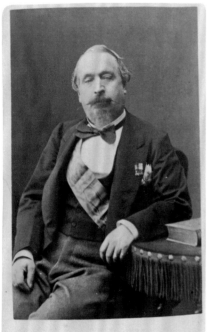

W. & D. DOWNEY COPYRIGHT

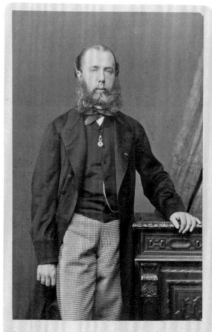

Bingham, Phot. 58, rue de Larochefoucauld.

the consequence of Manet's project. Its three chapters deal with, respectively, what happened before, in the conception, and in the completion of the Maximilian pictures.

If these works have not achieved the popular reputation among Manet's paintings of, say, his *Olympia* or *Le Déjeuner sur l'herbe* (fig. 22), a major reason must be that they were not exhibited in France during the artist's lifetime, Manet having been prohibited from showing them due to their sensitive political subject matter. He did arrange for a friend, the opera singer Emilie Ambre, to take the final painting (now in Mannheim) to New York and Boston in 1879–80 and show it there in rented rooms at the Clarendon Hotel and the Studio Building, respectively. However, this was a decade after the event it illustrated, and these displays seem not to have attracted much interest.[3] The painting did receive favorable notice when shown in 1898 in the Prince's Club, Knightsbridge, London, a venue that surely would have made the republican Manet squirm in annoyance.[4] Perhaps Manet's lithograph of the subject, published posthumously by his widow in 1884 in fifty impressions (after having been refused publication by the French authorities in 1869), had by then circulated sufficiently to create interest in the painting.[5] In any event, it was not until the first and the last of the series were exhibited at the Manet exhibition within the Paris Salon d'Automne of 1905—the famous *Fauve* Salon that made Henri Matisse notorious—that the magnitude of this enterprise could begin to be appreciated.[6] But even after Manet's reputation as the first modernist was solidified through the twentieth century, these paintings remained relatively obscure, except to specialists, as evidenced by a brief review of their appearance in exhibitions other than those just mentioned.[7]

The first of the three large paintings (fig. 21) was acquired by Frank Gair Macomber of Boston four years after its exhibition at the Salon d'Automne and thereafter remained unseen by the public until he donated it to the Museum of Fine Arts, Boston, in 1930. It is often said to have been abandoned, incomplete by Manet, and has, therefore, consistently been underestimated. After being shown in Paris in 1932, it remained unrepresented in a Manet exhibition until becoming the only work of the series to appear in the small but groundbreaking presentation at Brown University in 1981 (of which more later). After that it was included in the great Manet exhibition that took place in 1983 in Paris and New York. Then, apart from the London–Mannheim show, it was two decades before it appeared in Manet exhibitions again.

The second large painting (fig. 40), which suffered badly while in storage in Manet's studio, was cut up by his heirs to preserve the relatively intact sections. Although Edgar Degas sought out and reassembled these surviving pieces in the 1890s, The National Gallery, London, which acquired the composition in 1918, separated them again, and it was not until 1979 that the fragments were brought together and not until 1992 that they were recombined on one canvas to afford at least a partial sense of what the composition had originally looked like.

The third and final large painting (fig. 43) was exhibited at the Salon d'Automne in Paris and, five years later, was shown in the Berliner Secession of 1910, the same year that it was acquired by the Kunsthalle, Mannheim. It returned to Paris for an exhibition three years later, but then only left Mannheim for exhibitions three times between 1951 and 1964, and never for a Manet display, before being shown in London in 1992 and in 2006 in Madrid.

Unsurprisingly, perhaps, it is the smaller works that have become more familiar from exhibitions. The oil sketch in Copenhagen (fig. 42) has appeared in eight exhibitions since 1914, in addition to that at London and Mannheim. (Henceforward, I shall refer to each painting in this series by the name of the city in which it is now located.) Regular representation of the lithograph (fig. 41) has been made easier, of course, because it is an editioned work, although the general underestimation of prints as opposed to paintings has led to its being under valued in importance, both for the series and intrinsically.

Leaving aside the early invisibility of these works, imposed by the French censors, it is difficult to believe that compositions of this importance were so little sought-out by scholars and curators. One can imagine their being seen and known by a broader public, had they conformed to, and confirmed, the popular image of Manet as the painter of modern life in Paris. But they were not. Therefore, they have often been underestimated in general accounts of Manet's art and have not featured much in the wave of recent scholarship on the artist that is principally interested in Manet in his social context.

On the other hand, these works have attracted some of the most important twentieth-century commentators on Manet's art—critics like Paul Valéry and Georges Bataille and art historians from Julius Meier-Graefe to Michael Fried; their names will reappear in the pages that follow. But the recent literature on these works has been dominated by the ever-more-precise scholars who have been attracted by their uncertain sources and chronology. This documentary approach

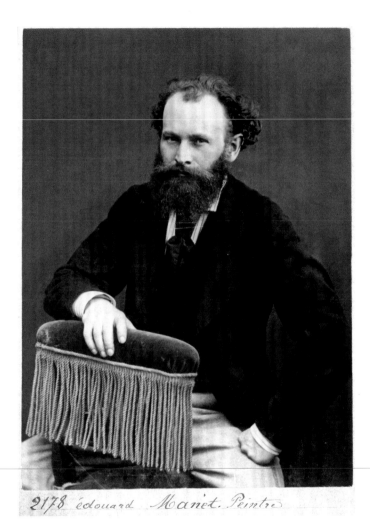

2178 édouard Manet. Peintre

was pioneered by Nils Gösta Sandblad in 1954, exponentially advanced by the extraordinary Brown University catalogue of 1981, produced by students working with Kermit Champa, and refined by Juliet Wilson-Bareau's catalogue for the aforementioned exhibition in London in 1992.[8] And, just as important, these works have engaged the attention of other painters: first, as we have heard, Degas; then the artists who responded to seeing the first and last compositions at the Salon d'Automne in 1905; then contemporary artists, among them Howard Hodgkin (who urged The National Gallery, London, to recombine the fragments of its version of the painting), R. B. Kitaj, Brice Marden, and Jasper Johns.[9] Despite their relative obscurity in Manet's oeuvre, these works have long attracted the truly curious, and they continue to do so.

Curiosity is attracted to what is puzzling, and these are puzzling pictures, not only because their appearance and access have made them difficult to place or because they are disturbing works in Manet's oeuvre. They are also puzzling because it is difficult to understand what Manet meant in putting together their components as he did in these five different ways. The first, Boston painting is, additionally, visually uncertain, owing to its loose painterliness, making it difficult to see and know for certain what precisely is being represented in parts of the composition. The second, London painting poses a similar problem because it is not whole. The Copenhagen painting and the lithograph also puzzle because their functions and places in the sequence of compositions are difficult to ascertain. And the final, Mannheim painting, visually the least ambiguous of the five works, exemplifies what is true of all of them, that seeing and knowing what is represented does not guarantee understanding of them. In this respect, they are at once continuous with other puzzling compositions by Manet, some of which will be discussed below, and anticipatory of great early-twentieth-century puzzle paintings like Pablo Picasso's *Les Demoiselles d'Avignon* and Matisse's *Bathers with a Turtle*, both created within a few years of the Salon d'Automne of 1905. These works continue to hold our attention precisely because we cannot know definitively what they mean.

Of course, we will want to argue what they might mean, which requires dividing up their puzzles into components that are amenable to factual documentation and plausible argument. In doing so, we shall learn that Manet's compositions represent neither an isolated outbreak of political expression in his art nor one that is easily separated from his less-specifically-partisan works. This will tell us that their own meanings are not exhausted by their topicality.

We shall also learn that, in the creation of these works, Manet did not act alone. His project depended upon the productions of earlier and contemporary painters, journalists, printmakers, and photographers, whose images influenced his and whose names will appear in the pages that follow. And it also depended, of course, upon the three men whose actions led to what happened at Querétaro and who, with Manet, formed two pairs of contemporaries.

The first pair could hardly afford a greater disparity of origin and attitude. Benito Juárez, an indigenous Indian, born in poverty in 1806, began as a small-town lawyer in Oaxaca and ended up as the reformist president of Mexico in 1861, while Louis-Napoleon Bonaparte, born to privilege in 1808 as the son of Napoleon I's stepdaughter, became Napoleon III, the deeply conservative emperor of France, in 1852, after a bloody coup d'état the previous year. In contrast, the second pair, a generation younger, reveals intriguing parallels in that both Manet and Maximilian may be broadly described as cultivated, liberal intellectuals, despite their vast difference in background. Manet was born on January 23, 1832, into a solid, upper-middle-class French family, while Ferdinand Maximilian, born some five months later on July 6 of the same year, was the nephew of Ferdinand, the emperor of Austria, and became archduke of Austria when his elder brother Franz Joseph assumed his uncle's throne in 1848, that "Year of Revolutions," which is where the first of the three chapters that follow will begin.

As noted earlier, this essay is divided into three chapters, which address, respectively, what happened before, in the conception, and in the completion of the Maximilian pictures. This is to say, they follow the traditional structure of the unity of time as comprising three "extases": having-been, coming-forth, and making-present. I have chosen this structure not only because its familiarity will, I trust, make this at times complex account easier to grasp. I have also chosen it because it seemed especially appropriate to a subject in which are woven many threads whose temporal dimension is crucial.

The first chapter, which introduces the four principals, covers the time that it took for the French intervention in Mexico, from 1848 through 1867, to be conceived and then build to its tragic conclusion and, in the same period, for Manet's interest in Napoleon III and his Latin American ambitions to form and begin to produce artistic results. This chapter explicitly acknowledges Manet's persistent interest in contemporary history and lifetime opposition to the autocratic government of Napoleon III. Every previous discussion of his depictions of Maximilian's

execution has either offered only a nominal report of the political and military events that led to it or has disengaged a fuller report of these events from an art-historical account of Manet's involvement with their consequences. What either approach misses, however, is an awareness of how the conception and development of the French intervention in Mexico formed a long-standing, changing backdrop to the unfolding of Manet's art, making its mark on his art even before he painted the Maximilian paintings. Therefore, this first chapter interweaves the political and military story in France and Mexico and the artistic story in France.

The remaining, second and third chapters address the Maximilian compositions themselves. Manet probably started to work on the subject of Maximilian's execution quite early in July of 1867, as soon as the first, detailed reports of what had happened at Querétaro began to reach Paris. The result was the painting now in Boston. By or in the autumn, however, he must have become dissatisfied with what he had achieved, for he then began on a second canvas, the painting in a fragmentary state that is now in London. Manet drastically altered his conception of his subject in the creation of this painting and when it, too, was set aside, probably in the spring of 1868, it formed the basis on which the subsequent works—the small study now in Copenhagen, the lithograph, and the final large painting now in Mannheim—were composed in the period through early 1869. These later works demonstrate revision and refinement, but not overall reconception, of what had been achieved by the London painting. This is to say, Manet had two models for imagining what had happened at Querétaro. The second chapter, the temporal subject of which is "coming-forth," addresses the first of these two models, realized in the Boston composition. This chapter's temporal dimensions include the time of the news of the execution arriving in installments in Paris, of the sources in Manet's own and others' art on which he drew in search of means to depict it, and of the process of the painting itself, which may be thought to record these overlapping time zones. In following these threads, we shall see that almost all of the documentary and art-historical sources of the sequence of five compositions were brought into play in the creation of this first, Boston painting.

The subject of the third, and final chapter is "making-present"; that is to say, how Manet drastically altered the conception of the Boston painting to evolve a new conception of his subject that was adumbrated in the London painting, revised in the Copenhagen painting and in the lithograph that accompanied it, and then realized finally in the Mannheim painting. In the philosopher Paul Ricoeur's

discussion of "Narrative Time," he speaks of the three, aforementioned "extases" of time, of which "making-present" is the last, and draws attention to "the primacy of the future over the past and the present in the unitary constituting of time."[10] In this chapter, the past of the events in Mexico and the present of Manet's immediate response to these events in the Boston painting are seen as giving way to the future of his final, summative understanding. But Ricoeur, remembering the work of another philosopher, Martin Heidegger, also speaks of "the closure of the future by being-toward death in its untransferable individuality." This reminds us that the subject of Manet's paintings itself is time, the time of the execution; the third, final chapter has something to say about this, too.

I have mentioned the names of a few scholars who have worked on this subject, and shall mention more in the endnotes and in the Bibliographical Note. Here, I need to say that what appears in this text builds on the diligence and acumen of many of them, and that my own efforts have been aided by those of Anna Swinbourne, who, among many other things, reexamined the newspaper reports that offer clues to the appearance and sequence of Manet's compositions and excerpted the most important ones in the Appendix on pages 182–91, and Jennifer Field, who undertook esssential documentary and photographic research.

Finally, some readers will wonder whether it is purely accidental that an exhibition and publication appearing in 2006 are devoted to works that depict the baleful consequences of a military intervention and regime change. It is not. In 1973, the art historian Albert Boime prefaced an article on these Manet compositions by an explicit comparison of the principals in the Mexican intervention with those in the war in Vietnam.[11] I shall offer no such detailed comparison to contemporary events and only say that, then as now, "it seems very unlikely that history will judge either the intervention itself or the ideas animating it kindly."[12] One of the subjects of what follows is how the evidence of journalistic reports, photographs, and other forms of visual documentation allowed Manet to learn of and make sense of such events in a way that is, effectively, the way that we still picture similar events for ourselves. Another is how contradictorily, at times consciously manipulated, this material can be and, therefore, how unknowable the details of what actually occurred are. And yet another is what we might learn from how the pivotal figure in the modern history of painting made original, affective, and political art out of this process of representation.

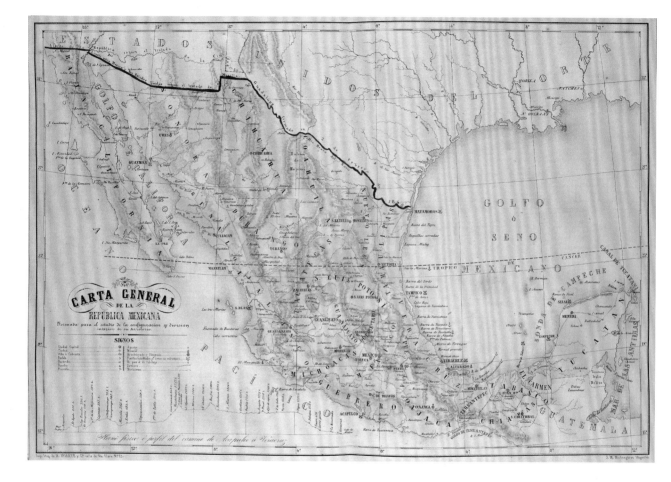

I.

ART *of* INTERVENTION

Do you take me for a history painter?… Reconstructing historical figures—
what a joke! Do you base a man's portrait on his hunting licence?

Edouard Manet[1]

There are two stories to tell in this chapter. The first, a political and military story, takes place mainly in France and Mexico between 1848 and 1867, describing events that will lead to the execution of the emperor Maximilian. The second, a story of Manet's artistic response to the events of the first story, takes place almost entirely in France in the same period, describing events that will lead to Manet's paintings of the execution.

 The first story is especially amenable to a narrative treatment since it combines developments in time and space: the marches of troops and the formations of governments; battles, conventions, alliances, and, finally, executions. The geographical movements of the story—from Paris to Mexico City; from Trieste to Querétaro—both partition and record the temporal flow of the story, somewhat as the moving hands of a clock do, somewhat as narrative itself does when it, too, both partitions and records events that occur in time.

 Paul Ricoeur has written of the intimate, indeed reciprocal relationship of narrativity and temporality: "I take temporality to be that structure of existence that reaches language in narrativity and narrativity to be the language structure that has temporality as its ultimate referent."[2] Time finds expression in our language in the form of storytelling, and storytelling refers finally and fundamentally to time. If a narrative, which records events in time, additionally records these events in changing spaces—and if these events are told in temporal sequence—it may well increase the momentum of the narrative. But, more importantly, it will tend to bolster credibility, or suspension of disbelief, in the verisimilitude of what is described. Gérard Genette, a theorist of narrative, has observed that verisimilitude is not the accidentally real but the essentially ideal.[3] This is to say, what seems most believably true to life is not necessarily what, in fact, happened but, rather, what the narrative persuasively argues did happen. And in a narrative, it follows, the strongest

6 Carta general de la
República Mexicana in
Antonio García y Cubas,
*Atlas geográfica, estadístico
é histórico de la República
Mexicana* (Mexico: Imprenta
de J. M. Lara, 1856)
Courtesy of The Hispanic
Society of America, New York

——— 25 ———

medium for persuading truthfulness, even above credible description, is a credible temporal sequence because of the implications of motivation and causality that it can provide. (And, if reinforced by a credible spatial sequence, its persuasiveness will increase.)

The first story told here was compiled from the most persuasive accounts of political and military historians who have studied the documentary evidence of the French intervention in Mexico.[4] From what has just been stated, it would seem that the most persuasive of these accounts would be the narratively strongest, those with the greatest temporal momentum. In fact, a careful reader knows very well that when a narrative argues too persuasively that something did happen, it may not have happened at all. And a sloppy reader knows even better that life is indeed composed of the accidentally real, not the essentially ideal. Therefore, strong narrative accounts of events that did happen may well, and appropriately, provoke skepticism as to their verisimilitude if not their veracity. For such accounts, not only is narrativity intimate with temporality; both are intimate with disbelief.

Needless to say, I begin in this way not to invite disbelief in the first, more narratively driven, of the two stories that this chapter tells, nor to claim a greater credibility for the second, less narratively driven one. I do so, rather, to draw attention to the ideal, closed, self-transforming, and self-regulating qualities of narrative accounts, for these qualities are akin to those of the "history painting" that Manet, in the beginning of this chapter, says is a joke.

Manet is reported to have made this brash remark, while a student in the studio of the respected academician Thomas Couture, to a fellow student who had suggested that he finish a work.[5] He continued: "There's only one good way. Capture what you see in one go. When it's right, it's right. When it's wrong, you start again. Anything else is nonsense." Manet was asserting that painting from life, which he advocated, required a trial-and-error spontaneity of approach, the polar opposite of which was the creation of finished surfaces. The province of history painting was the depiction of exemplary historical events, whose surfaces spoke of the finished, frozen past.

In fact, the mature painter Manet fussed endlessly with some of his canvases, achieving a very tightly formed surface, as well as leaving others in a much freer state, and considered canvases of both kind to be definitive, exhibitable works. And, obviously, he did change his mind about history painting because the subject of this publication is history paintings that he made. But these paintings

continue to worry the problem of which he spoke as a student, for he aimed to create paintings that seemed true to life even as they recorded important events, and he repudiated not merely the technically finished surface but also the closed, completed, and therefore incredible historical narrative that it signified. Effectively, history painting, as previously practiced, was a joke because it was essentially ideal, not accidentally real.

The second story told here, the subject of which is Manet's artistic response to the events of the first story in the same time period of 1848 to 1867, tells of his growing interest in the all-too-accidentally real, including his early and persistent interest in the vagaries of contemporary history and opposition to the autocratic, often imprudent government of Napoleon III. In telling it, I suggest that Manet may have disguised references to political events in Mexico, of which he would have read in the newspapers, in two and possibly three paintings. This strategy would not only have avoided the censors but also have pulled out these events from the temporal stream of contemporary history to fit them to his artistic pace, somewhat as the Manet story has the effect of braking the political story that this chapter tells.

The two stories, I said in the Introduction, have usually been told separately, but following them together fosters a necessary awareness of how French interest in Mexico formed a long-standing backdrop to the unfolding of Manet's art. It is useful in an additional way. Unsurprisingly, the narrative time of Manet's story will seem the slower of the two because there are fewer continuous events and geo-graphical movements to propel it and more descriptions and contingencies to slow it down. Therefore, as it interrupts the political history that is Manet's subject, it not only breaks the narrative continuity of that history, but also opens onto a human experience of time that is a stranger to narrative functions.[6] That too is Manet's subject. His reinvention of history painting, I shall suggest, meant oppo-sition to the coherence and certainty of a narrative, and required him to build paintings from the very factors that would seem most likely to tear them apart.[7]

REPRESSION IN FRANCE; REFORM IN MEXICO

MEXICO IN 1848

It was in that "Year of Revolutions," 1848, that the threads began slowly to come together. The year opened in Mexico with its government, having already lost Texas to the United States, being forced to accept the humiliation of surrendering New Mexico and California in the treaty that ended a war that the United States had provoked with precisely that aim. The very country in which, in 1823, President James Monroe had proclaimed his Monroe Doctrine of opposition to European designs on the Americas had now itself initiated the process of territorial aggression against Mexico that France would emulate. In 1848, moreover, gold was discovered in California, adding to the bitterness. This had the side effect, important to the present story, of causing the French population of Mexico, already the largest group of foreign, non-Spanish settlers, to begin further to enlarge in the north of the country, where silver deposits had been mined in the eighteenth century, now that California itself was closed to them. Their hopes of mineral wealth fueled existing beliefs that French influence could bring stability and prosperity to Mexico, to the benefit of France rather than to the United States.

Although Mexico had won independence from Spain in 1821, it had not yet become either stable or prosperous; indeed, it was hardly yet a state, if that term is taken to mean an organized political community with government recognized by the people. For Mexico remained a semifeudal conglomeration of regions of exceptionally difficult communication, whose overwhelming indigenous majority was controlled by white estate owners, the army, and the Catholic Church. The rivalries between these groups, as well as their opposition by even more fissiparous and even less-well-organized liberals, were particularly susceptible to, and encouraging of, wealthy external influence. This produced a sequence of precarious, short-lived, alternatively more conservative and more liberal regimes, each of which ended with the banishment or sometimes the execution of its leader. And, with this the risk of failure, it is hardly surprising that influential, conservative Mexicans looked, both nostalgically and opportunistically, to Europe for support. European governments, from those of Britain and Spain to that of the Vatican, even, were happy to oblige.

In one area, however, no European government had yet ventured to offer support, and that was in answering the plea to do what was commonplace in Europe itself: solve the problem of an uncertain dynasty by finding a foreign monarch who could rule with the support of foreign interests.[8] But pleas there had been, and since General Agustín de Iturbide, who won Mexico's independence from Spain, had himself been declared emperor a year later (1822), there was no reason (despite Iturbide's failure; he was exiled in less than another year) why another imperial government could not succeed. In 1848, as French settlers were attracted again to Mexico, this thought was very much in the mind of Louis-Napoleon Bonaparte, who, within four years, would become Napoleon III of France.

NAPOLEON AND MANET, 1848–51

The year 1848 opened in France by Louis-Napoleon returning from self-imposed exile in England. (He had gone there after escaping from the jail where he had been sent for attempting to overthrow Louis-Philippe's monarchy in 1840.) Once in France, he participated in the Constituent Assembly of the new Second Republic, which replaced that monarchy, but by late June of 1848, the Second Republic was in trouble. There was fighting on the streets of Paris, witnessed by a sixteen-year-old Manet, which led to the establishment of a conservative Party of Order. On December 16, the day the young Manet embarked as a naval cadet for Rio de Janeiro, Louis-Napoleon was elected president of the French Republic. Across Europe, revolution was being succeeded by repression. Ten days earlier, the suppression of revolutionary violence and disorder in Vienna had led to the abdication of the not always lucid Emperor Ferdinand in favor of his reactionary nephew Franz Joseph, who did not have much time for his younger brother, Maximilian, who was beginning to harbor liberal ideas.

Manet presumably knew about the events in Vienna when he left France. He probably had not heard of the new French president.[9] In any event, he was already a skeptic on the subject of ambitious politicians, having grown up with firm republican views, most especially from his father, who held senior positions in the French legal administration. In February 1849, his ship having finally dropped anchor at Rio de Janeiro, he wrote to his cousin Jules de Jouy, twenty years his elder and also an employee of the legal administration: "With your knowledge of politics, how do you feel about the election of L[ouis] Napoleon; for goodness sake don't go and make him an emperor, that would be too much of a good thing."[10]

Then, in March, disillusioned by naval life and just recovered from the agony of having being bitten on the foot by a snake outside Rio,[11] he wrote to his father: "Try to preserve our good republic until my return, for I well and truly fear that Louis Napoleon is not himself much of a republican."[12]

Two months later, in May 1849, the Constituent Assembly was dissolved, opening the way to repressive, anti-Republican measures that would lead, within a year and a half, to Louis-Napoleon's coup d'état of early December 1851 and then, on the twenty-first of that month, to his being made prince-president of France. Exactly eleven months later, the French people did indeed make him an emperor.

Upon Manet's return from Rio de Janeiro in June 1849, he took the entrance examination for the Ecole navale at Brest, but failed and therefore had to leave the French navy just a few months before his contemporary, Maximilian, joined the Austrian navy, to rise through privilege and become its commander in chief.[13] By the time of the coup d'état, Manet was a nineteen-year-old art student who had already spent a year in Couture's studio. Going out onto the streets, he narrowly escaped being swept up with protestors by a cavalry charge. The next day, he watched executions of protesters and, a few days later, went with members of Couture's class to sketch the corpses laid out at the Montmartre cemetery. "Many years later, Manet remembered the episodes he had witnessed," wrote Edmond Bazire, his first biographer. "He had only to revive his memories to reconstruct the horrifying drama of those executions and to retrace their sinister look and cold ferocity."[14]

MEXICO THROUGH EUROPEAN EYES

Manet completed his studies with Couture in February 1856. That same month, Napoleon III's first major imperialist intervention, the Crimean War, ended. In this episode, France and England had gone to Turkey's aid in order to check the expansionist ambitions of Russia. It precisely coincided, in Mexico, with the so-called Revolution of Ayutla, which, by summer 1855, had deposed the repressive General Antonio López de Santa Anna in a liberal uprising, looked upon kindly by the United States, that led, by year's end, to the appointment of Ignacio Comonfort as acting president. Knowing he was in trouble, Santa Anna had pleaded unsuccessfully with France and England for their intervention, and felt betrayed by these powers that would support Turkey against Russia but leave Mexico at the mercy of the United States. As the historian Nancy Nichols Barker has observed, the

situations of Mexico and Turkey thus became peculiarly analogous, Mexico frequently being seen, in the words of an 1856 memorandum sent to Napoleon, as a sort of "Turkey of the New World."[15]

Like Turkey, Mexico at mid-century, seen through mid-century European eyes, was all too capable of being thought to be on the margins of civilization—in fact, just beyond those margins—and its inhabitants as exemplifying Thomas Hobbes's famous definition of life in a state of nature: "nasty, brutish, and short."[16] That is to say, it was all too easy for those who were, to some extent or other, chauvinistic, racist, and insular, which meant most European politicians, to think of Mexico as a primitive nation and Mexicans as inherently incompetent, rather like unruly children, in the modern affairs of state. Similarly, the mass of travel literature that reached France from Mexican residents and travelers—almost one popular book in French a year, Barker estimates—reinforced the themes of inexhaustible natural wealth, an impossibly unstable government, the continuing danger of U.S. aggression, and the necessity of externally imposed order, specifically order imposed by France in support of a European princely ruler. It is inconceivable that Manet could have been unaware of such publications.

Abetting these views were the continuing turbulence of Mexico's internal politics, thought to indicate an absence of national identity, and its inability to honor its debts abroad, thought to indicate fiscal irresponsibility, despite the often usurious terms of the European lenders. And, among European diplomats in Mexico and public voices at home, it was the French who were most virulent in their disdain for what they saw as an inherent Mexican ineptitude, and most vocal in their insistence that all *races latines* needed monarchical government. In short, if Turkey was the "sick man of Europe," now receiving interventionary attention, Mexico was equally a sick man, whose need for such attention would come.

It is ironic, therefore, that as these attitudes were hardening, the Revolution of Ayutla not only deposed a dictator but also began the Mexican Reform Movement that made great strides toward responsible national government. These included the restriction of ecclesiastical privileges decreed by the energetic new minister of justice, Juárez, and, on February 5, 1857, a new federal Constitution of the Republic of Mexico. But this was not the kind of governmental order that the European critics and their Mexican royalist supporters had in mind. And, Turkey having been saved in 1856, the interventionists in both Mexico and France began again to mobilize. But once more they were to be disappointed, for yet another intervention in Europe

would take priority. What neither they nor anyone else could know was that this new intervention, in Italy in 1859, would make available the very man who, to Napoleon III at least, became the ideal candidate for emperor of Mexico.

In Vienna, on February 28, 1857, even before news of the new Mexican constitution had reached Europe, Emperor Franz Joseph of Austria sidelined his troublingly liberal brother Maximilian by appointing him governor of Lombardy-Venetia. That July, Maximilian married Princess Charlotte of Belgium, the seventeen-year-old daughter of King Leopold I, and began to lay ambitious plans for his new domain. Unfortunately for Maximilian, one year later, on January 14, 1858, an Italian named Felice Orsini tried, unsuccessfully, to assassinate Napoleon III, which provided Napoleon with a pretext to invade Italy. This led to the defeat of Austrian forces at Solferino and to Austria losing Lombardy-Venetia, which meant that Maximilian and Charlotte had to move. So, on Christmas Eve of 1860, they traveled to Trieste, to the castle of Miramare, from whose eponymous view of the sea Maximilian dreamed of foreign lands.

THE RISE OF JUÁREZ TO PRESIDENT OF MEXICO

Mexico, in the meantime, had gone through extraordinary changes in the less than three years since the February 1857 constitution. Comonfort, we remember, had been appointed acting president at the end of 1855. It took the Mexican Congress almost two years, until November 1857, to confirm his appointment as president. The uncertainty of which this speaks proved to be well founded, for within a month Comonfort had closed down the Congress in order to curtail the more radical liberals. Seizing the opportunity of this division, the conservative military rebelled, forced Comonfort into exile, and thereby plunged the country into civil war, the so-called War of the Reform. Juárez, president of the Supreme Court and, as such, Comonfort's constitutional successor, therefore affirmed his right to the presidency and established a liberal administration in the gulf seaport of Veracruz, cutting off the capital, Mexico City, from the foreign currency needed to support its army. His principal opponents, leading the conservative rebellion, were two young generals, Miguel Miramón and Tomás Mejía (figs. 8, 9). The former was a popular, ambitious soldier, known to be ruthless and proved to be capable of duplicity; the latter was a resourceful and respected indigenous Indian from the hills outside Querétaro, where both men would later be executed alongside Maximilian.

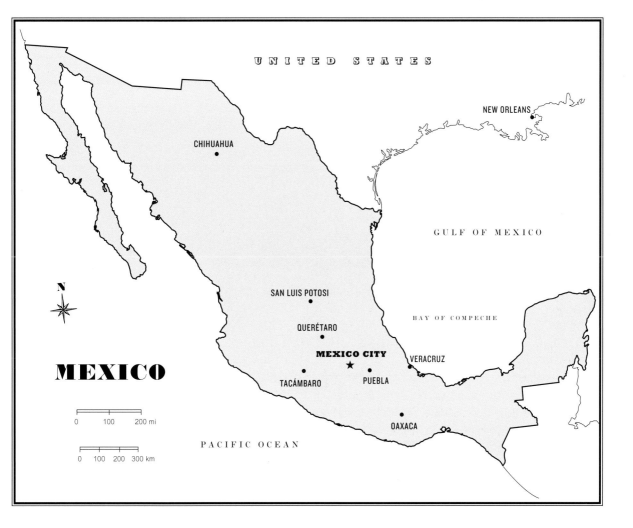

That event would take place after some seven years and four regime changes. The first such change came early in 1859 (as Napoleon was moving to attack the Austrians in Italy), when Miramón was elected president of the Mexican Republic by the beleaguered conservatives in Mexico City. Pleas had once again gone out to England and France for their support and when, in the spring, Juárez's government in Veracruz was recognized by the United States, these pleas from now very alarmed conservatives became desperate. But the Italian campaign crushed these new hopes of intervention as surely as the Crimean War had earlier. And, desperation increasing, ugly things were happening that would not be quickly forgotten. Miramón's General Leonardo Márques defeated the liberal general Santos Degollado at Tacubaya, outside Mexico City, and, claiming to be acting on Miramón's orders, shot fifty-three prisoners, including soldiers confined to the hospital and the doctors and orderlies caring for them. Miramón denied any responsibility for what became known as the Massacre of Tacubaya, but the following year, 1860, he unquestionably was responsible for the deaths of thirty-eight

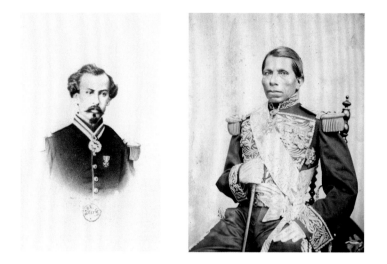

civilians—women, children, and old men—during his siege of Veracruz.[17] He was only finally defeated by Juárez's forces on December 22 of that year, and fled into exile, just as, across the ocean, Maximilian and Charlotte were settling in for their first Christmas at Miramare.

Less than two weeks later, Juárez entered Mexico City in triumph and was soon declared the country's constitutional president. In France, this met with predictable reactions: Mexico was in the hands of dangerous liberals who could not possibly have the support of their countrymen; its government was bankrupt; its army was exhausted and would easily fall prey to U.S. aggression, or to any country that was ready to move in and impose order.

8 ALPHONSE LIÉBERT
General Miguel Miramón
September–October 1867
Carte-de-visite photograph
(after Aubert), image:
3 9/16 x 2 3/16" (9 x 5.5 cm)
Bibliothèque Nationale, Paris

9 FRANÇOIS AUBERT
General Tomás Mejía. c. 1864
Albumen print, 6 13/16 x 5 1/8"
(17.3 x 13 cm)
Collection of the Royal Army
Museum, Brussels

FRENCH INTERVENTION: MANET'S RESPONSE

NAPOLEON, EUGÉNIE, AND THE DUC DE MORNY

In May of 1861, Manet moved to a new, large studio on the rue Guyot, which he would occupy until 1870, and made his first appearance as an exhibiting artist. He showed at the Paris Salon the portrait of his parents, M. and Mme Auguste Manet (Musée d'Orsay, Paris), and *The Spanish Singer* (fig. 63), which, though reviled by some of the critics, received an honorable mention and attracted the admiration of young painters and writers, including Henri Fantin-Latour and Charles Baudelaire.[18]

As is well known, an interest in Spanish art and culture had been growing in France well before mid-century, to be given a big boost by the empress Eugénie, a Spanish aristocrat of twenty-seven when the forty-five-year-old Napoleon married her in 1853. The beautiful Eugénie was not only an aficionado of bullfighting and an exhibitionist, given to smoking and cross-dressing, but also a devout Catholic, and as assertive in her religion as in her pleasures. Her former interests

made her fascinating to republicans like Manet; Theodore Reff offers the intriguing suggestion that the next great Spanish painting that Manet exhibited, at the Salon des Refusés of 1863, *Mademoiselle V.... in the Costume of an Espada* (fig. 10), hints at the image of Eugénie that would have been current in his circles.[19] However, her latter interests made her very dangerous indeed. Juárez's disenfranchisement of the church in Mexico, a few years after the imperial marriage, had made her a vehement, public supporter of her husband's vision of an activist foreign policy toward Central America.

Symptomatic of Eugénie's position had been the dedication to her, in 1857, of what became a widely read and respected book, *Le Mexique,* written by Mathieu de Fossey, a French resident of Mexico for some quarter of a century.[20] It would become a reference work for European diplomats, and its message—that England and France should ally to support Mexico against the United States as they had supported Turkey against Russia—would have been welcome reading to Eugénie. She was, in fact, extremely ill-informed about Latin America but, precisely because she believed its peoples to be the same as "the Spanish race,"[21] felt well-qualified, as the former condesa de Teba, to speak on their behalf. Thus, an outspoken Hispanicism and Catholicism infused her acquired interventionist sentiments with a high degree of virtuous morality. This sanctioned the fiction that her husband sought a kind of benevolent hegemony over that region, whereas what he really sought, as she knew very well, was political and economic power. But, as both of them knew, even benevolent hegemons sometimes have to act ruthlessly.[22]

In 1861, that is how Napoleon III did act, taking swift advantage of a customary excuse for action and of the removal of the normal impediment against it. The excuse was an unpaid debt, which had dogged Mexico's relationships with virtually all European powers since its independence, producing an interminable sequence of sordid disputes, some ending in coercive action. And, in July 1861, a month after assuming the presidency of Mexico, bankrupt after the civil war, Juárez had declared a moratorium on the repayment of foreign debts incurred by his predecessor, Miramón. For Juárez had discovered, to his astonishment, that the interest alone on these debts amounted to more than two years of Mexico's national income. Chief among them was a now-notorious, usurious loan from a Swiss bank owner in Mexico City, Jean-Baptiste Jecker, made in return for treasury bonds that, in addition to their now-unpaid value, included rights to mineral exploration in northern Mexico. It would later transpire that Jecker had, in fact, cut his

losses by selling some of these bonds—largely owing to their carrying these rights—to the Duc de Morny, a wealthy financier who was Napoleon's illegitimate half brother and adviser. Needless to say, his advice included intervention in Mexico.[23] In 1837, the French had sent an expeditionary force to Veracruz to pressure for repayments. So why not now? The normal impediment against action was the danger that the United States would enforce the Monroe Doctrine, but this was suddenly removed; in April 1861 the United States plunged into civil war.

MEXICO: THE FIRST YEAR OF THE INTERVENTION, 1861–62

In response to the announcement of the debt moratorium, Britain and Spain as well as France broke off diplomatic relations with Mexico and convened a Tripartite Convention for early October to decide what to do. Even before the convention took place, a Mexican monarchist, José Manuel Hidalgo, a protégé of the empress Eugénie, had urged Napoleon that the time was ripe for a French intervention; Napoleon had decided that Hidalgo was correct; and Maximilian at Miramare had been informed that Napoleon proposed to send an expeditionary force to Mexico to compel it to repay its debts, if Britain and Spain would support him. His bellicosity was almost thwarted when the United States offered to pay these debts on behalf of Mexico, in exchange for the security of mortgages on public lands and mineral rights, if the allies would refrain from mounting the expedition. Unsurprisingly, because these very mortgages and rights were precisely what Napoleon (and his adviser, the Duc de Morny) secretly wanted, the offer was refused. So it happened that, on October 31, the allies signed an agreement that called for a tactical, topical intervention. By early January of 1862, more than ten thousand allied troops had disembarked at Veracruz under the leadership of the Spanish general Juan Prim, seven thousand of them French soldiers.

At this point, the situation was not so very different from other instances of European gunboat diplomacy designed to coerce Mexico into making good its defaulted promises. Hence, Juárez began arrangements for a conference with the allies, which would start the next month, in order to resolve the dispute. But it was rumored that General Prim aspired to the throne of Mexico; perhaps for this reason, or from lawyerly foresight, Juárez took the precaution of promulgating a decree, on January 25, which declared that the death penalty would be enforced against any Mexican who assisted a foreign intervention and against any foreigner who made an armed invasion without the declaration of war. This proved to be

prescient, for the conference broke down in failure in April. During its progress, Prim had learned that, contrary to expectations, there was not a large monarchical party in Mexico, and he wrote to Napoleon to alert him to this. Napoleon disregarded the warning and dispatched more French troops. Finally realizing that Napoleon had more in mind than the recovery of unpaid debt, Britain and Spain withdrew their troops, leaving the French to advance confidently on Mexico City. On May 5, at Puebla, they met a Mexican force, which, they had been told, was composed of rabble that could not afford the slightest resistance to the most renowned army of Europe.

Up to this point, ordinary Frenchmen had not paid much attention either to Mexico or to their emperor's ambitions for Latin America. Intellectuals, especially politically concerned intellectuals, and most especially politically concerned intellectuals with an interest in and experience of Latin America, like Manet, presumably would have taken a keen interest in the events that we have been following. Of course, they would not have been privy to the reports that went to the foreign office, at the Quai d'Orsay, telling how easy it would be to achieve an invasion of Mexico. But from books like Fossey's *Le Mexique*, as well as from publication and discussion of foreign policy in newspapers, they would have well understood the imperial ambitions of Napoleon and have had a sense of his grand design for Latin America. Unquestionably, the republican Manet was more than sufficiently informed to have opposed this, and Napoleon's other imperialist ventures, from the beginning. To ordinary people, though, there was a distinct lack of interest in both Mexico and the emperor's vision; Napoleon himself learned just this in the autumn of 1861 from the *procureurs généraux*, the district attorneys of each department of the country, who were required to report frankly on public opinion to the minister of interior. And he learned the same thing in spring 1862, although he did hear criticism from within Paris for continuing to send troops to Mexico.[24] But all this changed when the news came back from Puebla.

Cinco de Mayo, now celebrated as a Mexican national holiday, was an utter humiliation for the most renowned army of Europe; eight hundred killed, wounded, or missing. And, before that season's campaign was over, hundreds more French soldiers had died from the continuing ferocious resistance or from tropical disease. Reports of the rout at Puebla, denied at first in Paris, could not be contained by the censors, and not only produced criticism in the opposition newspapers and speeches in legislative debates but also awakened the broader French public, in

the provinces as well as in Paris, to what had been happening. As expected in such situations, public opinion soon polarized between those who sought revenge and those who wanted the troops brought home.

MANET'S FIRST RESPONSE TO THE FRENCH INTERVENTION, 1862

It was probably in the spring of 1862, but whether before or after news of the events at Puebla reached Paris cannot be known, that Manet painted the aforementioned *Mlle V.... in the Costume of an Espada* (hereafter: *Mlle V.*; fig. 10). If Reff is correct in seeing in this painting an allusion to the empress Eugénie, then perhaps this fashionable woman, playing a part in a make-believe Hispanic arena of death, may also have been expected to stir thoughts of an almost equally incredible drama in Mexico. The *espada*, the person who kills the bull in a *corrida*, is shown to be posturing, up close, while something violent is going on in the distance. Unquestionably, the Hispanic was on Manet's mind in 1862, for that year he also painted the *Young Woman Reclining in Spanish Costume* (Yale University Art Gallery, New Haven, Conn.) and a work he never exhibited, now commonly called *Gypsy with Cigarette* (Princeton University Art Gallery, Princeton, N.J.), which was first inventoried with the title *Femme mexicaine,* that, if plausible, is obviously telling in the present context.[25] Additionally, he made two prints after Hispanic works, connotative of civilized enjoyment of violence, then thought to be by Diego Velázquez, a portrait of Philip IV hunting and a company of elegant cavaliers.[26]

If the prints refer to Velázquez, the paintings refer to Franciso Goya; *Young Woman Reclining in Spanish Costume* relates generally to his *Majas,* and *Mlle V.*, specifically to his *Tauromaquia* print series (fig. 11), from one of which the picador attacked by and attacking the bull in the background of this painting was borrowed. Did Manet know or surmise that the bulls in Goya's prints may symbolize popular resistance to the first Napoleon's campaign to conquer Spain, and did he replicate this image in order to tell of the replication of that campaign, in Mexico, by Napoleon's nephew?[27] This background image is so out of scale with the foreground figure and so disturbingly abuts it, to link the violence and the posturing, that it has caused Manet's critics to complain of his compositional difficulties and Manet's defenders to speak of his pictorial audacity[28] But perhaps a thematic point was being made.

The Mexicanness as well as Spanishness of Manet's paintings at the time were noticed. In the words of one critic, "Imagine Goya gone to Mexico, become

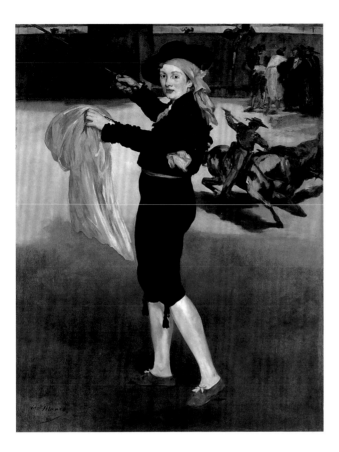

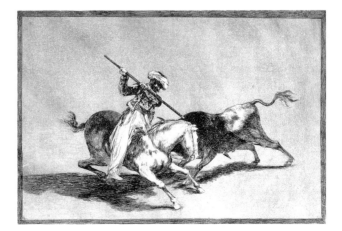

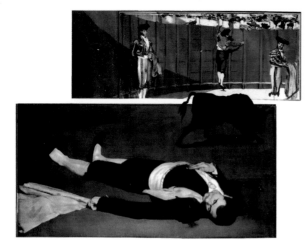

savage in the *pampas,* scribbling his canvases with the red juice of crushed Mexican beetles, and you will have M. Manet, the realist of the moment."[29] But any specifically political Mexican association escaped notice, as did, in the main, the disproportion between foreground and background figures.[30] However, what appears to have been a no greater disproportion provoked howls of disbelief in the case of a painting called *Incident in a Bullfight* (fig.12) shown at the Salon of 1864. Here again, though, a possible political message remained unnoticed.

 Manet had struggled with this painting for a long time before exhibiting it, and scholars and conservators have confirmed what a reviewer noticed at the time: that it had been extensively reworked.[31] The reworking had aimed at simplification. Manet had excised four minor *toreros* and a *picador* on a horse, which motif linked the painting to *Mlle V.,* leaving only a toreador on the ground and, behind him, the bull that had killed him, turned away to charge toward three *toreros* near the back fence of the arena. And Manet's pictorial process continued after the Salon exhibition, when, according to his friend Antonin Proust, he "boldly took out a pocket knife one day and cut out the figure of the dead *toreador.*"[32] The reason for this was certainly, in part, the hostile criticism that the painting had received (fig. 13), but not only that, for if Manet was truly dissatisfied with a painting, he would continue to work on it or would paint another subject over it on the same canvas.[33] It was also because, as Reff puts it, "cutting was merely the most extreme component of a creative process that habitually included scraping down, washing out, and painting over."[34]

 We shall have occasion to return to this very unconventionally liberal understanding of the options available to the painter for, as Reff concluded, "This way of improvising directly on the canvas without the traditional preliminary drawing— likened by Manet himself to learning to swim by plunging head first into the water— inaugurated what would become a familiar Modernist method."[35] For the moment, though, we need to know that *Incident in a Bullfight* was bisected and each part further reworked. The lower part produced a work, known to have been completed prior to February 1865, which Manet first entitled *The Dead Toreador* (fig. 15) but

12 Reconstruction by Susan Grace Galassi and Ann Hoenigswald of the second version of Manet's Incident in a Bullfight (1862–64), from Manet's The Dead Toreador, in the collection of the National Gallery of Art, Washington, D.C., and The Bullfight, in The Frick Collection, New York

13 **BERTALL (CHARLES-ALBERT D'ARNOUX)** Caricature of Edouard Manet's Incident in a Bullfight From *Le Journal amusant,* May 21, 1864

14 **EDOUARD MANET** The Bullfight. 1862–65 Oil on canvas, 18 7/8 x 42 7/8" (47.9 x 108.9 cm) © The Frick Collection, New York

15 **EDOUARD MANET** The Dead Toreador 1862–64 Oil on canvas, 29 7/8 x 60 3/8" (75.9 x 153.3 cm) National Gallery of Art, Washington, D.C. Widener Collection

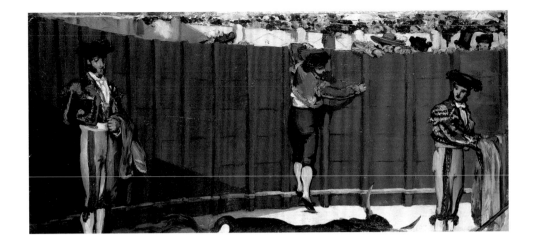

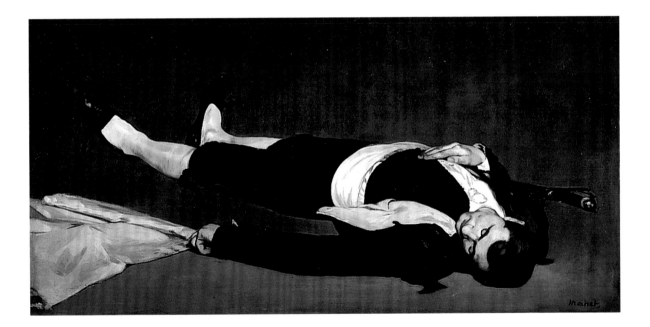

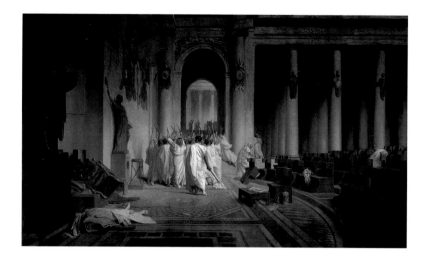

16 JEAN-LÉON GÉRÔME
The Death of Caesar. 1859
Oil on canvas, 33 11/16 x 57 5/16"
(85.5 x 145.5 cm)
The Walters Art Museum,
Baltimore

subsequently renamed, more universally, *The Dead Man,* for an exhibition that opened in Paris on May 22, 1867. The upper part produced a work called *The Bullfight* (fig. 14), which was probably completed after September 1865, when Manet finally witnessed a bullfight in Madrid.[36]

Looking forward: In mid-May 1867, when *The Dead Toreador* became *The Dead Man,* Maximilian surrendered to Juárez's forces, beginning a process that would lead to his execution. Even if this event was too recent to have influenced Manet, he certainly knew that Maximilian had been cornered, besieged at Querétaro, since mid-March. But why would this particular, reworked fragment be chosen to be retitled in this way? Looking backward: *Incident in a Bullfight,* although not exhibited until the spring of 1864, may well have been begun, Reff argues, almost two years earlier in response to the French humiliation at Puebla and to the continuing French casualties in Mexico in 1862.[37]

It had long been known that Manet may have based his fallen bullfighter on a painting of a dead soldier, then attributed to Velázquez (The National Gallery, London), or on Jean-Léon Gérôme's *The Death of Caesar* of 1859 (fig. 16), or on both works. Remembering the possible iconographic meaning of the bull in Goya's prints, Reff has argued that this bullfighter, too, may be thought to represent an anonymous victim of popular resistance to Napoleon III's campaign to conquer Mexico. Transformed into *The Dead Man,* in May 1867, he may have come to represent, for Manet, a specific victim of that campaign's failure, an emperor like Caesar.[38]

Why, then, did *Incident in a Bullfight* give Manet so much trouble? Conservation studies appear to confirm the statement of Adolphe Tabarant, in the first modern, 1947 catalogue of Manet's work—taken seriously only by Reff—that the artist had begun it in the summer or autumn of 1862 only to abandon it, return to it, give it up again, and then bring it to exhibitable shape in the winter of 1863–64.[39] Its large size—estimated to have been approximately 49 x 66" (126 x 168 cm)[40]— was unprecedented for Manet in 1862 and that may have been the problem, but

he was successfully tackling even larger paintings in 1863, while he was still apparently struggling with this one. His difficulty may well have been that he was, indeed, not simply painting an incident in a bullfight. Rather, he may have been attempting to make a history painting, which told of important events, but of a new kind, only to find himself close to making one of an old kind, namely, an allegory. "Do you take me for a history painter?" he had said. "Reconstructing historical figures—what a joke!"

In this case, he did avoid reconstructing historical figures. (And he did follow his own advice, "When it's wrong, you start again.") But, if this was meant as a reference to Puebla, it hardly succeeded as such. He could not, of course, overtly represent a French military humiliation; the censors would not have allowed it. And yet, as Reff and Wilson-Bareau acknowledge, no critic who wrote of the painting at the Salon of 1864 recognized, or at least spoke of, its possible political meaning, and only one, Théophile Thoré, politically radical as well as visually astute, allowed that inference, by comparing the dead toreador—"another victim of the viciousness of public morals"—to a woman's corpse in a painting in the salon of Russian atrocities in Poland.[41] But, then, no critic could safely publish an interpretation of a painting representing a bullfight as actually about a French military humiliation.

EAGLES IN MEXICO: ANGELS IN FRANCE

With the French now in Mexico, having suffered defeat in 1862 and preparing to retaliate the following year, this is as good a point as any at which to pause and return to the problems of narrative representation that were broached at the beginning of this chapter. For the very contingency of the preceding account of Manet's 1862 paintings must offer a sharp contrast to the certainty of the account of the Mexican intervention. France had suffered defeat in 1862 and prepared to respond the following year. Did Manet's 1862 paintings respond to that defeat? No available answer to that question is verifiable.[42] I find it difficult to believe that Mexico did not enter Manet's mind while making bullfight paintings in 1862, yet I feel comfortable in saying that he probably did not embark on these paintings with the intention of making paintings about Mexico; and, even, that he may not have been consciously referring to Mexico while he was making them. There are unconscious intentions. To alter a sentence by Christopher Ricks on another major

modernist, what matters is that Manet is doing the imagining, not that he be fully deliberately conscious of the countless intimations that are in his art.[43] And, to follow an old rule of thumb, or is it tautology, the greater the work, the greater in number the intimations.

POLITICAL NARRATIVES

This is a convenient moment at which to make this observation because the manner in which an intimation, or let us say a meaning, is presented assumes a very particular significance within an autocracy, and within a medium that seeks to rise beyond mere polemic and propaganda. The polemic, the work seen to be reducible to a single meaning, is not only unprotected against censorship. It will not appear to satisfy the expectations, created by the historicity of art, of providing multiplicity of meaning, the better to retain the viewer's attention by creating uncertainty in his response. And, of course, the work that is reducible to a single, polemical meaning will not function properly as a truly political statement either, if by that we mean—more than simply asserting a belief or describing something affecting that either reinforces or alters a belief—a statement that extends the thread of recognition and understanding beyond what previously was seen and known, therefore complicating not simplifying. These issues were critically important to Manet, a necessary part of his imagining. Contemporaneous responses to his paintings opened the interpretation that he was indifferent to his subjects; nobody can seriously hold that position now, yet nobody seriously can deny that a stance of indifference to his ostensible subjects was sometimes a part of the medium of his art because it allowed its intimations to open.

In the case of an allegory, the ostensible subject is not meant to be the principal subject; the ostensible and the actual subjects are understood to be divided and layered.[44] For *Mlle V.* and *Incident in a Bullfight*, and other paintings by Manet, the ostensible and additional subjects are layered but not divided. There will be primary and secondary meanings, and tertiary ones, but they will often intermingle, and it will be uncertain what their order of importance is. It is safe to say that Mexico is not a primary meaning of *Mlle V.*, which is a portrait of a French model playing the part of a Spanish *espada*, a Hispanic costume piece, and a parody of a Salon painting. Since it shows a figure who may remind one for a moment of the elegant Empress Eugénie in a contrasted setting of violence, it may cause Mexico to cross one's mind.[45] Similarly, *Incident in a Bullfight* is just

that and also a description of a specific incident, the recent killing of a bullfighter named Pepete; a reminder that Goya had recorded the killing of a bullfighter with a similar name of Pepe Illo; and an expression of revulsion against bullfighting, and therefore against the regimes that encouraged it. Quite where Mexico appears on its chain of intimations is uncertain.[46] We need to know these Mexican stories to recognize them; the paintings do not reveal them. In this respect, if they do refer to events in Mexico, they approach the condition of allegories.

"Paintings address us," Michael Podro has written, "and they do so in part through creating uncertainty; our engagement with them involves a continuous adjustment as we can scan them for suggestions on how to proceed and for confirmation or disconfirmation of our response."[47] In *Mlle V.* and *Incident in a Bullfight,* it would seem that elements of iconography are what make us think, possibly, of Napoleon III in Mexico after making us think, possibly, of Napoleon I in Spain. It is doubtful, however, whether we would pay attention to the elements of iconography that allow such an association if the realism of their representation had not been violated, and violated in such a way as to draw our attention to the anomalousness of these elements of iconography to the narratives in which they are placed. In order to make us think, possibly, of Napoleon I in Spain, Manet not only had to quote Goya; he also had to disclose his source at the expense of the narrative continuity of the ostensible subject. Perhaps that would be enough also to make us think, in the mid-1860s, of the current emperor's adventures in Mexico. But perhaps not. Therefore, Manet needed to overlay this quotation with another, of a painting of a dead soldier or of a dead emperor; of the appearance of the present empress.

However, no quotation, no alien iconographical signal, was likely to be noticed unless it jarred the continuity of the narrative. There had to be a disruption. It might be created by a noticeably different level of specificity in descriptiveness or finish; by an apparent anomalousness of color, tonality, or illumination; or by means of a compositional dissonance, as set against the normative means of the painting. It may not always be certain what is normative, therefore what is disruptive, but in this confusion, too, the disruptive principle obtains. For the meaning of the disruption is not only the meaning of the disrupting element itself; it is also in the means by which continuity is jarred. In both *Mlle V.* and *Incident in a Bullfight,* it is jarred by the opposition and dislocation of forward and backward, near and far, clear and unclear, controlling and controlled, strong and weak.[48] Manet directs

our attention to and across distance—lateral and spatial distance together—making us conscious of the dissonance of the saccadic jumps and pauses in our viewing. This speaks of his historical method.

A theorist of narrative, Hayden White, has observed that "the reality that is represented in the historical narrative, in 'speaking itself,' speaks *to* us, summons us from afar (this 'afar' is the land of forms), and displays to us a formal coherency that we ourselves lack."[49] I have spoken of the layering of meanings and creation of uncertainty in Manet's painting, of their disruption of narrative continuity and their spatial dislocations. Therefore, it seems odd to be alluding to coherence at this point. But I did say earlier that Manet's reinvention of history painting not only meant opposition to the coherence and certainty of a narrative, but also required him to build unity for his paintings from the very factors that would seem most likely to tear them apart.[50] "The historical narrative," White adds, "reveals to us a world that is putatively 'finished,' done with, over, and yet not dissolved, not falling apart. In this world, reality wears the mask of a meaning, the completeness and fullness of which we can only *imagine,* never experience."[51] Instead of bringing from afar a completeness that can only be imagined, perhaps Manet may be thought to bring what is afar into a unity built from what is falling apart, not from any single unifying principle but by dissolving and reforming oppositions, reversals, and inversions that cannot be imagined but have to be experienced.[52]

History claims authority, says White. It needs to, because more than one version of the same set of events can be imagined, and it does so by summoning us to an arena of formal coherence, therefore credibility. It seeks to make desirable its version of what happened; to make its reality an object of desire. This means that, again in White's words, "the reality which lends itself to narrative representation is the *conflict* between desire, on the one side, and the law on the other,"[53] and it means that most overtly in an autocracy. Ordering for desirability may seek complicity with the desires of an audience, even an autocratic audience; at its most compliant, this will mean imposing upon events what is lawfully desirable, namely, the formal coherence of a narrative order that stories familiar and credible to the audience will possess. This was the juste-milieu approach of the paintings that were popular in the Salons. Insofar as Manet's paintings disrupt such coherence and refuse to offer an imagination of completeness but require its experiential building, they may be said to disrupt the expected, lawful means of narrative credibility. And all of Manet's paintings constructed in this way may,

irrespective of their subjects and their intimations, be held to be political construc-
tions precisely in their destruction of lawful means of meaning.

MANET'S VIOLENCE

It is, therefore, unsurprising that the theme of aggressive destruction appears in
contemporaneous critical responses to Manet's art; there is both the claim that his
paintings are aggressive—for example, that "his sharp and irritating color pierces
the eyes like a steel saw"[54]—and that his paintings actually deserve an aggressive
response. Michael Fried, in particular, has spoken of "Manet's deliberate courting
of unintelligibility, of what was seen as the extreme violence of his paintings' con-
trasts and oppositions, of the use of the word 'cruelty' in connection with his art."[55]
He was discussing the Maximilian paintings, and I shall return to what he had to
say about them, but his more general point—that Manet's art, more than any other,
initiates the modernist task of performing a repudiatory, destructive operation on
aspects of the past[56]—is not limited to Manet's representations of subjects of
violence. As Fried reminds us, we have only to think of the enraged reactions to
Le Déjeuner sur l'herbe (fig. 22) when it was shown at the Salon des Refusés in
1863, and the *Olympia* (now Musée d'Orsay, Paris) when it appeared at the Salon
in 1865, reactions that exemplify how Manet exposed a relationship between sight
and spectatorship on the one hand and the desire for, and fear of, physical vio-
lence, and the violence of physicality, on the other.

And yet, subjects of violence had to have a special place in an art that
both sought to destroy and itself tempted destruction. This is one of the explana-
tions of Manet's remark, puzzling to some of his admirers: "There's one thing I've
always wanted to do. I would like to paint a Crucifixion." He said this to Antonin
Proust, after he had completed his portrait of 1880 (fig. 17), who reported what
Manet then said: "I painted you as Christ wearing a hat, in your frock coat with a
rose in the buttonhole—as Christ on his way to visit Mary Magdalene. But Christ
on the cross. What a symbol! Even if you searched for ever, you would never find
anything to equal it. Minerva is a fine subject, Venus too. But the heroic image and
the image of love must for ever be surpassed by the image of sorrow. It lies at the
root of the whole human condition and is its poetry."[57]

One obvious subtext of the sacrilegious joke is: When I exhibited *Olympia,*
I was criticized for making a goddess look like a prostitute; so now I have painted
you as God, at least the son of God, on his way to visit a prostitute. (Proust had

just been appointed Minister of Fine Arts.) Another is Manet's anguish at his own suffering from syphilis as well as from public rejection.[58] And, yet, a crucifixion was indeed the surpassing symbol insofar as a picture of that particular suffering from violence opened up more intimations than any other: to the entire story of the passion; to Christ's life story; to belief in redemption by that sacrifice; to the humane and civilized ideals of the community.[59]

 Manet made this statement near the end of his life and more than a decade after he had painted his Maximilian works. However, as we shall see, an aura of Christian comparison hung over these paintings, and Manet himself may well have thought of them in these terms. If so, it becomes especially interesting to consider the painting that he exhibited with the "Mexican" *Incident in a Bullfight* in the Salon of 1864, another image of violent death, *The Dead Christ and the Angels* (fig. 18). Whereas the former painting, we have heard, could well have been begun in immediate response to the French defeat at Puebla on May 5, 1862, we know Manet began the latter painting no sooner than November 1863. Therefore, before turning to this painting, we need to know first what had been happening in the interim in Mexico.

17 **EDOUARD MANET**
Antonin Proust. 1880
Oil on canvas, 51 x 37 3/4"
(129.5 x 95.9 cm)
Toledo Museum of Art. Gift of
Edward Drummond Libbey,
1925.108

18 **EDOUARD MANET**
The Dead Christ and the
Angels. 1864
Oil on canvas, 70 5/8 x 59"
(179.4 x 149.9 cm)
The Metropolitan Museum of
Art, New York. H. O. Havemeyer
Collection, Bequest of
Mrs. H. O. Havemeyer, 1929
(29.100.51)

PUEBLA AVENGED, 1863

What had happened was that the defeat at Puebla, having at first been denied by the French government, was then used as an excuse to send more troops to Mexico in order to restore national honor. Napoleon I's official birthday on August 15, 1862, became the occasion for chauvinistic celebration, by which time reinforcements were on their way to Veracruz. Manet recorded the celebrations in a sardonic, unpublished lithograph, showing a crippled figure with crutches in the foreground.[60] In January of 1863, the Corps Législatif offered an overwhelming vote of confidence for the government's Mexican policy and, by mid-March, Puebla was under siege.

By now, there could be no misunderstanding as to what this intervention was about. The French army had met and was continuing to meet unexpected resistance, popular support for the establishment of a monarchy having failed to materialize. As the siege wore on, Napoleon came very close to calling off the whole affair. But two months later, in May 1863, just over a year after the French had been humiliated (and a matter of weeks after Manet's first major exhibition had opened at Louis Martinet's gallery in Paris, followed by the Paris Salon des Refusés), the French had their revenge. Juárez having been forced to flee to the north, to San Luis Potosí, the tough veteran Marshal Achille-François Bazaine entered Mexico City in June and established a provisional government. The following month, an Assembly of Notables in Mexico City voted in favor of a constitutional, hereditary monarchy. During that year's celebration of the emperor's official birthday, the Champ de Mars was illuminated, decorated with giant *N*s and references to Puebla and Mexico City, and similar festivities were organized in 33,000 communes across the country.[61]

But Napoleon was not celebrating. He has been painted as blindly pursuing an unrealistic course, yet he was very well aware that his victories in battle in 1863 did not mean that he had won a war. "I realize that I have gotten myself into a tight corner," he told a confidant, "but the affair has to be liquidated."[62] Liquidating it meant avoiding the sacrifice of French blood and wealth by passing on the responsibility to someone else. And if that someone else were an Austrian archduke, it could aid another of Napoleon's schemes: the formation of an alliance with Austria. Hence, even while France was celebrating its victories, a Mexican commission had, with Napoleon's encouragement, set off for Miramare and in early October offered the imperial crown to Maximilian. Maximilian, knowing that

this was a situation fraught with danger, provisionally accepted on two conditions: that the great powers guarantee his position; and that the offer of the crown be made on behalf of the Mexican people. The aforementioned Assembly of Notables cabled its offer, which seemed to satisfy the second condition, but the first condition still had to be addressed.

THE DEAD CHRIST AND THE ANGELS, 1863–64

Sometime in November 1863, Manet wrote to a friend: "I am going to do a dead Christ, with angels, a variation on the scene of the Magdalen at the sepulchre according to St. John."[63] The painting has been characterized as evoking the "tension between Christ's divinity, or the will of the Father, and the suffering which his human body must endure"[64] (fig. 18). If this is at all plausible, Manet's understanding of the subject has to have been affected by his having just restored family honor by marrying Suzanne Leenhoff, the woman who had been his father's mistress, and bringing their son into the family under the guise of his being his wife's brother.[65] And perhaps it was affected by his knowledge of another paternal resolve: Napoleon's determination to see Maximilian accept the Mexican throne. He did accept in April of 1864, after meeting Napoleon in Paris the previous month and gaining the promise of limited French protection, while Manet was working on his painting.

Since *The Angels at the Tomb of Christ,* to use the title with which it was exhibited at the Salon of 1864, was shown with *Incident in a Bullfight,* we have to wonder about the relationship of these two very bizarre paintings. It has been suggested that the former shows Christ as "victim of a divine destiny" in contrast to the dead toreador, who is a "victim of the bullring's game of chance and of the bull's brute force."[66] But if *Incident in a Bullfight* illustrates an anonymous French victim of Napoleon's chancy Mexican game, and of the brute force that he met there, perhaps *The Angels at the Tomb of Christ* also makes some reference to Mexico. Among the widely noticed anomalies in this altogether perplexing painting are the exuberant wings of the angels—"tinted with azure more intense than the farthest reaches of the sky," wrote Thoré. "No earthly bird can boast such plumage"—and among its still unsatisfactorily explained anomalies is the very much alive snake that moves across the foreground.[67] Given Manet's famous attraction to jokes and visual puns,[68] it is not impossible that the eagle-and-snake emblem of Mexico had crossed his mind (fig. 19); perhaps even the snake that

19 Flag of the Mexican Republic
19th century
From *Mexico: los proyectos
de una nacion, 1821–1888*
General Research Division,
The New York Public Library
Astor, Lenox and Tilden
Foundations

had bitten him so painfully when he was a naval cadet in Rio de Janeiro.[69]

Whether or not that was the case, this painting deserves an extended discussion in this context less because of a possible, oblique intimation of Mexico than because it rehearses a group of related issues that will be extremely important for the Maximilian paintings. First among these is its imagination of an unseen event, known only through written texts (in this case, the Gospel of St. John) and earlier reproductive images (here, prints after Paolo Veronese and Francisco Ribalta).[70] As George Heard Hamilton has observed, Manet's *The Angels at the Tomb of Christ* must be seen as a challenge to Gustave Courbet's fundamental principle that an artist should only paint what he sees, a principle expounded in a celebrated open letter to students at the Ecole des Beaux-Arts, sent, ironically perhaps, on Christmas Day of 1861, and stating that "painting is an essentially *concrete* art and can only consist of the representation of *real* and *existing* things . . . ; an object which is *abstract*, not visible, nonexistent, is not within the realm of painting."[71] Furthermore, it seems that Courbet had been specifically dismissive in 1864 on the subject of angels in paintings, and had subsequently attacked this work of Manet's for not showing whether angels have backsides and for depicting wings that could not support their heavy bodies.[72]

So, did Manet represent angels implausibly to show that they are not real and existing things? This is, of course, an illogical question.[73] What can be said is that Manet did draw attention, in this work, to the question of being able to see, and therefore paint, something that is not visible to be seen, and therefore painted.

On the rocks behind which the snake glides, Manet wrote: "*évang. sel. St. Jean/chap. XX v. XII*" (Gospel according to St. John, chapter 20, verse 12). Chapter twenty tells of Mary Magdalen being told that the body of the crucified Christ is missing from the tomb; then she looks into the tomb (leading to verse twelve): "And seeth two angels in white sitting, the one at the head, and the other at the feet, where the body of Jesus had lain." In the Gospel, therefore, unlike Manet's painting, Christ's body is not in the sepulchre. So, why did Manet provide that specific biblical reference within his painting, and reinforce it with a title, *The Angels at the Tomb of Christ,* that allows the inference that Christ is not in the tomb, then proceed to paint Christ within the tomb?

One answer is: we are asked to believe that Christ, though not in the tomb, was nonetheless visible to a viewer who originally occupied the present viewer's place in front of the angels at the tomb of Christ. It has long been known that Manet's painting, when exhibited in 1864, was immediately associated with the name of Ernest Renan, whose *La Vie de Jésus* had appeared in June of 1863 to enormous controversy owing to its image of an extremely human Jesus moving in less than miraculous ways.[74] Most provocative—indeed, thought to be sacrilegious—was his suggestion, in his discussion of St. John's retelling of the Magdalen's testimony, that "the powerful imagination of Mary of Magdala played a capital role in this event . . . in which the passion of a hallucinating woman gave the world a resuscitated God."[75] From this, we might conclude that Manet, prompted by Renan's text, added the figure of Christ in illustration of the Magdalen's hallucination.[76]

And yet, the hallucination, if it was that, comes later than verse twelve of chapter twenty of St. John that Manet had specified and, therefore, may be assumed to have read. It comes at the point that the Magdalen turns away from the sepulchre and sees Christ, who had been behind her, but does not recognize Him, believing Him to be the gardener. So why would Manet represent something at direct odds with the chronology of the text that he cited?

Is it possible that Manet, choosing to represent the angels at the tomb of Christ rather than Christ as gardener, which he had done already in 1856, nonetheless wished to find a way to include the image of Christ, and, therefore, included the image (or hallucinated image) of Christ already behind her that the Magdalen was about to see? This may not seem very plausible. Yet Manet, if he had indeed read St. John as well as Renan, had to know that he was representing her vision of Christ in a place and at a time that were both before, and in front of, its reported occurrence. And so did the viewers of his painting who also had read these accounts.[77] Manet was prepared to conflate two temporal and spatial moments and show an anticipatory hallucination, to show that the conflation of two successive narrative episodes into one pictorial instant is hallucinatory, in a retelling of history that pulls apart what students of narrative have called the *story*, the events to be related, and the *discourse*, the story as it is actually related.[78] This dislocation, and layering, is rather different from, and more complex than, what obtained in *Mlle V.* and *Incident in a Bullfight* because those paintings did not illustrate known texts in the way that this one does, and in the way that the

Maximilian paintings will. Here, Manet is continuing the dialectic of the earlier paintings at a deeper imaginative level by pitting the extent and complexity of the narrative against the immediacy of the composition, and the disequilibrium of the composition against the coherence of the story that it tells. How narrative time meets, and is (and is not) absorbed in, pictorial time—in structures of both analogies and contradictions—informs his entire artistic practice, but in his paintings that tell known stories it gains a particular resonance.

Why was Manet attracted to this episode from St. John? We have heard possible biographical and political answers to this question. So, let us finally consider a pictorial one, which is more relevant to the Maximilian paintings than any other. St. John tells of how the Magdalen, turning away from the tomb, saw a visual image that she could not identify. That image identified itself as Christ and told her not to touch Him—"*Noli me tangere*"—because He had not yet ascended to return to His father. Verification by touch of a visual identification, of what may have been merely an hallucination, was denied. Renan's account claimed that this was indeed an hallucination. But, later, when the image of Christ appeared to the assembled disciples, one of them, Thomas, said that he would not acknowledge Him until he had not only seen but also touched the wounds of crucifixion. This, Christ allowed, famously remarking, "Because thou hast seen me, thou hast believed: blessed *are* they that have not seen, and *yet* have believed."[79] This often-repeated episode, which speaks of the verification of sight by touch and of the verification of belief by sight supported by touch, is as critical a gloss on the art of painting as the thematically related biblical story of Christ restoring sight to the blind:[80] the latter speaking of what painting can seek to do, the former of the skepticism that visual images can provoke.

Manet's painting engages the question of verification of sight by touch because it shows Christ, as Fried has observed, in a liminal state between death and resuscitation; at once set in place and apparently beginning to move.[81] As a painting, obviously it disallows verification. Yet, it also allows the viewer to anticipate the fiction of verification by offering a description of a resuscitation on the cusp of occurrence, one that would call for verification in the biblical story. An invitation is thus offered by the figure of Christ, on behalf of the painting, that the action that seems about to happen may be linked to the viewer's reaction, of skepticism or belief, within a time frame that is specific to this composition.

We know that, for witnesses of violence, time appears to slow down in a protracted duration (and that there is a mechanical explanation for this).[82] Manet, whose paintings were regularly thought to be violent and who is here painting a subject of violence, can be said to invoke this slow-motion effect in order to individualize the viewer's firsthand experience of a transfixing scene. Just as he pitches a textual conception, which signals an absence, against a visual perception, which signals a presence, however hallucinatory, so he pitches the viewer's own temporal experience against the biblical narrative, another tension of perception and conception. And he does that not in indifference to that narrative; he tells us so by inviting skepticism of the reality of the visual image. He thus seeks to hold the perception to an intuitive logic of his own invention that seems as inevitable and plausible as it seems ready to be transformed in our viewing.

Interestingly, what Manet had originally conceived as "a dead Christ with Angels" had become a "Christ Resuscitating Attended by Angels" before it was exhibited at the Salon of 1864 as *The Angels at the Tomb of Christ*.[83] But, when he changed the title of *Dead Toreador* to *The Dead Man* for his solo exhibition in May 1867, he changed the title of this painting back to *The Dead Christ and the Angels*. I have suggested that the revised title, *The Dead Man,* might allude to Maximilian's plight that spring. Perhaps Manet's reinsertion of Christ's name in this companion painting had a similar motivation. In any event, I have devoted so much attention to it because Manet would replicate (repeat in a revised form) its representation of a suffering hero supported by two attendants in his paintings of Maximilian executed between his two generals.

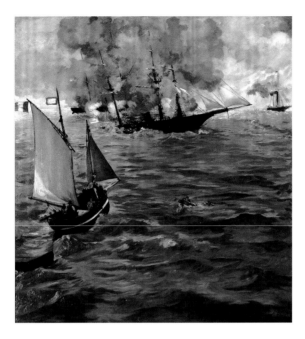

THE ROAD TO QUERÉTARO

On June 19, 1864, Manet would be reminded of events across the Atlantic when an American Union vessel and a Confederate ship battled off the coast of France, the latter (whose cause Napoleon III supported) suffering defeat. This event Manet recorded in *The Battle of the "Kearsage" and the "Alabama"* (fig. 20).[84] However, let us now leave Manet and conclude this chapter with a summary of Maximilian's short, three-year rule of Mexico.

MAXIMILIAN'S FIRST YEAR IN MEXICO, 1864–65

A week prior to this naval battle, Maximilian and Charlotte—Carlotta, as she would now be known—made their entry into Mexico City after having arrived from Trieste at the gulf coast port of Veracruz. The guarantees that Napoleon finally had offered to Maximilian had been minimal: he had neither guaranteed the territorial integrity of the Mexican empire nor had promised to defend it against the United States, but only offered a military occupation of three years, at Maximilian's expense. (This meant that Maximilian had to assume the debt owed to Jecker and, therefore, Napoleon's half brother, the Duc de Morny.) The meagerness of Napoleon's offer reflected his annoyance that Austria had rebuffed his proposed alliance; his recognition that Maximilian was an idealist who would not refuse the crown, even with all the problems that came with it; and his very realistic if cold-blooded desire to cut his own losses. And he realized that it was not the Mexican throne but his own that he had to be concerned with. After his diplomatic failure with Austria, the growing unpopularity of the Mexican adventure told him that he should distance himself from it as soon as and as best he could. (If only Maximilian were firmly in

place before the end of the Civil War in the United States, all could come out well in the end!) As for Maximilian himself, he was bitterly disappointed by the terms under which he went to Mexico, but at least he went with the assurance that he would receive the enthusiastic support of the Mexican people, and could accomplish great things on their behalf.

Unfortunately, Maximilian's arrival in Veracruz and then in Mexico City did not meet with quite the reception that he had been given to expect by the conservative monarchists who had invited him. It was surprisingly apathetic. However, his surprise soon was more than matched by theirs, for the new emperor quickly appointed a liberal ministry that restricted ecclesiastical privileges and power, thus effectively maintaining the policy of the deposed Juárez. There was conviction, certainly, in Maximilian's desire to do well for the broad mass of his citizens, but if there was also an element of conciliation to the previous regime, it did not succeed. Juárez refused to concede leadership to Maximilian and, in October, established an opposition government at Chihuahua in the north. But he was contained there, while Maximilian established himself in the great palace of Chapultepec, developing a range of social programs which included, mirroring one in France, the photographic documentation of criminals and prostitutes, the better to control civil disorder.[85] This particular program was spearheaded by a French photographer named François Aubert, of whom we shall hear again.

MAXIMILIAN'S SECOND YEAR IN MEXICO, 1865–66

It was unquestionably a great relief to Napoleon to have Maximilian settled in Mexico. But, when the American Civil War ended the following April, of 1865, he was rightly concerned, and there was understandably great anxiety among Maximilian's supporters in Mexico and Europe that the United States would now come to Juárez's support. This concern increased when Maximilian's military superiority proved to be vulnerable—Belgian forces in his service were routed by those of Juárez at Tacámbaro on April 11—and when President Abraham Lincoln's assassination, three days later, put U.S. policies into doubt. Despite Unionist sympathy for Juárez—and antipathy toward Napoleon III for his hope for a Confederate victory—Lincoln had maintained a policy of neutrality in Mexico, and there were fears that his successor would not do the same. These fears were not realized, yet Napoleon's desire to see Maximilian firmly established before the Civil War ended had not materialized, and the possibility of future U.S. intervention

could not be dismissed. The new U.S. president, Andrew Johnson, reaffirmed his country's recognition of Juárez's government, and boisterous rallies began to be held in New York against Maximilian and against the French for having installed him. But events like these were to be expected, given the weight of U.S. public opinion, and, despite Tacámbaro, the French army seemed to be in firm control of the country, so there was not really reason for alarm.

By the summer of 1865, however, the tide was turning. French control of the provinces was eroding, and Maximilian—and Napoleon—had to acknowledge that the war against Juárez's guerilla forces was not going well. By autumn, the guerillas were clearly uncontrollable, and both Maximilian and Napoleon began to be very worried.

Maximilian found himself vacillating between extremely liberal measures, which understandably angered his conservative supporters and did nothing to slow his opponents, and alarmingly repressive and sometimes irrational actions, which seemed injudicious, even to his supporters, and were provocations to his opponents. Very difficult to understand was his invitation to the daughter-in-law of the only previous emperor of Mexico, Agustín de Iturbide, living in New York, to bring her son to Mexico City for adoption so as to live in proper imperial circumstances, then abducting the child when his mother thought twice about the wisdom of this consignment. This affair caused howls of disbelief and disapproval in the world press, especially in the United States. Very dangerous was his enacting, on October 3, 1865, of the so-called Black Decree, which called for the enforcement, without appeal and within twenty-four hours, of the death penalty for all unauthorized armed persons and their supporters in Mexico.

Meanwhile, in France, the government won a convincing majority in the Corps Législatif in April 1865 in favor of continuing the war despite recent setbacks, but not at all as convincing as the vote two years earlier when the defeat at Puebla had to be avenged.[86] Now Mexico was Maximilian's business, and the reports of the provincial *procureurs* were showing that the war was unpopular and that the troops should be brought home. Napoleon was now firmly convinced that he had made a mistake.

So also was General Miramón, who had preceded Juárez as president and who now made secret offers to join Juárez's side, offers that were rejected but would be disclosed at his trial alongside Maximilian. The other general who would be tried then, Mejía, was continuing the struggle, yet beginning to suffer from

small incursions of U.S. troops, illegal but no less damaging for that. By early 1866, U.S. volunteers were openly going to fight with Juárez. As Maximilian's armies started to surrender to guerilla forces, it became clear in the United States that, owing to the pressure of public opinion in favor of French withdrawal, it had become impossible to enforce the Neutrality Act or to prevent recruiting. Unofficially, the United States had intervened.

On January 15, 1866, Napoleon, having decided he had to act, wrote to Maximilian saying that he was going to withdraw French troops from Mexico. Before waiting for a reply, he announced this decision a week later in a message to the Corps Législatif that was framed around what he knew were two blatant lies: France had performed its duty, and Maximilian was strong enough to stand alone. By summer, with the French readying to withdraw, Maximilian's future looked extremely grave, which is when Carlotta determined to go to Europe and plead with Napoleon to change his mind, and with others to urge him to change his mind. This initiated the first, well-known, personal calamity of this sorry business, when Carlotta, shunned by those who had encouraged the Mexican adventure in the first place, and increasingly convinced that Napoleon had dispatched agents to poison and silence her, besieged herself in a hotel in Rome. There, refusing to eat anything except the cooked chickens she had brought live into her room, she slowly but surely began to lose her mind. Finally persuaded to return to Miramare in October, she became so insensible of reality that it was never entirely clear whether or not she understood her husband's fate.[87]

THE ROAD TO QUERÉTARO, 1867

By then, Marshal Bazaine had withdrawn French troops from the north of Mexico, and Maximilian was being pressed from France to abdicate and himself prepare for withdrawal. But pride and duty made him refuse. On February 5, 1867, French forces finally left Mexico City, to embark from Veracruz on March 16. The day after they left, Maximilian, with his two conservative generals Miramón and Mejía, arrived at Querétaro, north of Mexico City, where they awaited Juárez's advancing army. They were besieged there for two months before Maximilian was betrayed, Juárez's troops were able to enter the city, and surrender was the only option.[88]

Maximilian, Miramón, and Mejía were charged with treason under the old Juárez decree of January 25, 1862, for helping a foreign army invade Mexico and overthrowing the lawful government, a charge motivated by Maximilian's recent,

October 3, 1865, Black Decree of similar severity. The court martial began on June 13 and was over the following day, when the death sentence was announced for all three defendants. As the news spread, some Mexican supporters of Maximilian made it clear to him that his escape could be managed, but he refused, saying it would be cowardly; others pleaded with Juárez to pardon him, but Juárez refused, rightly concerned that Maximilian would set up a government in exile; and many Europeans, from Queen Victoria to Victor Hugo, sent telegrams to Juárez, urging that Maximilian's life should be spared. The French newspapers fully reported these events, and, needless to say, Manet had to be aware of them. In Europe, the majority sentiment was that Juárez simply did not have the nerve to do it, and Manet may perhaps have heard of a report in *The Times* of London on June 25 that Maximilian's life was safe because "Juárez is afraid to shoot him."[89] A week later, the European newspapers were carrying a different story.

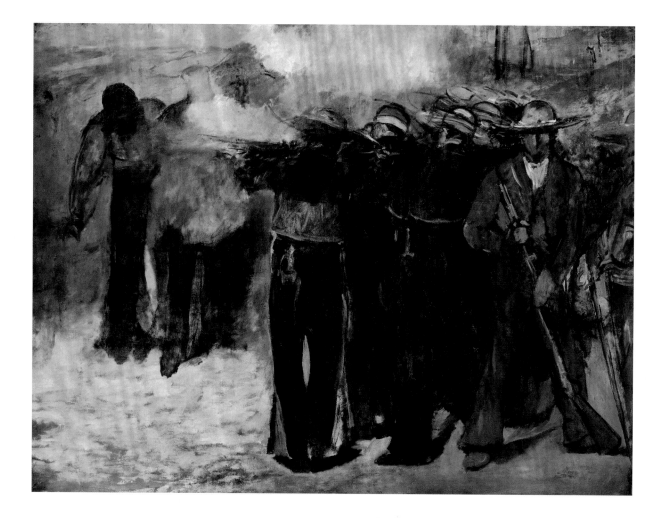

II.

RESONANCE *of* EXECUTION

He [Edgar Degas] admired and envied the assurance of Manet, whose
eye and hand were certainty itself, who could infallibly find in his model
the wherewithal to convey all his force, and completely realize his aim.
In Manet there was a decisive power, a sort of instinct for pictorial strategy.
In his best canvases he attained poetry, the summit of art, by means of
what I may perhaps call . . . resonance of execution.
But how can painting be put into words?

Paul Valéry[1]

The poet and essayist Paul Valéry's assessment of Manet, based on conversa-
tions with Manet's friend Edgar Degas, stresses his instinctive decisiveness
matched to technical assurance; his intuitive ability to find unique pictorial direc-
tion in his subject matter; and his intensification and enrichment of a work in
progress by forcing it along in a state of protracted, reflexive energy—a reso-
nance of execution. Presumably, the pun was unintended, yet the Execution
of Maximilian compositions do indeed offer the most compelling example of this
central feature of Manet's method of working. Over a period of probably some
three months, he conceived the Boston painting (fig. 21) around which this chap-
ter unfolds, and over another year or so reconceived its subject to produce the
remaining works in the series, discussed in chapter three. Taken together, these
works represent the most sustained, concentrated, and ambitious summit of
his art as a "resonance of execution," as the painstaking development and contin-
uing reimagination of an image that he knew and we know as *The Execution of*
Emperor Maximilian.[2]

Manet, we can confidently say, did not witness the execution of Emperor
Maximilian. A consequence of this has been that the modern study of these com-
positions has concentrated on discovering what Manet believed to have taken place
at Querétaro on June 19, 1867. Properly so, for we also can confidently say that
Manet, who said that he could not work purely from the imagination, made it his
job to find out what had occurred. We know this from a witness, Théodore Duret,

21 **EDOUARD MANET**
Execution of the Emperor
Maximilian. 1867
Oil on canvas, 6' 5 1/8" x 8' 6 1/4"
(195.9 x 259.7 cm)
Museum of Fine Arts, Boston
Gift of Mr. and Mrs. Frank Gair
Macomber, 30.444

who saw something of these works in progress and must have discussed them with the artist. While Duret's account dates from some thirty-five years after the events they describe, it does seem authentic, if perhaps not entirely accurate:

> In 1867 and 1868, [Manet] painted *The Execution of Maximilian.* . . . Its composition occupied him for many months. He first tried to discover the circumstances and details of the drama. This is why the three victims are placed so close to the execution squad, to accord with what actually occurred. When he was satisfied with the effect he intended, he began to paint his picture, with the help of an infantry platoon lent to him from a barracks, as models for the firing squad. He asked two friends to pose for Generals Mejía and Miramón, although he altered their heads. Only Maximilian's head was painted in the conventional way, from a photograph. When a first composition and even a second appeared not to match the detailed information he was finally able to obtain, he painted the work again, for the third time, in its final and definitive form.[3]

Manet, we will remember, had complained of history painting: "Do you base a man's portrait on his hunting licence?"[4] That is, do you depict an historical figure on the basis merely of a written text? In fact, textual sources would be a crucially important part of his practice of making these history paintings. He did base them on documentary evidence. Therefore, Duret invites us to imagine Manet's advancing knowledge of what had occurred at Querétaro influencing the changes that he made from one work to the next until a definitive understanding of what had occurred produced a definitive work. Modern scholarship has been assiduous in discovering the evidence available to Manet, thereby filling out Duret's account in increasing detail to describe how the sequence of newspaper reports, photographs, and prints to which Manet probably had access may be said to have influenced the development of his compositions. More precisely, changes within or from one composition to the next have been ascribed to new information that came to Manet's attention. Consequently, the date at which the information became available to Manet has been used to establish the dating and sequence of the compositions.[5]

However, leaving aside the possibility that Manet did not respond immedi-

ately to new information—for that is only a possibility—we do know for certain that some of the new information that Manet received did not cause any pictorial change. Thus, Pamela M. Jones, writing in the Brown University catalogue of 1981, properly cautions that Manet's interest in current events is not only illuminated by his use of documentary evidence but also "by evaluating the nature of those documentary details which he consciously and consistently rejected."[6] This reminds us that, *pace* Duret and those who have followed him, Manet was not shaping a report but creating a history, which is told by leaving some things out as well as by including other things.[7] But knowing that Manet did reject a lot of what he learned from newspapers and other sources tells us two other critical things. First, that the development of his compositions was, at best, driven not simply by new information but by certain kinds of new information, which is also to say that his paintings cannot be said to have been motivated by the successive refinement and accuracy of the information, only by refined and accurate information that suited other purposes. And, second, that the inference allowed by Duret, and some of the more recent scholars, that Manet's evolution of a definitive understanding of what had occurred at Querétaro paralleled and motivated his evolution of a definitive work that recorded what had occurred, just cannot possibly be true.

In fact, Manet never definitively knew what had happened at Querétaro because nobody definitively knew, or knows, what happened there. In the previous chapter I spoke of how art-historical discussion will seem contingent when compared to the broad historical record, which gains assurance and credibility from the certainty and sequentiality of known events. That will not be the case, however, when it comes to details of events, for there always have been and always will be discrepancies in the accounts of witnesses, officials, reporters, editors. We know this ourselves from our own reading of the newspapers.

We are, therefore, to imagine Manet poring over a succession of newspaper reports of a distant horrifying event, hoping for clarification and definitive truth, as we do now, and either not finding it or disbelieving it, as we do now. We are also to imagine him picking out what seemed plausible, perhaps because it came from a trusted source; perhaps because it sounded accidentally real rather than essentially ideal; or because it seemed credibly candid. But also, importantly, because it offered him material to work with, either reinforcing or altering his artistic as well as his political expectations. And we are finally to imagine him putting and piecing together these fragments, knowing that they did not realistically or

completely describe what had happened, but offered, rather, the means of an imaginative act of recovery of something distant and quickly receding into the past.

FIRST IMPRESSIONS: THE BOSTON PAINTING

"We must consider that I may be violently attacked. Wouldn't it be better to marshal our forces and hold yours in reserve to do something then?" This is not Maximilian writing to one of his generals, but Manet writing to Emile Zola.[8] Manet was uneasy with Zola's proposal to reissue a laudatory article on him that had first appeared in January 1867. The reissue, in pamphlet form, was to appear on the occasion of a solo show of Manet's paintings that he was going to open outside the grounds of the Exposition Universelle in May. In fact, the pamphlet was issued, and Manet was violently attacked, and to add to his troubles he was worrying about the rise of his younger rival, Claude Monet. "So much so," wrote Edmond Duranty, "people are saying that, having *manetized* him [Monet], he would now like to *de-monetize* him."[9]

Let us allow, then pass over as plausible but inessential, the possibility that the exceptional looseness of the Boston painting, then the seriality that it initiated, were prompted by competitiveness with Monet. Even if Manet had seen, for example, that Monet's *A Seascape, Shipping at Moonlight* (National Galleries of Scotland, Edinburgh) of 1866 was a much freer version of what he had done with *The Battle of the "Kearsarge" and the "Alabama"* (fig. 20) two years earlier, the Boston painting did not require that example; as noted in the previous chapter, his own method of beginning a painting offered the example of even greater freedom. And even if he was aware of Monet beginning to make successive paintings of the same subject, this was from a desire both to record "the transitory, the fugitive, the contingent" (Baudelaire's famous 1859 definition of modernity) and to control it by means of temporal sequencing,[10] whereas Manet's aim, in each work of his series, was surely a more complex one: both to collapse temporality into the instant of execution and to allow, in the space around that depicted instant, intimations of protracted moments that prolong, rather than quite succeed, the shocking instant.

Nonetheless, there is a competitive quality in the Boston painting, the terms of which (far more than those of the later compositions) seem to speak to a younger colleague like Monet: wanting to make a big, bold statement that expresses "the transitory, the fugitive, the contingent" moment as much in technique as in

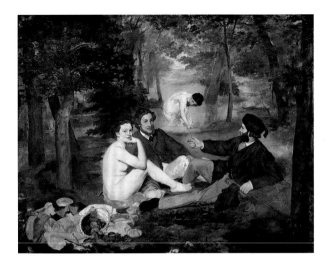

compositional motif. (But if it does thus address a younger painter, it speaks a message derived from older ones.) Nonetheless, its painterly freedom has led nearly all commentators to describe it as a preliminary sketch of some sort, unfinished and abandoned. A consensus exists that it represents Manet's first response to the news from Querétaro. However, it does not necessarily follow that it should be judged to be merely the origin of the later compositions; or that its painterly freedom should be taken to denote either pictorial incompletion or a paucity of information from Querétaro, or lack of reportorial accuracy in the representation of information. Champa, speaking of "its simultaneous quality and strangeness in Manet's oeuvre," offered a wiser, less-biased opinion: "Other versions of the *Execution* . . . represent more of what we think of as Manet's 'style.' The Boston version, however, presents the range of flexibility of Manet's artistry stretched to its expressive and illustrative limits."[11]

THE EXECUTION OF THE BOSTON PAINTING

This very large painting of seemingly life-size figures is, at 6' 5¹⁄₈" x 8' 6¹⁄₄" (195.9 x 259.7 cm), almost as big as Manet's largest painting to date, the 1863 *Le Déjeuner sur l'herbe* (6' 9⁷⁄₈" x 8' 8¹⁄₈"; 208 x 264.5 cm; fig. 22) Therefore, it far exceeds the standard-size canvases that were sold by dealers in artists' supplies, and would have had to be specially ordered. And its artist-applied ground would have taken time to paint and dry. (The same is true of the other two large paintings in the series.) Before actually beginning to paint, Manet "first tried to discover the circumstances and details of the drama," said Duret. As we shall see, Manet is generally thought to have begun the Boston painting almost immediately upon reading the first full, albeit unverified account of Maximilian's execution, which appeared on July 8, 1867. If this is taken to mean that the report motivated him to order the canvas, he could not have actually set to work until, optimistically, a week later in mid-July, which is around the time that the official reports began to appear.

It would seem, from the appearance of the painting, that Manet carried it forward in one campaign of work, then returned to it in another one or possibly two campaigns, whether with little or much time between the campaigns is impossible to tell. We will learn that the final campaign was unlikely to have been engaged until after Manet read an August 11 newspaper report on the execution at Querétaro. No further report produced information essential to the painting, and there is no other evidence to suggest how long Manet worked on it after reengaging (or continuing to engage) it in mid-August. Judging again from the appearance of the painting, if the first campaign did occupy Manet from mid-July to mid-August, then the second campaign (and the third, if there was one) could hardly have occupied him any longer than a month. In fact, two month-long campaigns are probably too long because the painting allows the inference that it was painted in great haste.[12] Besides, we know that Manet spent some and perhaps much of the summer of 1867 away from Paris.[13]

The painting is frequently referred to as a painted sketch (*esquisse*) or, more accurately, a full-size painted sketch (*ébauche*) and, therefore, de facto, a preliminary composition. It may give the impression that it was done on a colored ground; such grounds were common in nineteenth-century (and earlier) paintings.[14] However, Manet rarely, if ever, used colored grounds after his early student days, and this work is no exception. It is composed, as Manet would have understood an *ébauche* should be composed, from the lessons of his teacher Couture and from the example of recent French artists that he admired, from Eugène Delacroix to Gustave Courbet. That is, it gives the appearance of the freshness and spontaneity associated with first impressions, seemingly having started as a brush drawing in a sauce of thinned-down, brownish paint (possibly over charcoal outlines) that established the basic figural composition and that was enlarged by washes of the same mixture.

The conventional procedure in Manet's time was that an *ébauche,* allowed to dry, would form the foundation for building additional, more finished, tighter layers of paint that both precised and colored the composition. However, Manet often followed his master Couture in working on a still-damp *ébauche*—he did so here—so that it is hard to say where the *ébauche* ends and the painting proper begins. (Like Couture, he showed himself willing to let wet washes dissolve contours and scrapings expand them, and goes further in allowing an overall blurring to evoke the temporality of what is illustrated and of his illustrational means.) And, addition-

ally and unconventionally, he embarked upon the addition of color within what was nominally an *ébauche* procedure. He did so in both of the ways that would have been usual later on in the process—building up in thin, transparent layers and adding more opaque layers and glazing them over—and, as common to both methods, building up the lights in thick paint while keeping the darks thin.[15]

As Anne Coffin Hanson, the most curious about these matters, has observed, the Boston painting is more colorful than it first appears.[16] The green tunic of the left-hand soldier in the firing squad, seen from the back, opposes the red sash of the right-hand soldier, seen from the front. In a lower key, the blacks and grays of the costumes at the left complement the warm, rusty browns at the right. The cream yellow ground in the left foreground balances the pale blues in the right background in two grand, opposing chords. The smoky, atmospheric quality of the painting in the left half of a dividing diagonal contrasts to the increasing clarity of the other half, as one scans left to right. And thus, by coloristic as well as tonal and compositional means, the painting slowly but surely elicits a progressive reading from right to left, and back again. Less distinct victims give way to more distinct soldiers, and vice versa, and the picture pivots across the two poles of a faceless victim who has been shot and is falling and a facing soldier who stands motionless, ready with his rifle resting on the ground. He is the noncommissioned officer (NCO), who was waiting to deliver the *coup de grâce* if the squad had not managed to kill the condemned men. It hadn't.

Manet painted this officer over the figures of the troop of soldiers, which tells us that he did so in a second campaign of work on his picture. Presumably, the second officer, only partially visible beside him, and carrying a long, curved sword, was painted at the same time, since he tentatively occupies a space of similar width to that beyond the victims at the opposite, left-hand margin of the canvas. (This presumes that Manet began by giving his two-part figural grouping equal breathing room on both sides.) During that same, second campaign, Manet may have also begun to change the identities of the soldiers' hats from sombreros to kepis and to repaint their costumes from the rusty brown that is visible beneath the present darker tones, unless these changes were made in a third campaign, after the addition of the two officers, both of whom wear unmodified sombreros and brown costumes.

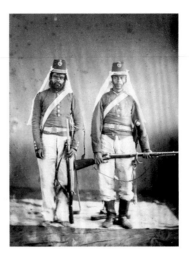

23 Mexican soldiers in uniform. c. 1867
Albumen print, 3 $^{15}/_{16}$ x 2 $^{3}/_{8}$"
(10 x 6 cm)
Collection of the Royal Army
Museum, Brussels

THE SUBJECT OF THE BOSTON PAINTING

However, to speak too definitively of identities is to misunderstand the purpose of an *ébauche,* which was to suggest, not to define. We must, therefore, be careful not to assume too much. We can say that the soldiers wear short jackets and flared trousers, which, with their sombreros, suggest that they were begun on the basis of images of the costume of Mexican guerillas rather than on the uniforms of Juárez's regular army. Therefore, Manet must have seen such images of guerilla costumes, and scholars have proposed where he may have done so.[17] It is now commonly accepted that Manet began to change these costumes when he learned, from an August 11 newspaper report, how the soldiers were attired and that, having been ignorant of Mexican army uniforms, he had made a mistake. But we cannot say definitely that Manet was unaware of what Mexican regular army costume looked like when he began to paint. In fact, it is very likely that he did, given the wide circulation of photographs and prints of Mexican scenes and the exhibition, in the annual Salons, of paintings of Mexican soldiers in battle, during the whole period of the French intervention (fig. 23).[18] Therefore, his choice to represent guerilla rather than army costumes would seem to have been made not from ignorance but from knowledge of the options before him.

Conversely, we must be careful not to ascribe knowledge where there was probably ignorance. It is also commonly accepted that Manet represents, in the Boston painting, Maximilian being executed between his two generals, Tomás Mejía and Miguel Miramón. In fact, all that we reasonably can say is that he represents two, and only possibly three, unidentifiable victims. One victim, with a darkened face, to the left, slumps but does not fall; abraded vertical elements behind him suggest that a post may originally have supported him.[19] Beside him, a taller figure wearing a sombrero, with a pale but featureless face, remains upright. And, beside and behind that figure, there may, but may not, be an indication of a third figure. Obviously, the tall figure must have been intended as Maximilian. The slumping figure occupies the position that will be occupied in later compositions by Mejía, who will also be represented as darker in complexion than the other two

victims. But we should resist looking ahead in order to be more specific than Manet; for now, this figure must be thought to be nameless as well as faceless.

We should resist similar interpretative temptations: seeing the upright elements in the right background as bayonets and lances derived from paintings or prints that Manet could have seen; wondering if the overpainting conceals anecdotal motifs of the execution that appeared in early, fanciful press stories.[20] Instead, we should notice the impossibility of firm identification that this painting asserts. Its blurred, irregular patches of spread, thinned, compacted, scratched, and abraded paint are not simply representations of the smoke of the rifles or the fall of morning light upon the execution; neither are they marks of tentativeness and indecision. Rather, they should be thought of as positive statements of uncertainty, of someone bound to a project of knowledge who yet adopts what the Romantic poet John Keats famously described as negative capability, "capable of being in uncertainties, mysteries, doubts, without any irritable reaching after fact and reason."[21] More precisely, in this case, of someone torn between painting uncertainty and advancing a project of knowledge.

MANET'S FIRST PAINTING CAMPAIGN;
THE JULY 8 REPORT OF THE EXECUTIONS

As we have seen, news of the executions at Querétaro reached Paris on July 1, 1867.[22] By July 3, they had been reported in most newspapers in Europe, with a horror and disbelief that ignored the long history of executed leaders in Mexico.[23] On July 5, the news was announced in the French Senate. For conservatives, anger against Mexico was mingled with anger against the United States, even to the extent of suggesting that Maximilian had been defeated by that nation; there was no immediate response from the French liberal opposition.[24] Additional, but still very general reports of the execution followed on July 5 and 6;[25] then, on July 8, there appeared in *Le Figaro* the first report that purported to detail what actually had happened at Querétaro on June 19.[26] This was a hearsay account, which *Le Figaro* said had been taken from a New Orleans newspaper, which reportedly said that it had taken it from a Querétaro newspaper. However, since news of an event in the middle of Mexico in wartime could hardly have reached Europe in just two weeks (except by the prohibitively expensive, transatlantic cable that had only just been laid the previous September), an accompanying editor's note conceded that it was probably not authentic.[27] In fact, *Le Figaro* had anticipated its own story

by publishing, the previous day, an article describing the manner in which executions normally were carried out in Mexico.[28]

Ever since this July 8 report was unearthed by Martin Davies in 1956,[29] it has become accepted that it, and the previous day's article, provided Manet with the information that he needed to begin the Boston painting, but not to carry it to the point when he stopped working on it. Furthermore, it has been accepted that Manet was forced to modify and eventually to cease working on this painting owing to the appearance of more fully detailed reports of the executions,[30] reports that demonstrated that certain inferences that Manet had made on the basis of the July 8 report were incorrect. These reports began to appear on July 22, some two weeks after that report, and continued through October 10, with the particularly crucial report that necessitated changes appearing on August 11. This wave of reports comprised a virtual media blitz on the subject that was accompanied, by August, it is thought, by the circulation of engravings and photographs that pretended to document episodes and objects in this sensational news story. Manet, it is also accepted, either saw some of these images or read reports by those who had seen them, which also affected his decision to abandon work on the Boston painting and influenced the London painting that replaced it.

Effectively, we are asked to believe, first, that Manet required documentary evidence to begin his painting, and was satisfied with what he probably knew were low evidential standards because he had no other option if he wanted to begin, and second, that he abandoned the painting when he learned of what he believed to be more reliable, fuller evidence, which demonstrated to him that his painting was reportorially flawed.

This is not unreasonable. Yet, it would lead us to presume that the Boston painting began as an illustration of the events described in *Le Figaro* on July 8 and ended because its illustration was seriously compromised by the later reports. However, when one compares what Manet could have read on July 8 and what he painted, most remarkable is not what he took from that report but what he did not take. And when one considers what the later reports may have compromised, with respect to the authenticity of his image, it is by no means certain that they did.

Presuming that Manet read *Le Figaro* on July 8 and based the Boston painting on the reports it contained, what may he be thought to have adopted from this source? We can say with reasonable certainty that Manet took two things from the report: the fact that the executions took place outside at seven in the

morning, although the evidence of the painting does not allow us to say whether it is dawn or dusk; and the fact that the firing squad was accompanied by two non-commissioned officers, although the report says that there were two noncommissioned officers plus a commanding officer and that there were three firing squads, one for each prisoner—information that Manet rejected. More generously, for the painting is ambiguous on these subjects, it may be conceded that Manet adopted the facts that the executions took place near a hill, but not that they took place near a cemetery wall, which was also in the report, and that the squad (the report says squads) was probably only three paces from the victims. Even allowing these two questionable adoptions, we need to add to Manet's rejection of one of the three officers, two of the three firing squads, and the cemetery wall, his further rejection of large crowds trying to scale the walls to see the execution, sword commands signaling the squads to shoot, the victims, except Mejía, seated on stools, three coffins carried by Indians, and three crosses to mark the places of execution. And we need to add to this his probable rejection of the number of soldiers in the squad being five, in addition to the officers, since the indeterminate pictorial evidence suggests a larger number. In truth, the only fact that Manet may unequivocally be said to have adopted from *Le Figaro* of July 8 was that the executions took place outdoors.

The inescapable conclusion is that Manet did not, in fact, have to have read this issue of *Le Figaro* in order to begin the Boston painting. I am not saying that he did not read it. He probably did read it before beginning (or possibly during) the painting of this picture, for we must not disallow the option that its painting proceeded and took direction from a conscious dismissal rather than an ignorance of much of what was understood to have happened at Querétaro. However, the foregoing conclusion does argue that the Boston painting proceeded and took direction, in the main, not from documentary sources. It argues that, if Manet read *Le Figaro* of July 8, which he probably did, his painting nonetheless proceeded and took direction, in the main, from art-historical sources, which formed the filters that passed through what was compatible in the newspaper and stopped what was not. We will now turn to these sources, which will allow us greater access than the topical documentation to the genesis and, to the extent that is possible, the development of this composition. During this process we may hope to answer a question that has been left open: to what extent did the more reliable documentary reports, which began to appear toward the end of July, influence Manet's

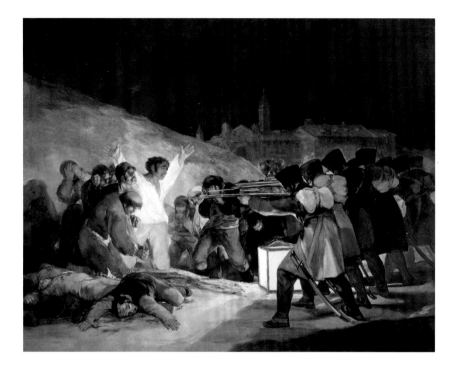

Page 86.

LE DEUX MAI.

decision to abandon work on the Boston painting and affect the shaping of the London painting that replaced it.

PAST REMINDERS

Since as early as 1910, five years after the Boston painting was first exhibited, it has been understood that it is very deeply indebted to Goya's 1814 painting *The Third of May, 1808* (fig. 24).[31] Yet, it has never been fully and satisfactorily explained why Manet turned to Goya at this particular moment. True, he must have seen Goya's great painting at the Prado when he visited Spain in 1865, but he did not mention it, Goya taking a definite second place to his admiration for Velázquez.[32]

WHY GOYA?

Fried has argued convincingly that Manet's solo exhibition of fifty-six of his works, which opened in late May of 1867, prompted him to reconsider the direction his art was taking,[33] as such retrospective exhibitions often do. In particular, Fried asserted, it demonstrated to the artist that he should discontinue the sequence of single-figure compositions that he had been making since his visit to Spain, prompted by his admiration for Velázquez, and return to his pre-Madrid approach of creating more complex compositions with a multivalent relation to their sources. Manet had decided to mount this solo show after two of these single-figure compositions (*The Tragic Actor* and *The Fifer;* fig. 65) had been rejected at the Salon of 1866, but also remembering, presumably, the excitingly stormy response to the more complex *Le Déjeuner sur l'herbe* at the Salon des Refusés in 1863 and the *Olympia* the previous year. Courbet had mounted a defiant solo show in 1855 and was doing so again in 1867, so Manet had that example. But his own exhibition seemed extremely disordered, so mixed in its types of paintings—single figures, groups, different genres, copies, and so on—that if it had a pattern, it was, as Carol Armstrong has noticed, "a staccato rhythm of dispersal and interspersal, the miscellaneous and the extraneous, pairs and singles, and disparate suits of two and three."[34] It was as if Manet, she adds, "had isolated and honed in upon the principle of 'inconsistency'" that had been associated with Courbet. One of the criticisms that Courbet had suffered was that he could not conceive a *tableau* as a unified ensemble but was satisfied by *morceaux*, pieces of reality; Manet was accused of the same thing.[35] His exhibition, looking like an assemblage of *morceaux* as well as juxtaposing *morceaux* and *tableaux,* invited reexamination of his artistic path.

But why this particular Goya? One reason must have been that Charles Yriarte, who was one of Manet's Paris acquaintances, had just published a wood engraving of it in April 1867 in a book on the Spanish painter (fig. 25).[36] Although Manet's reworking of Goya's painting replicates, indeed exaggerates, its painterliness, the drastic simplification of the image in this crude reproduction may well have attracted him because it reminded him of his own, earlier compositions, which he would have been reviewing to prepare for his exhibition.

Manet may also have seen a connection, unnoticed by art historians, between the Goya and a painting that had been exhibited in the Salon of 1866 and could now be seen again at the Exposition Universelle, which had opened on April 1. This painting, Tony Robert-Fleury's *Warsaw, 8 April 1861*[37] (fig. 26), depicts Russian troops, off-stage left except for their rifle barrels, shooting down Polish nationalist protestors, prominent among them two monks who recall the monk in Goya's painting of French troops shooting down Spanish nationalists.[38] Additionally, the rifles of its off-stage soldiers recall those of a famous print from Goya's *Disasters of War* series, which the artist could have known (fig. 27).[39] Robert-Fleury's painting may well have attracted Manet's attention because, we will remember, his own *Incident in a Bullfight* (fig. 12) had been compared, in a review of the Salon of 1864, to another painting of an anti-Russian scene from the same arena of conflict, Désiré Laugée's *Incident in the Polish Wars of 1863* (no longer extant). Moreover, the Warsaw massacre had a resonance in France (victorious against Russia in defense of Turkey in the Crimean War) of a magnitude that was only exceeded by the execution of Maximilian in Mexico (the Turkey of the New World), so a potential chain of associations was in place that could link acts of imperialist aggression in Mexico, Turkey, Poland, and Goya's Spain.

An obvious link between the Warsaw massacre and Maximilian's execution is that enemies of France perpetrated both. Without making this connection, a number of commentators have noted that the initial response in Paris to the execution was strongly pro-French and anti-Juárez, and have suggested that Manet,

26 TONY ROBERT-FLEURY
Warsaw, 8 April 1861
Salon of 1866
Oil on canvas, dimensions unknown
Château de Montrésor, France

27 FRANCISCO DE GOYA Y LUCIENTES
And There's Nothing to Be Done (Y no hai remedio)
Plate 15 from *Disasters of War*
1810–14
Etching, drypoint, burin, and burnisher, 5 3/4 x 6 1/2"
(14.5 x 16.5 cm)
The Metropolitan Museum of Art, New York. Harris Brisbane Dick Fund, 1932 (32.62.17)

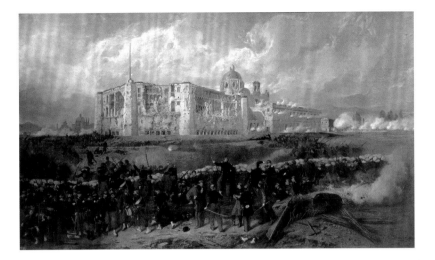

28 JEAN-ADOLPHE BEAUCÉ
General Bazaine Attacks
Fort San Xavier During
the Siege of Puebla, March
29, 1863 (Death of General
Laumière). 1867
Oil on canvas, 7' 5/8" x 12' 3 5/8"
(215 x 375 cm)
Châteaux de Versailles et
de Trianon, Versailles

caught up in this sentiment, turned to Goya's painting because it provided the vehicle for a nationalistic picture with an analogous subject, albeit in reverse; in the Goya, "peasants" are the victims of "French invaders"; in the Manet, the opposite.[40] However, it is difficult to believe that Manet, long an opponent of the French intervention, would either have been pro-French on this issue or have been ready to adopt a political source image in order to reverse its meaning.

We have seen how Manet's references to Goya in his *Incident in a Bullfight* (fig. 12), and possibly in his *Mlle V.* (fig. 10), may be construed as alluding to Goya's symbolization of popular resistance to Napoleon I's campaign to conquer Spain, and hence of similar resistance of his nephew's attempt to do the same thing in Mexico. If we accept that as correct, we will realize what sense it made to Manet to turn again to an incident in Spain, created by Napoleon I and replicated in Mexico by Napoleon III, represented in a painting by Goya, which he, Manet, could replicate. Moreover, if Reff is correct that Manet intended *Incident in a Bullfight* to allude to the French defeat in Mexico at Puebla on the fifth of May, was it not appropriate to turn to a painting of French atrocities in Spain on the third of May to represent something just as horrifying that was the result of French betrayal?

Additionally, an enormous, conservative, heroic battle painting representing an incident in the French recapture of Puebla, Jean-Adolphe Beaucé's *General Bazaine Attacks Fort San Xavier During the Siege of Puebla, March 29, 1863* (fig. 28), had gone on view at the Salon of 1867 on May 1.[41] When, two months later, news arrived of Maximilian's execution, that picture would have been an embarrassing reminder of how far from heroically the Mexican affair had ended. And perhaps a prompting to Manet to paint as ambitious a reply.

There are three large affinities between Manet's and Goya's paintings. The first is compositional: a bipartite division between, at the right, the soldiers seen in shadow and (with the two exceptions that were late additions) from the back, and, at the left, the victims seen in greater illumination and from the front, each part set against what looks like a shallowly arched hill, the right-hand one with suggestions

of architecture. The second is technical: the dramatic Romanticism of patterned light and shade, painterly brushwork, and deep, luminous color glowing through tonal substance. And the third is thematic: the implication of painful duration and continuum of destruction in the apparent extension of the depicted moment of execution. This emerges, in the Goya painting, from his showing the advancing, the about to be executed, and the fallen victims, and, in the Manet, from what he obscures—definition of contour, descriptive detail, spatial clarity, coloristic specificity—in the smudged, scored, and dappled manipulation of the medium.[42]

COURBET'S EXAMPLE

This latter aspect of obscurantism, which separates Manet's painting from Goya's—defying the replicated artistic source in a different but no less decisive way than Manet defied his documentary sources—is what principally accounts for what Champa refers to when he says that the Boston painting "presents the range of flexibility of Manet's artistry stretched to its expressive and illustrative limits."[43] To this should be added that this painting began by privileging the expressive over the illustrative, and then began to shift to the illustrative, a direction that the other compositions would continue to follow.

In its expressiveness, it draws not only on Goya's Romanticism but also, possibly, on Delacroix's, sharing with his late paintings a deliberate denial of linear contours and blurring of descriptive detail.[44] However, it filters both through the example of Courbet's realism. In particular, Manet draws upon Courbet's example of depicting topical subjects at the scale and with the gravity traditionally reserved for subjects from history, and of conveying the immediacy of these subjects both by a frank painterliness and by making the beholder conscious of dialogues between subject and treatment and between the space of the painting and that of the beholder.[45] (That Courbet's and Manet's motives were different—the former wanting to destroy history painting and the latter to reinvent it—did not make Courbet's practice any less accessible to Manet.) A particular painting by Courbet may have offered a specific example in these respects, his huge, unfinished *Firemen Rushing to the Fire* of 1850–51 (fig. 29), in which Courbet uses (in Fried's words) "the motif of a massive and repetitive movement of bodies toward the picture surface as a means of eliding the gap between painting and beholder, and what is more, . . . does so with an uncharacteristic violence."[46] This smoky, nocturnal scene shows units of four men abreast pulling a fire wagon toward

the left foreground and seemingly being redirected by two conspicuous figures of higher authority at the right, who look at them but stride toward and point to the beholder. Such an aggressive picture would have offered an example to Manet of the representation of urgently motivated action, and implied reaction, which enrolls the viewer under the condition of dangerous emergency.

It may well have been Manet's experience of Courbet's art (if not of this particular painting) that allowed him access to the painterliness of Goya, not to mention of Delacroix.[47] However, more important for this series of Manet's paintings than their painterliness, which would be strongly tempered in successive works, was that these artists had shaped alternatives to the form of history painting established in France by Jacques-Louis David's *The Oath of the Horatii* (fig. 30), shown in 1785. This work was still the towering, if now unapproachable model for representations of events of historical importance. Before following this thought, though, which will carry us beyond Manet's refusal of David's approach to his return to it, and from Manet's refusal of the illustrative to an embrace of it, we need to learn two things. First, how Manet borrowed not only from earlier artists but also from himself in his first modification of the Boston painting. Second, what he derived from a newspaper report of August 11, 1867, in *Le Figaro,* which influenced the second modification of the painting (possibly continuous with the preceding one). This report must have turned Manet's thoughts to the illustrative, being specific to the appearance of the actors in this drama as none had been before.

MANET'S SECOND PAINTING CAMPAIGN; THE TWO OFFICERS

Manet's first modification of the painting involved the addition of the two, right-hand figures. The figure to the left of the two carries a rifle and, as we have said, may be assumed to represent the officer—traditionally, a noncommissioned officer (NCO)—whose task in an execution is to deliver the *coup de grâce,* ensuring that the victim is indeed dead. (The July 31 report mentioned that an NCO took two

Type mexicain. — Soldat des frontières.

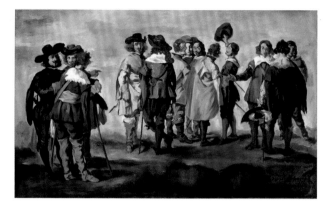

shots to ensure this.) This figure faces the viewer (the only figure in the painting to do so), which is an unlikely position for someone with the NCO's task, seeming more like that of a guard to keep viewers away from what is taking place. (However, unlike the impassively facing figures in other paintings by Manet, this one seems masked and faceless, hardly seeing.) The second figure, bisected by the edge of the painting, carries a sword, and may be assumed to represent the commanding officer of an execution squad, whose task is to deliver the sword command to fire. (The July 8 report does mention sword commands.) His features are indistinct, but he appears to be looking at the NCO—or the guard to keep viewers away. In any event, he, too, is not in a position to see the execution. Neither is he, therefore, in a position to deliver the sword command to fire. This traditionally was done either by abruptly raising the sword or by slowly raising and then abruptly lowering it; in either case, the commander had to be visible to the execution squad and, in the Boston painting, he is not.

If we feel the need to find a documentary source for the image of the sword carrier, we should consider a photograph of Marshal Achille-François Bazaine and his staff in Mexico in 1866, which was issued printed in reverse with an isolated sword carrier on the right-hand side.[48] But the figure in Manet's painting is really too indistinct in identity to support any such comparison. This is not true of the NCO with the rifle, for which two sources have been suggested: an engraving of a Mexican guerilla published in 1863 (fig. 31) and another published in 1865.[49] Both are plausible. Of greater critical interest, though, is how these two figures together fit in a sequence of replications (revisions into a new format) of representations in Manet's own art that he laid out in 1862. This year, we will remember, was when Manet also painted *Mlle V.* and began *Incident in a Bullfight*, paintings which, I have suggested, may reflect his reactions to the events in Mexico.

31 POULOUIER (BOULIER?)
Mexican Type. Frontier Soldier. From Emile de la Bédollière, *Histoire populaire illustrée de l'armée du Mexique* 1863
Wood engraving, 6 1/8 x 4 3/8" (15.6 x 11.1 cm)
General Research Division, The New York Public Library. Astor, Lenox and Tilden Foundations

32 EDOUARD MANET
The Little Cavaliers c. 1859–60
Oil on canvas, 18 x 29 3/4" (45.7 x 75.6 cm)
Chrysler Museum of Art, Norfolk, Virginia. Gift of Walter P. Chrysler, Jr. 71.679

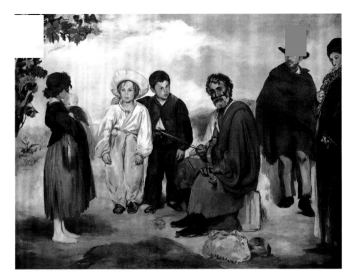

MANET'S SOURCES IN HIS OWN ART

The two figures in question derive, in the first place, from an Hispanic source, namely, the painting then thought to be by Velázquez that Manet copied in oil in 1859–60 (fig. 32), and in etchings in 1861–62 under the title *The Little Cavaliers*.[50] At the left of the composition, in an isolated group of three figures, we see the faces of two, then thought to be of Vélazquez and Bartolomé Esteban Murillo. As is well known, Manet adapted this composition for his *Concert in the Tuileries* (The National Gallery, London) of 1862, except that he substituted his own portrait (bisected by the framing edge at the left) and that of former studio mate Alfred de Balleroy for those in the etching, thereby quoting himself quoting Velázquez. But, as also is well known, this bisected image appears at the opposite, right-hand side of his *Old Musician* of the same year (fig. 33). This time, the bisected figure appears next to a reprise of the figure in Manet's *Absinthe Drinker* (Ny Carlsberg Glyptotek, Copenhagen), his first, rejected submission to the Salon of 1859, and often interpreted as a marginalized self-image. At the same, right-hand side of the Boston painting, whole and bisected figures appear again, but now returned to military identity in the form of the sword carrier and the NCO.

Matters are complicated, however, for two reasons. First, not only do the two officers in the Boston painting thus replicate two of the figures at the left of *The Little Cavaliers,* but also the victims in the Boston painting make a passing, oblique reference to the trio of figures to which these two belong.[51] The victims, separated from the firing squad,[52] allude to the separation of this trio from the central group of cavaliers, with only a pointing gesture of one of the cavaliers to join them; and to the prominent, wide-brimmed hat of the Velázquez figure—the figure whom Manet had transformed to represent himself in *Concert in the Tuileries.* To allow that the victims refer to the same sources as produced the officers of their execution is also to allow an identification on Manet's behalf with both sides. But, second, the victims in the Boston painting make a more overt reference, as Jones

has noted, to two other figures in Manet's *The Old Musician:* the two boys.[53] Fried has equated the boy on the left with Jean-Antoine Watteau's *Gilles* (Louvre, Paris), and described the one on the right as his "Spanish" companion, in a discussion of how *The Old Musician* "brought together French and Spanish sources within the framework of a republican account of the French pictorial tradition."[54] Manet's "recycling [of this group] in the *Execution*," he adds, "might be said to make that latent political content explicit."[55]

It may also be said to add a note of Christian iconography to the Boston painting.[56] For, as Jones reminds us, the figure of Gilles in Watteau's painting was widely associated with that of Christ, and Maximilian's sombrero recalls not only the hat of the Velázquez–Manet figure but also Gilles's halolike hat.[57] Furthermore, the old musician himself, who points the bow of his violin toward the two boys, is the symbol of the artist in that painting. In the Boston painting, he may be thought to expand to become the troop of soldiers who similarly point their rifles at the light-and-dark pair of victims. (Another topical interpretation of Gilles was as a doomed gladiator.[58])

Newspaper reports of Maximilian's execution were, by mid-July and early August, beginning to note that the emperor had attributed his defeat to the Judas-like treason of Colonel Miguel López, who had indeed betrayed him, but whom, like Christ, he had forgiven.[59] Reports also noted that Maximilian had gone so far as to identify himself with Christ as a requested but unwanted ruler.[60] This is to say that Manet had evidential justification for transposing the Christian iconography of *The Old Musician* to the Boston painting. Besides, Goya's *The Third of May* also encouraged that transposition, with the cruciform shape of its principal victim. And, of course, Manet had painted a picture of the dead Christ (fig. 18) that may have a bearing on the events in Mexico, either intrinsically or by association with the *Incident in a Bullfight,* whose own picturesque Hispanicism is extended and enlarged in the Boston painting.

Before turning to Manet's final revisions to the Boston painting, one additional source in his own work deserves mention. This stands at the beginning of the strand in the aforementioned chain that then runs from Velázquez–Manet to an-at-best-indifferent witness of Christ's death to the sword carrier. In 1861, when Manet was working on some of his etchings of *The Little Cavaliers,* he painted *Boy with a Sword* (fig. 34), a portrait of Léon Leenhoff. The influence of Spanish painting on this work was noted right away and, subsequently, has been associated

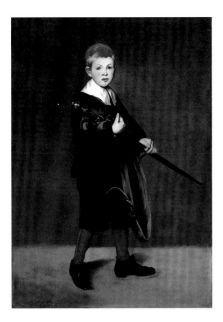

with both Velázquez and Goya. Reff has suggested that it represents the boy as a seventeenth-century page, and the master at whom he gazes is the painter, who identified himself with Velázquez in *The Little Cavaliers*.[61] Nancy Locke, more ambitiously, suggests that it depicts Léon Leenhoff as a young prince or heir to the throne—or, rather, as an unacknowledged, illegitimate heir, since the paternity of Leenhoff, who was nominally Manet's stepson and probably his stepbrother, was never revealed.[62] In either interpretation, if the association with the Boston sword carrier is allowed, that soldier, whose signal initiated Maximilian's execution, is intimately associated with the artist. If Reff's interpretation is followed, the consequence is that he acts on Manet's behalf, to please him; if Locke's is followed, that the illegitimate prince instigates the death of the emperor. It may be objected here that it is unreasonable to attach either of these associations to a hardly visible, indeed, an almost hidden image in the Boston painting. To which it may be replied that perhaps this image is hidden precisely because it carries so many troublesome associations.

THE REPORT OF THE PRESENT

Through July of 1867, many and contradictory reports about what had happened at Querétaro were circulating in Europe. Some soon gained currency and thus seem proved to be correct: the three principals only were executed, all wearing civilian dress,[63] on the Cerro de las Campanas (hill of the bells) outside Querétaro.[64] Others may also have been correct, for example: Maximilian said, "What a beautiful sky! That's what I wanted on the day of my death!"[65] and therefore he wore a sombrero with the brim turned down to shade his face.[66] But it was still difficult to be sure what the participants in the event may have looked like.

MANET'S THIRD PAINTING CAMPAIGN; THE AUGUST 11 REPORT

However, in *Le Figaro* of August 11, the journalist Albert Wolff quoted the text of a letter that, he said, had evaded the censors on the way to one of his friends. The letter provided details of the capture, trial, and execution, including the three attempts it took to end Maximilian's life.[67] "With the letter," Wolff wrote, "were four photographs, which I have in front of me." The first was of the convent to which Maximilian was taken prior to his execution. The second showed the execution squad (see fig. 35): "It is composed of six soldiers, a corporal, and an officer. The soldiers have hideous, sinister faces. The uniform resembles the French uniform: the kepi and the tunic seem to be made of gray cloth, the white leather belt, the pants, which descend to the feet, are of darker material. The corporal, the one who killed Maximilian, is a very handsome boy; he has a sweet face that contrasts sharply with the lugubrious task he was assigned. The most curious of the seven [sic] is the commanding officer of the firing squad; he is not even eighteen."

The third and fourth photographs showed, respectively, the frock coat and the waistcoat, riddled with bullet holes, that Maximilian had worn when he was executed.[68] The photographs were by François Aubert, and would be widely distributed in France, despite the attempts by censors to prohibit them, even jailing a photography dealer for being in possession of some.[69] It has long been accepted that Manet needed to have read this report, if not seen the photographs, to have begun to change the soldiers' uniforms in the Boston painting. In fact, he didn't, since it was more than likely that he had already seen earlier photographs or prints that showed such uniforms. Nonetheless, this sensational report may well have occasioned his beginning to transform the sombreros into caps, straightening the trousers, and overpainting the reddish-brown tones of the costumes a blue-black—or, at least, made Manet conscious that to effect this change would place the Mexican soldiers in what looked like the uniforms of French soldiers.[70]

It is impossible to know whether this third campaign of work on the painting was or was not continuous with the second. What is certain is that, in this campaign, Manet began and then stopped changing the hats and uniforms of the soldiers and then ceased working on the painting altogether. This has led to the suggestion that he did this because he would have "wanted to recast it to take account of important new information published in an influential Paris newspaper,"[71] that is to say, in *Le Figaro* on August 11. But this does not answer the question: If Manet had already begun to recast his painting for this very reason, why did he

stop doing so? He could hardly have stopped because, recasting his picture in the interests of documentary accuracy, he found that he did not yet have enough information to continue. As Jones pointed out, if Manet had seen the photographs mentioned by Wolff, he could have painted the costumes more precisely than he did; and if he was interested in achieving this kind of documentary precision at this time, he could have obtained the photographs.[72] And, as for his possibly waiting for yet more information to arrive after the Wolff report and its described photographs, there is nothing in any subsequent compositions in the series that definitely requires any information that was published after the Wolff report. Besides, Manet's response to the July 8 report shows that he used documentary evidence very selectively, so why should it be thought surprising that he chose to use it sparingly in responding to the August 11 report?

Still, the painting is so strange in Manet's oeuvre that we have to keep asking why it was left as it was. A frequent suggestion is that it is indeed an *ébauche* and, therefore, once Manet had carried it along sufficiently to know where he wished to go, he set it aside in order to realize his conception on a new canvas.[73] But this does not fly, either, for two reasons. First, Manet did not realize on a new canvas what had been adumbrated in the *ébauche*; he drastically altered that conception. Second, an *ébauche* was not meant to be set aside but to be further developed, submerged in the finishing process of painting. This was normal practice for Manet, and even when prudence should have suggested that he turn to a new canvas, as when he had begun on a perilously thin one, he did not do so.[74] Besides, as we have already learned, there was rarely a clear-cut line in his practice between the *ébauche* and the finishing stage of a painting.

In traditional practice, an *ébauche,* when completed, would be allowed to dry fully. Surprisingly rigorous methods were recommended in some of the manuals to ensure this, which included scraping and washing the canvas in order to efface irregularities in the surface, while leaving a ghost of an image on which to build. Manet was known to have been extremely ruthless in this way throughout the entire development of a painting, not reserving such severity for the putative

ébauche stage.[75] The Boston painting reveals a lot of scraping and repainting, but no overall purging of the surface, suggesting that Manet had decided not to prepare it for another campaign of work. Either he was satisfied enough with the painting to want to retain it, but obviously not satisfied enough with it to prevent him from beginning work on a second canvas, or he simply lost interest in it when he realized that the image as established could no longer serve efficiently as an *ébauche*, given the substantial changes that he knew he wanted to make to the composition for pictorial, not merely for documentary, reasons. Or both.

NEWS AND HISTORY

The strongest defense of the Boston painting, as an intended composition as left, comes from authors in the Brown University catalogue of 1981, especially Elizabeth A. Reid, who asks us to think of it as Manet's novel response to the problem of painting a history painting, or *histoire*, traditionally devoted to an important past event, on a subject that was still effectively a news story. For Reid, it is "unique in the tradition of *histoire* in that Manet was working on the event before it was documentarily closed, that is before the news reports had been sorted or had approached the condition of 'history,' unlike the *Kearsarge and the Alabama,* and unlike the later versions of the *Execution.*"[76]

The Battle of the *"Kearsarge" and the "Alabama"* (fig. 20), painted and exhibited only one month after the event, depicts a news story of an incident off the coast of France that Manet may or may not have seen.[77] Manet chose not to make a history painting out of the clash of the two ships, showing them at a distance rather than illustrating the human drama of the battle. But he could have done so, for there was no uncertainty about what happened; it had already become history. In Reid's account, the Boston painting, "in its obviously generative state of creation . . . vividly portrays Manet's excitement of trying spontaneously to equate the reception of the news with the hurried act of painting that news, so that the visual process and the intellectual process are occurring at one and the same time. Manet is interested in how one comprehends and how that comprehension translates visually."[78] The result, she claims, is "an image so immediate, and ultimately so complete in terms of viewer involvement, that the event necessarily recurs every time it is visually taken on."[79]

This interpretation verges anachronistically on the Bergsonian, yet it conveys some of the strangeness of the experience of this painting. And it asks us

to notice what this strangeness tells us of very critical features of the painting, indeed, of the compositions that follow. These features include: its status as a history painting; its mode of reaction to contemporary events; its means of translation from knowing and telling; and the twinned temporality of the evolving news story and the evolution of Manet's painting that tells it.

This leads to the conclusion that what looks like indecision with respect to the uniforms and headgear, being a representation of Manet's visualization of new information coming in as he is painting, conveys his changing assignment of blame from soldiers in Mexican uniform to those whose uniforms "resemble the French uniform."[80] While this and the succeeding compositions are, I shall suggest, deeply moral paintings, to do more than attribute uncertainty of judgment to this transformation seems dubious. The area in question describes not certainty of transformation but uncertainty of identification. Yet, Reid is surely correct in effectively arguing that the "unfinish" of the Boston painting speaks of the process of inscribing contemporary story material, as it appears, on a slate that has the dimensions and status for telling historical stories. This coincides with what we have learned of Manet's indebtedness to the freedom of Romantic and Realist painting. For Manet follows Goya and Courbet in using the format of history painting to tell of dramatic contemporary scenes. Only, he avoids the arrested motion of *The Third of May* and the unnaturally stilled, photographic movement of *Firemen Rushing to the Fire*. But, enlarging their technical freedom, he discovers an alternative: the figural illustration is immobile, but the surface is alive with movement that seems almost and sometimes entirely independent of the illustration, as happens in the late paintings of Delacroix. Manet, unlike Courbet, allows himself not always or entirely to find a pictorial equivalent for the object he is depicting.[81]

What this means, however, is that the temporality of the emerging news story may indeed be imagined as depicted in the mobile surface painterliness, yet the painterliness can seem to be disengaged from the story that it tells. Part of the strangeness of the Boston picture, and contributing to its providing the effect of a constantly recurring event, is the uncertain adhesion of the illustrative means to the illustrated story. Thus, far from conveying a sense either of contemporaneity or of history, lacking the vividness of the former or the settledness of the latter, it has an effect like that of a recurring dream image, a fantasy image "subject to delayed activation," as Sigmund Freud has it. Such an image cannot be described as having a specific, stable meaning at any temporal moment; its meaning is,

rather, constructed in a sequence of replications, performed by the subject, of representations of the event as it is recalled.[82] If we accept Manet's invitation thus to perform the painting in our viewing, it may become increasingly sinister, more nightmare than dream, as we repeat and repeat the experience. If this does happen, it happens in part because we imaginatively enter the picture over the opposition, it seems, of the menacing masked bandit of the NCO before us; in part because, having entered, there seems no ending to the reenactments that the painting affords.

As we shall learn, the later compositions in the series also invite our performance of them, and are discomforting, but they do not produce quite so disturbing, so worryingly atavistic an affect. Nonetheless, it would be sheer speculation to say that Manet may have set aside the painting because it was frightening. I think that we can say, with Reid, that, as the illustrated event began to recede into history, it was more readily assimilated to the traditional norms of history painting, and for that reason Manet may, therefore, have been prompted to set the Boston painting aside.[83] Yet, not because it then seemed too immediate to the event as it had been occurring; it doesn't. It seems, in fact, a more ancient than modern scene. Jack Flam has to be correct in saying that it may have come to seem unsatisfactory to Manet because it looked picturesque, a costume drama in an exotic place.[84] (Zola would later say, about Manet's lithograph of this subject, that only "fanciful artists give the Mexicans costumes from comic opera."[85]) I think that, additionally, its picturesque opens onto the grotesque, which pushes it not only away in place but also back in time. And this leads me to wonder whether its lack, not vividness, of contemporaneity caused Manet to continue to seek contemporaneity even as the illustrated event was receding into history and, therefore, into the realm of history painting.

Another author in the Brown University catalogue, Kathryn L. Brush, perceptively observed that Manet appeared to have intuited that his principal model for the Boston painting, Goya's *The Third of May*, was itself a response to the primary, longstanding model of history painting in France, David's *Oath of the Horatii*. Goya reversed the traditional left-to-right narrative movement of the David, and with it, its direction from strong, male, warrior-actors to weak, female, civilian sufferers from their actions, guiding the viewer first to the heroic Spanish victims who heroically stand up against the French soldiers.[86] Manet did something analogous in the Boston painting, but without engaging with his ultimate source,

the David painting. He would do so in the London and subsequent compositions. Recognizing that, however, does not mean that Manet simply collapsed into the arms of the French tradition. We should be wondering what caused him to turn to a Davidian model, both because this is intrinsically worth knowing and because knowing it may lead us to any particular connotations that this model had for Manet owing to the means of its adoption.

MODERN HISTORY

There are two options. The first is that contemporaneous history painting returned Manet to David. As John House has described, the decline of history painting by the 1860s had produced its replacement in the Salons by genre paintings, nudes, and costume pieces, and the most prominent attempt to modernize history paint-ings, by painting scenes of warfare, had collapsed into panoramas full of masses of tiny figures.[87] Among the revivalist attempts, there were some that equated contemporary and historical events, among them Degas's peculiar Salon debut of 1865, *Scenes of War in the Middle Ages* (Musée d'Orsay, Paris), which allego-rized the sufferings of New Orleans after its seizure by Union forces in 1862 in what pretends to be a scene from the history of medieval Orléans, with archers shooting down female civilians.[88] Manet must have seen it. Compositionally, it may have interested him, but it hardly offered a model to be adopted.

Manet may well have been more interested in the opposite, modernizing approach, which was to represent military events by evoking the private feelings of individual soldiers. This approach seems to have been popularized by Paul-Alexandre Protais, whose *The Morning Before the Attack* (fig. 36) could have been seen by Manet at the Salon of 1863, then again at the Exposition Universelle of 1867. House tells us that it provoked complaints due to its emphasis on the individuality of the soldiers, one critic writing that "the soldier is a collective being; he obeys and does not deliberate. . . . An isolated soldier is a man, that is to say a being with personal initiative; a company . . . will always be a group of soldiers, that is to say beings whose initiative comes from elsewhere."[89] House observes that these comments are particularly relevant to Manet's subsequent treatment of the firing squad "in strictly serried ranks, their faces invisible, quite without recourse to the rhetoric of bodily gesture and facial expression that give Protais's figures their appeal."[90] Well, yes and no. The squad itself continued to appear impersonal but the NCO continued to have great individuality.

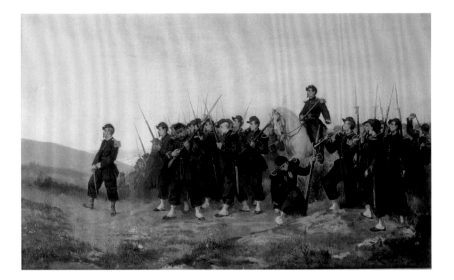

36 ALEXANDRE PROTAIS
The Morning Before the
Attack. 1863
Oil on canvas, 19 ⁵/₁₆ x 31 ¹/₂"
(49 x 80 cm)
Musée Condé, Chantilly

But can Protais's approach be said to be realistic to the necessarily uncertain knowledge of what happens on the battlefield or to the contingency of the means of translation from knowing to telling? Clearly not, and even to ask that question would seem to be unfairly anachronistic, except that Manet seemed to be thinking about this in making the Boston painting. Yet, his emphasis on the contingency of his painterly process of inscribing contemporary story material conveyed neither the sudden freshness of the event nor the uncertainty of knowledge of it. At least, it did so only by asking the viewer to continue to replay it, and came to have the additional disadvantage of seeming distant but not historically definitive.

However, there was a model, unmentioned in the literature on this subject, for what Manet was wishing to do. We do not know whether the artist was aware of it, but we may reasonably assume that he was. The model was the early sort of photo-collage that was used to produce some of the *carte-de-visite* images of Maximilian's execution.[91]

One such memorable work (fig. 37) was composed by cutting out the figures of the firing squad from another photograph (fig. 38), dividing the squad in half and placing the halves to either side of three larger figures onto which the victims' heads (of varying sizes) have been placed. This composite work was set against the background of another photograph, showing the place of execution (fig. 39); then the completed composition was rephotographed. The oddities of scale and juxtaposition with which images from two principal and as many as six additional sources are combined would have reminded Manet, if he saw this *carte de visite*, of the comparable incongruities of his own earlier paintings for which he had been pilloried, but exaggerated. Perhaps this encouraged him to return to their approach, recognizing that the features of his paintings that had been ridiculed were precisely those that conveyed the shock of the new. And perhaps he also recognized a far more distant ancestor than his own earlier self for these pasted-on figures in David's *The Oath of the Horatii*. The posed, armored stiffness

of David's figures deserves comparison to the photographs that Manet could have seen as well as to what he probably made of them and the David together. The result could be something with both the incongruous topicality of the *carte de visite* and the historical severity of Davidian, Neoclassical painting.

TIME, SPACE, AND NARRATION

I began this chapter by speaking of the greater assurance of our knowledge of events than of the details that fill them out, and asked the reader to imagine Manet poring through the newspapers trying to make sense of such details. I want to return to these two subjects in bringing this chapter to a close by offering a more precise distinction between events and details, and by asking us again to imagine Manet poring over the newspapers, only now to ponder the very process through which he learned of events and details.

Thanks to Duret and his successors, we know what information was available to Manet in the shaping of his compositions. However, there has been remarkably little curiosity about whether their shaping may have been affected by the process of his acquiring this information. I referred in the previous chapter to a familiar distinction between the *story*, the events to be related, and the *discourse*, the story as it is actually related. In these terms, we know a lot about how the *story* shaped his compositions but little about how the *discourse* may have done so, too.

Narratives are composed of events and existents.[92] Events in a narrative tend to be related or mutually entailing, which is how they shape narrative time. What I have referred to as details of events are more properly called existents, that is to say, the people, places, and things that occupy and are occupied by events. "Our deeds determine us, as much as we determine our deeds."[93] But, even though existents may thus motivate events and be motivated by them, they occupy another dimension: If events shape the temporality of a narrative, existents shape its spatiality. Seymour Chatman summarizes the matter: "As the dimension of story-events is time, that of story-existence is space."[94] When Manet read one newspaper report after the next, he was adding somewhat to his fund of information of story-events (but not much: the important story-event was simple; the execution of Maximilian and his generals). However, he was adding far more to his knowledge of story-existence (of details of the people, place, and things that composed the event of the execution).

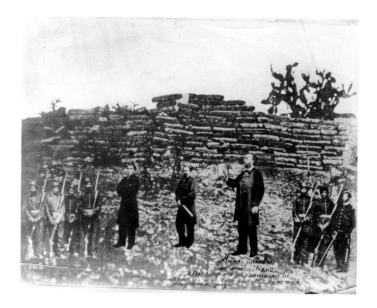

With respect to story-events, therefore, while the discourse of a typical single newspaper report more or less followed the sequence of the story (of the events as they had occurred at Querétaro), the discourse of successive newspaper reports did not extend that sequence (as, say, a serial would). Rather, they more or less repeated it. The structure of their discourse comprised not a continuation of the story, but a sequential replay of (the discourse of) the story. If we are to allow that their discourse could have helped to shape Manet's compositions, it may have done so by offering the example of this model. A single discourse of a single story might be told and retold, altering meaning not by changing the events of the story, or rearranging their sequence, but in the repetitions of the retelling. The relevance of this will become especially apparent in the following chapter, the subject of which is precisely those repetitions.

It may be objected that successive newspaper reports, and successive paintings, tell changed stories and thereby accrue a changed meaning. True, yet their changed descriptions were not to any significant extent changes in the events of the story but rather changes of detail, that is, changes in the existents of the story. The repetitions of the retelling did not, or did not substantially, add to Manet's knowledge of story-events; neither, therefore, of the temporal dimension of what had occurred. However, they did add to his knowledge of story-existence—therefore, of the story's spatial dimension—accumulating new details of the people, place, and things that composed the event of the execution. Since "we distinguish story-time from discourse-time," says Chatman, "we must distinguish story-space from discourse-space."[95] This means that we must distinguish between what Manet could have learned of the story-space of Querétaro (the information of existents in the verbal and visual stories) and what he may have learned from the discourse-space of the verbal and visual stories that told this information. And, here again, we need to consider the different discourse-spaces of individual reports and of successive reports considered as a sequence.

In the case of individual reports, both verbal and visual, the space of the discourse is the space of the here and now in which striking events are described with (a sometime not always plausible) reportorial clarity. An obvious example of this is the contrived photograph that I have mentioned, but many of the documentary photographs as well as the verbal reports offer a significant sense of surprise of immediacy, of the now not simply as an abstraction but as made present in the articulation of a description. In a well-known formulation by Heidegger, "Saying

'now' is the discursive Articulation of a *making-present* which temporalizes itself in a unity with a retentive awaiting."[96] In Ricoeur's analysis, this sense of "now" does not belong to clock time but to the "present of preoccupation, which is a 'making-present,' inseparable from awaiting and retaining."[97] May we perhaps view, anachronistic though it will be, Manet's interest in the surprise of immediacy as a comparable focusing of concern—the focusing of a continuing preoccupation, in an extended duration, with things of concern and, hence, with concern in its existential dimension?[98] If so, this is also to view Manet, whose figures were reviled for being like marionettes, lacking in psychological interiority,[99] as a painter not of "indifference" but of moral engagement. And it is to view Manet's attempt, in the Boston painting, to depict an extended duration as a failed experiment that showed an awaiting and retaining, but separate from, not lodged in, a sense of making-present.

In the case of the successive reports of the execution, both verbal and visual, that Manet sought out, the space of their discourse as a whole cannot, of course, be said to be the space of the here and now. Rather, it must be thought to be an imaginative space in which the accumulation of here-and-now information layers sometimes confirming, sometimes contradictory detail. Action deserves its name, said Hannah Arendt, when it aims at being recollected in stories that provide a narrative identity to the doer; thus, "history repeats action in the figure of the memorable."[100] In the present case, the action (the story-event) is thus repeated in the discourse and becomes memorable. However, it is the changing information about it (the story-existence) that successively alters and redefines the identities of the doers. These changing identities that accumulated in the layered succession of the verbal and visual reports worked well with Manet's practice of making paintings from accumulated sources.

One more thing needs to be said here. As we have heard, the reports that Manet read and saw appeared over an extended period of several months. Nonetheless, their individual here-and-now quality and their successively greater increase in information of existents than of events served to confine the temporal momentum of their discourse. Nothing new happened; more or less the same events kept on being retold. This element of stasis in the discourse reflected and reinforced the temporal and spatial confinement of the story itself. A single event that happens suddenly in one place is extremely resistant to narrativization, and what event could be more temporally and spatially confined than the fusillade of an execution?

The layering of information of existents slows the momentum of a narrative as the stringing of information of events advances it. Even if a description of existents is given narrative momentum (perhaps by recording the process of looking and describing), it will brake or even arrest the momentum of the larger story to which it belongs. It hardly needs saying that the constraint on narrativity of single, sudden events and of passages of description has great bearing on the subject of Manet's paintings studied here. His creation of these paintings was constrained by the difficulty—according to Gotthold Ephraim Lessing, the inability—of representing temporally distinct moments in visual art, which requires the depiction of arrested movement, Lessing and others have insisted.[101] How this constraint on painting as a visual art aligns to the constraint on narrativity provided by this particular subject has great bearing on what follows in the next chapter.

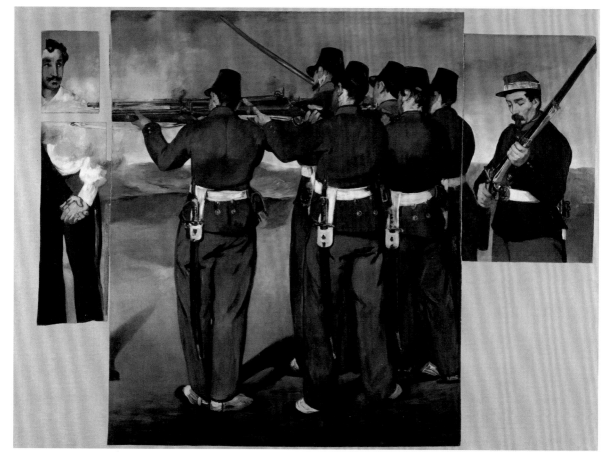

40 EDOUARD MANET

The Execution of Maximilian. 1867–68
Oil on canvas, 6' 4" x 9' 3 $^{13}/_{16}$"
(193 x 284 cm)
The National Gallery, London. Bought 1918

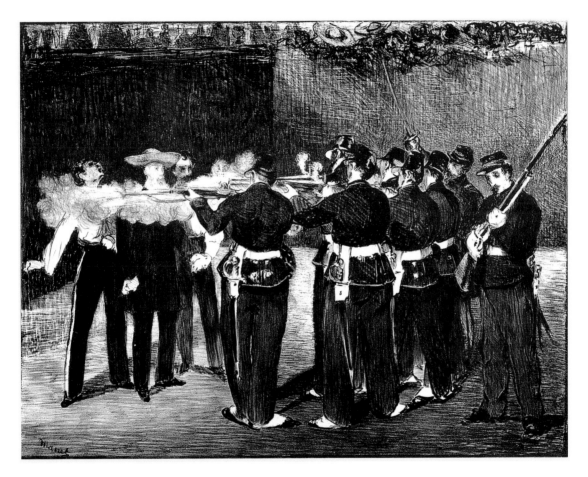

41 EDOUARD MANET

The Execution of the Emperor Maximilian. 1868–69
Lithograph on chine collé,
plate: 13 ³/₈ x 17 ¹/₄" (34 x 43.8 cm)
The Metropolitan Museum of Art, New York
Rogers Fund, 1921 (21.48)

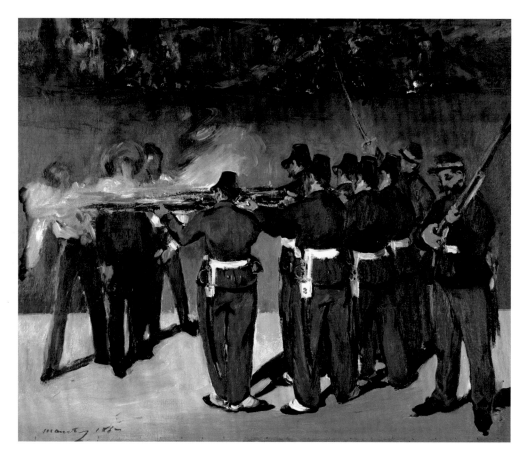

42 EDOUARD MANET

The Execution of Maximilian. 1868–69
Oil on canvas, 18 $^{7}/_{8}$ x 22 $^{13}/_{16}$" (48 x 58 cm)
Ny Carlsberg Glyptotek, Copenhagen

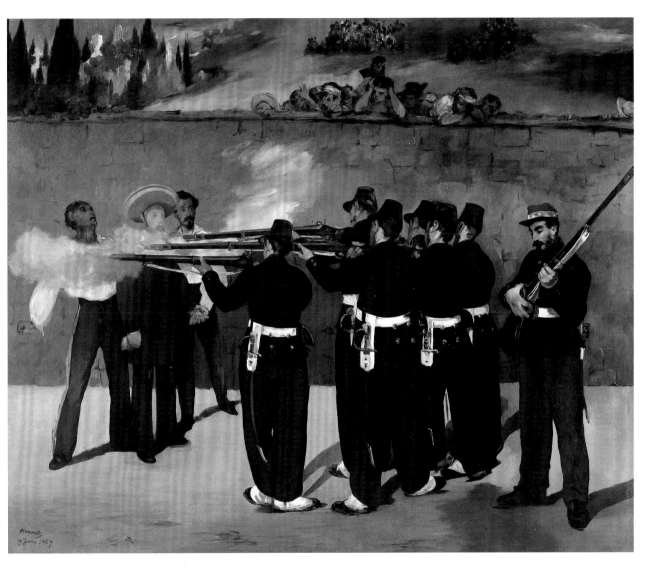

43 EDOUARD MANET
The Execution of Emperor Maximilian. 1868–69
Oil on canvas, 8' 3 ³/₁₆" x 9' 10 ⁷/₈" (252 x 302 cm)
Kunsthalle, Mannheim

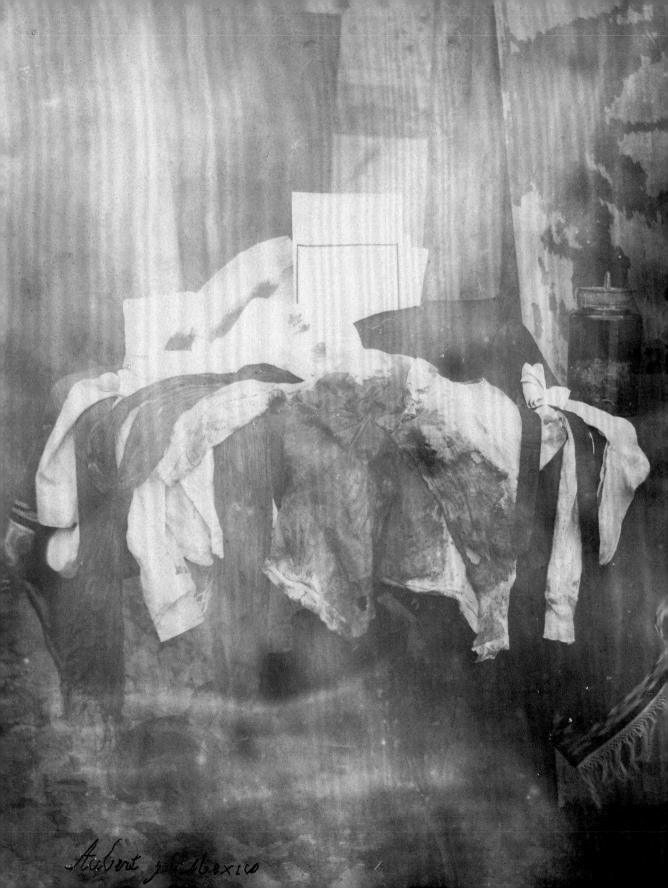

Aubert y C Mexico

III.

SENSE *of* ENDING

As soon as a story is well known ... retelling takes the place of telling.
Then following the story is less important than apprehending the
well-known end as implied in the beginning and the well-known
episodes as leading to this end.

Paul Ricoeur[1]

Manet returned to Paris from his summer holiday for Baudelaire's funeral on September 2, 1867. His solo exhibition closed on October 10. It seems reasonable to assume—almost everyone has—that it must have been around this time that he set aside the Boston painting (fig. 21) and turned to a new canvas, hoping to complete it in time for the next Salon, to open the following May.

THE MEMORY OF THE PRESENT: THE LONDON PAINTING

This painting, the London one (fig. 40), was announced for exhibition in that Salon,[2] but was not shown, which tells us that it was unfinished or had been abandoned by May 1868 or that Manet had been prohibited from showing it.[3] By the time of Manet's death in 1883, the left side of the canvas may well have already been cut away to remove, presumably, the figure of Mejía as well as, certainly, all except the lower part of the left arm of Maximilian, to leave of the victims only an image of most of Miramón.[4] After having then languished and suffered in storage, the painting was cut into four fragments by Léon Leenhoff, who sold them after discarding and burning the by-then, he claimed, seriously damaged lower parts of the figures of Miramón and the NCO (and the soldier adjacent to him). The outraged Degas sought out the four fragments and reunited them.[5]

The London painting is about the same height, nearly two meters, as its predecessor, but it must have been significantly wider, three meters or more as compared to the little over two-and-a-half meters of the Boston painting. Its format is more friezelike, therefore more inviting of a sequential horizontal reading, as

44 FRANÇOIS AUBERT
Untitled (Bloody clothes
from the execution of
Emperor Maximilian). 1867
Albumen silver print,
8 5/8 x 6 3/8" (21.9 x 16.2 cm)
The Museum of Modern Art,
New York. Purchase

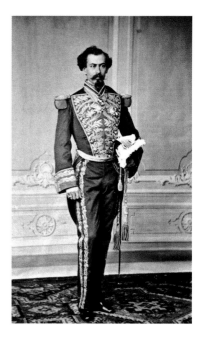

with paintings by David, than the Boston work. So is the clarity of its depiction, which is also continuous with that of the figural silhouetting and portrait realism of Manet's own paintings of the earlier 1860s. It is, therefore, possible to judge that the London painting is indeed true to the documentary evidence that had been available to Manet since Wolff's article of August 11 (see p. 82). But the painting does not call upon any subsequently published information. (The only documentary feature not adumbrated, however obscurely, by the Boston painting—Maximilian and Miramón holding hands—had been available even earlier.[6]) Neither does it require any other illustrative source material than that already mentioned, with the possible single exception of source material for the one pose that is strikingly new to the London painting: the figure of the NCO, who now holds and inspects his rifle rather than resting it upon the ground.

A soldier who similarly inspects his rifle, in front of and apart from the action, in *The Morning Before the Attack* by Protais (fig. 36), discussed in the previous chapter, has been suggested as a possible source.[7] Another might be the civilian with the rifle to the left in Delacroix's *Liberty Leading the People* of 1830 (fig. 45), while the famous, body-dividing sash of the pistol-toting boy to the right of Liberty offers a precedent for the way the NCO's beige musket strap almost merges with the background and, therefore, similarly seems to bisect his body.[8] But Manet did not necessarily need either of these sources for, if his early biographers are to be believed, he arranged for a squad of infantry to march to his studio and there pose with their muskets raised to firing position.[9] So he could well have had one of them pose for the NCO. We are told that he had a friend, the violinist Damourette, pose for the figure of Miramón, although he presumably painted the head from a photograph (fig. 46).[10]

45 EUGÈNE DELACROIX
Liberty Leading
the People. 1830
Oil on canvas, 8' 6 ³⁄₈" x
10' 5 ¹⁵⁄₁₆" (260 x 325 cm)
Louvre, Paris

46 CHARLES REUTLINGER
Miguel Miramón
Photograph, image:
3¹⁄₂ x 2 ¹⁄₁₆" (8.9 x 5.3 cm)
Austrian National Library,
Vienna. Picture Archive

THE FIRING SQUAD IN THE LONDON PAINTING

If the London painting does reflect how the soldiers actually were posed, Manet had the six in the firing squad hold positions quite close to those in the Boston painting: in both works, the left-hand soldier in the squad stands feet together, and, insofar as one can judge, so do the others, who are tightly bunched together in the front line. Those who are visible in the second line are less tightly bunched and have their feet apart. Comparing the soldiers in the two paintings, the London work appears to have clarified the ambiguities of the Boston picture. It does so with respect to their uniforms; it does not entirely with respect to their number; and it does not at all with respect to the fictive space that they occupy.

Wolff had said that the uniform of the soldiers in the photographs of the firing squad resembles "the French uniform: the kepi and the tunic seem to be made of gray cloth, the white leather belt, the pants, which decend to the feet, are of darker material." The London painting approximates that, although Manet reversed the values of the kepi and tunic and the trousers. Wilson-Bareau tells us that the uniforms are not authentic to those of the French soldiers who could have modeled for Manet, and that the swords were of a type that had long been abandoned except by gendarmerie in France.[11] Manet did paint the spats that were not part of the Mexican uniform, and he armed his soldiers with standard French infantry muskets instead of the U.S. muskets shown in the photographs.[12] As Wilson-Bareau says, Manet told Zola in February of 1868, when he was working on both this picture and Zola's portrait, "I can't do anything without a model. I don't know how to invent."[13] Yet, he was obviously as selective, and as inventive, with an observed model as with an illustrative one. This raises doubts about whether he painted directly from posed soldiers, for an X-ray of the work reveals that they were laid in with very little revision on the canvas, whereas the figures of the NCO and Miramón were altered as, in all probability, was the background (fig. 47).[14]

The number of soldiers shown in the firing squad in the Boston painting is unspecifiable. In the London painting, six (plus the NCO) are clearly counted, until one notices flashes of red in the background. A sliver of red falls between the second and third kepi from the right in the squad and appears to indicate the presence of a red cap similar to that worn by the NCO. A patch rather than sliver, this time of a duller red with unclear light-and-dark gray smudges and whitish markings upon it (fig. 48), appears between the heads of the third and fourth soldiers from the right. Its descriptive function is uncertain. So is that of two streaks

of red paint in the lower part of the soldier whose right leg was cut by the trim-
ming of the canvas edge. One streak marks the reflection at the end of his sword.
The other falls between his parted legs. The almost invisible cap unquestionably
represents the almost invisible commanding officer—the earlier sword carrier—
whose sword in this painting can be seen raised (or having been raised and being
lowered) to a diagonal to issue the command to fire. It is tempting to view the
rightmost streak of paint below as an indication of red trousers worn by this officer,
but they would hardly show through the compacted squad of soldiers. And why
his sword should reflect red is perplexing.

The squad has just fired—smoke and flames issue from the two visible tips
of the three visible muskets (the other tip was cut off when the canvas was frag-
mented)—but Miramón is unhurt, for he stares back across the painting with the
coolness of a boulevardier turning to look at a passerby.[15] (Who he is looking at is
hard to tell because there is nobody to register recognition of being seen; the
faces of the squad are invisible, and the NCO looks down at his rifle.) The Boston
painting allowed the inference, but was not clear, that only the left-hand figure,
Mejía, had been shot; therefore, it seems, the victims were to be shot in sequence—
as in Goya's *The Third of May* (fig. 24). The unhurt Miramón suggests that Manet
made it clear in the London painting that this was a sequential execution.

The reader will have noticed that I have referred to six soldiers in the squad
(plus the NCO and the commanding officer) but only three muskets. The handle of
a fourth musket is visible, held by the soldier at the right in the second rank. The
smudges and markings on the dull red patch that I mentioned earlier fall immedi-
ately to the left of that handle, so they presumably depict the dropped firing ham-
mer and puff of smoke as the musket fires; but the meaning of the red patch itself
remains unclear. The remaining two muskets are unseen. Five of the six soldiers
in the squad form a strange compacted mass, a sort of composite figure.[16] They
concentrate on their target and no longer need to pay attention to the officer
they obscure, having already registered his command, yet they crowd him, just as
bodyguards shield a client from view. And their crowding appears to disallow
space enough for him to stand. Manet reinforces this effect by compacting the
paint of the area of ground that he has opened between the first soldier and the
five others, an area that rises like a wall up the canvas. Part of the functioin of this
area is, indeed, to disallow space behind the soldiers, and thereby help to con-
ceal the officer. Another part of the function is to isolate one soldier, who, although

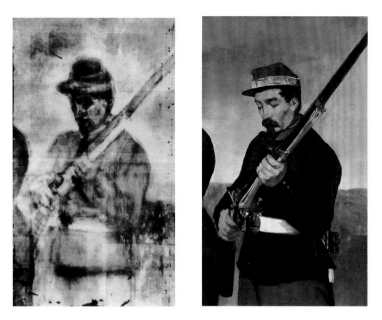

still separated from the victims, is closer to them than to the rest of the squad.

This isolated soldier is seen from the back whereas the rest of the squad is seen partially from the side as it rotates to face the victims. Therefore, this soldier mirrors the almost as separated NCO at the right of the painting, who rotates in the opposite direction, away from the victims, to face toward (but not entirely toward) the viewer. The NCO, in turn, mirrors the isolated soldier in that he is also seen to be complicit in the execution, although he stands apart; he will, in fact, conclude the execution by administering the *coup de grâce*. Obviously, he could not have had that role had he remained facing the viewer, as he does (albeit facelessly) in the Boston composition.

49 Detail from composite X-ray of Manet's The Execution of Maximilian in The National Gallery, London

50 EDOUARD MANET
The Execution of Maximilian (detail).
The National Gallery, London (see fig. 40 for entire painting)

THE NCO AND THE VICTIMS IN THE LONDON PAINTING

One of the few changes of position that Manet made as he was painting the London work was to alter the right hand of the NCO from the active position of cocking the hammer of his musket to the passive position of merely holding his musket, and holding it slightly away from his body, as if not quite accepting it, or as if disclaiming his possession of it (figs. 49, 50). (This position is unlike that of the soldiers in the firing squad, whose muskets are pulled in tight to their bodies.) The previously mentioned effect of the musket strap carrying the ground color through the NCO's body, thereby dividing it, contributes to the sense that the NCO, looking down on the musket, sees something alien to him, if he even sees it. For it must be acknowledged that, although Manet raised the head of the NCO while painting it, his downward glance is so pronounced that he could almost be asleep.[17] Together, these peculiarities in the treatment of how the NCO holds the musket suggest that he is disengaged from the action of the squad, deferring of the action that we know that he will have to take, and seemingly unconscious of the field of slaughter.

(These peculiarities in the grip of the NCO's two hands will, sooner or later, attract attention to two hands that clasp across the painting, Miramón's and Maximilian's, and to the fact that, oddly, they are two left hands.)

Champa suggested that the facial features of the NCO in the London paint-ing resemble those of Napoleon III, to which Jones adds that if the resemblance were intended "the political statement would have been amazingly strong."[18] If so, not only would this have been to implicate Napoleon in Maximilian's death, but also, the implications of disengagement, deferral, and indifference pictured in Napoleon's surrogate representation would have been amazingly politicized. Of course, that it is possible even to raise this question speaks volumes about the stylistic shift between the Boston and London paintings.

Given that the features of Miramón are as portraitlike as those of the NCO, we might reasonably assume that the same was true of the features of Maximilian and Mejía. Hence, the three portraits of the victims would have faced, across the anonymous firing squad, the portrait of the NCO, who would deliver the *coup de grâce* that finally killed them. Miramón and Mejía would have been in plane with the forward members of the squad, even possibly with the slightly more forward posi-tion of the NCO.[19] (He can be seen in his entirety in the 1883 photograph; fig. 51.) As a result, the squad's muskets, although now placed parallel to the picture plane—rather than inclining back into the fictive space, as in the Boston paint-ing—would still have had the target of Mejía (and possibly Maximilian) at which to fire. However, Miramón looks somewhat oversized; therefore, Maximilian, who was depicted in the other compositions as taller, must have been even more oversized. (Were he, and therefore Mejía, perhaps cut off for that reason, with the original idea of suturing on new images and repainting Miramón?) Also, Miramón's glance is very unsettling; how unsettling is impossible to tell without the other two victims.

THE COMPOSITION AND SETTING OF THE LONDON PAINTING

Knowing that the three victims must have been tightly grouped makes it somewhat easier to judge the pacing of the friezelike composition. From left to right, it must have read as: a tight group of three; a space; a single figure; a slightly smaller space; a tight group of five (concealing a sixth figure); a much smaller space; a single figure. Thus, while the action of execution reads from right to left, the decrease in the width of the negative spaces from left to right literally concentrates attention on the NCO.[20] And the presence of the landscape within the action of the execution makes the London painting very different from its predecessor. The action of the Boston painting takes place in the space of a landscape, a picturesque, Romantic landscape; that of the London painting divides and engages the space of a landscape, a flattened landscape like a theatrical backdrop,[21] and a particularly featureless one at that. The theatrical association of the London painting makes the protagonists into performers; however, its featurelessness creates the opposite to theatrical association of a place distant and silent, and, therefore, evokes a place of an unwitnessed action. In saying this, I allude to Fried's descriptions of Davidian paintings of a self-sufficiency so great as not to acknowledge the presence of the beholder.[22]

In Fried's interpretation of Manet's painting (specifically, of the final, Mannheim canvas), the artist not only avoids the theatricality of acknowledging the beholder, but also neutralizes the common way of doing that, by representing figures so absorbed that they seem indifferent to the beholder. However, as Fried acknowledges, Manet could hardly have chosen more unpromising material for such a task than a subject that required him to represent soldiers absorbed in their task and victims absorbed in the consciousness of their fate.[23] I shall return to how Manet may be thought to address this problem when we come to the Mannheim painting. For the present, however, we might begin to ponder how the setting of the London painting, theatrical in its stage-set association and anti-theatrical in its sense of an unwitnessed place, engages the figural action.[24]

Compared to the protagonists with portrait faces, the squad, not having visible faces, necessarily seems depersonalized.[25] It also seems more anonymous, more mechanically engaged in its task than it does in the Boston painting. It does so because of its compacted grouping; because the repeated belts and swords tell of military sameness (despite Manet having apparently neglected to paint the hand guard of the sword on the right); and because they are painted

52 HILAIRE-GERMAIN-EDGAR DEGAS
Young Spartans
Exercising. c. 1860
Oil on canvas, 43 ⅛ x 61"
(109.5 x 155 cm)
The National Gallery, London

so matter-of-factly. However, they do not step forward to their task, as the soldiers forming the killing machine do in Goya's *The Third of May* (fig. 24); rather, they stand, poised like marksmen firing merely at a target; like actors pretending to be soldiers; or like figures that are posing in suspended action. They are like the young Spartan girls challenging the boys to fight in the painting that Degas was reworking in this period (fig. 52).[26]

Manet's landscape seems even more distant than that of the Degas, both geographically and temporally, almost prehistoric despite the presence of modernized killing. As such, it also seems depleted of culture, removed from civilizing safety and privilege. It certainly seems to disengage from Mexico a short time past. Antique subjects like Degas's, thought Baudelaire, risked losing "the memory of the present," a phrase that implies that memory relates more naturally to the present than to the past. To represent the present is usually to remember the present as past (i.e., when it has become past in its perception), but the "presentness" of the present may be remembered and regained through a medium that epitomizes presentness. For Baudelaire, childhood was such a medium, and for him connoted, in Paul de Man's words, "a freshness of perception that results from a slate wiped clear, from the absence of a past that has not yet had time to tarnish the immediacy of perception (although what is thus freshly discovered prefigures the end of this very freshness)."[27] But there were other such mediums, and we will eventually need to consider whether Manet engaged with this issue—or, rather, how, for I shall argue that he did.

CHANGING PLACES: THE LITHOGRAPH
AND THE COPENHAGEN PAINTING

Just how the small painting, effectively an oil sketch, in Copenhagen (at 18 $^7/_8$ x
22 $^{13}/_{16}$"; 48 x 58 cm, very much smaller than the other three paintings; fig. 42),
and the even smaller lithograph (13 $^3/_8$ x 17 $^1/_4$"; 34 x 43.8 cm; fig. 41) fit into the
sequence of compositions of the *Execution* has been the subject of much debate.[28]
It is very possible that Manet may have decided to make the lithograph after failing
to exhibit the London painting in the Salon of 1868, in order to refine and then
disseminate an image he had not yet been able to complete to his satisfaction.[29]
However, we know that the lithograph was completed and the lithographic stone
sent to the printer, Alfred Lemercier, by January 1869.[30] It is difficult to believe that
Manet would not have tried to publish until then a work made early in the sequence,
unless it was worked on over a very extended period.

This may well have been the case, for some features of the lithograph fol-
low the London painting while others revise it—concurrently with the Copenhagen
oil sketch, for certain—to anticipate the Mannheim painting. The lithograph and
oil sketch show spectators looking at the execution over a wall in the background,
a feature that also appears in the Mannheim painting. Therefore, these works
definitely either precede or follow that painting. They must have been begun
before it because the caesuras between the figures in both the lithograph and
the Copenhagen painting are close to those in the London painting; those in
the Mannheim painting are significantly different. Even without claiming that the
caesuras are more refined in the Mannheim painting, which they are, we can
confidently place the conception of these two works between that of the London
and Mannheim paintings. Manet, we know, gave away the Copenhagen painting,
thereby suggesting that he did not need to retain it because it had served its
purpose.[31] Equally confidently, then, we can describe the Copenhagen painting
as an oil sketch that prepared for the Mannheim painting.

Manet was away from Paris for much of the summer of 1868. Possibly,
the lithograph was begun before then, but it and the oil sketch must have been
made mainly in the autumn and winter—in a process of dialogue with the London
painting, with each other, and eventually with the Mannheim painting itself.

It was Manet's practice to make prints after paintings rather than in prepa-
ration for them. This lithograph, made after the London painting, actually prepared
the way for the Mannheim work, yet it may have been completed after the Mannheim

53 EDOUARD MANET
The Execution of
Maximilian (detail)
Ny Carlsberg Glyptotek,
Copenhagen (see fig. 42 for
entire painting)

painting had been taken to the point where it was ready to be exhibited. For, on February 7, 1869, *La Chronique des arts et de la curiosité* not only announced that Manet had made a painting of the "Death of Maximilian," which it pronounced to be "excellent," but it had also been unofficially informed that if the artist presented it to the Salon it would very likely be rejected. It also stated that he had "executed on a lithographic stone a sketch of this picture," which had also been censored.[32] Note the phrase "a sketch *of* this picture," not a sketch *for* the picture, which someone at *La Chronique* appears to have seen.

It is difficult to say with certainty which came first, the oil sketch or the lithograph. To suggest that they were worked on simultaneously is not only a convenient compromise but also has the advantage of probably being true. Anne-Birgitte Fonsmark's close study of the oil sketch has revealed numbering still visible at the edges of the canvas, indicating grid lines that appear to correspond to the format of the lithograph, suggesting that it was squared-up to transfer its imagery there. However, there are marks of a second squaring up in the form of measuring points (fig. 53); these, Fonsmark suggests, were probably intended to position a grid of threads, which would not mar the surface of a painting intended to be given away as a gift.[33] This suggests that Manet worked from the oil sketch to the lithograph, then back to the oil sketch, before transferring its composition to the canvas of the Mannheim painting. However, if the lithograph was begun to record and refine the composition of the London painting, it was begun first. This will be confirmed as we follow Manet's changes from the London composition as he developed his lithograph and oil sketch and shaped the Mannheim composition.

Before embarking upon this journey, however, it needs saying why these changes are worth following. The answer is that they provide a very good sense of Manet's improvisatory manner of working, as the two small works proceeded in dialogue with each other and with the preceding two and the succeeding large compositions. From this, we can infer that Manet was thinking of synthesis, and we can follow how he proceeded toward it. Moreover, the changes reveal the three

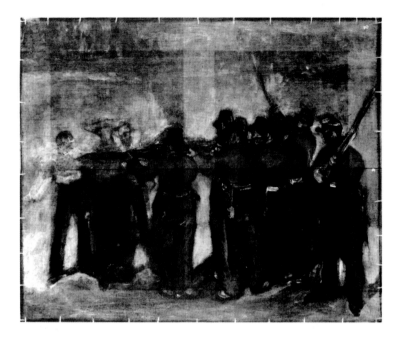

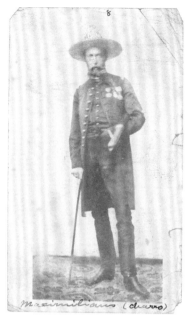

54 Composite X-ray of Manet's The Execution of Maximilian in the Ny Carlsberg Glyptotek, Copenhagen

55 ANONYMOUS Maximilian in a Mexican Hat. 1867 Albumen print, 4 x 2 $^{7}/_{16}$" (10.1 x 6.2 cm) Instituto Nacional de Antropología e Historia, Castillo de Chapultepec, Mexico City

large aspects of the composition that he felt were so critical that he had to fuss with them: first, the position and appearance of the victims; second, the position and appearance of the two officers; and third, the setting of the execution. Effectively, everything was to be revised except the firing squad itself.

THE VICTIMS IN THE LITHOGRAPH AND THE OIL SKETCH

Both the lithograph and an early state of the oil sketch shown by an X-ray (fig. 54) reveal the trio of victims to be positioned where it could well have been in the London painting, tilting back at an angle of about thirty degrees.[34] Again, Miramón faces almost forward at the rear, the upper corner of his head obscured by the brim of Maximilian's sombrero (fig. 55). Only, the trio has been moved to the right, close to the firing squad, so much so that Miramón's left foot and lower leg touch the left leg of the soldier, first in the squad, who diagonally faces him, thereby now closing the caesura between Miramón and that soldier. The horizontal change does not alter the functional relationship of squad to victims that was established in the London painting: the muskets, although again seeming to be parallel to the picture plane, still have the target of Mejía, certainly, to shoot at. Only the distance of shooting is brutally shortened. In the completed sketch, the trio of victims has been turned back diagonally at a steeper angle of some forty degrees, marked by a vivid shadow that joins the trio. Additionally, Miramón is now turned away from the near frontality of the London painting, the lithograph, and the early state of the oil sketch, so that his left foot is just short of a wall now running across the canvas. In the process of making the lithograph and the oil sketch, Manet therefore pushed the victims back into space, almost as far back as they are in the Boston

painting,[35] and adopted the same disposition of figures for the Mannheim painting. However, the oil sketch is unclear on whether he has inclined the muskets back into fictive space, as in the Boston painting, or left them parallel to the picture plane, as in the London painting and lithograph. It hardly needs saying that this adds enormous importance to the credibility of the depiction of execution.

Manet repeated the facial appearance of Miramón in the London painting in the lithograph. (Neither the X-ray nor the oil sketch reveals facial features.) The figures of Maximilian and Mejía have, of course, disappeared from the London painting. However, the state of the oil sketch recorded on the X-ray reveals figures that look a lot like those in the Boston painting, Mejía in a slumping posture contrasted to the tall figure of Maximilian, with his sombrero pulled down flat on his head. This suggests that Manet had retained these poses in the London painting while adding the figure of Miramón, hardly visible at all in the Boston composition. The lithograph makes one alteration to the early state of the oil sketch, showing that Manet had altered the head of Mejía, throwing it backward to record the impulse of the fusillade. The completed oil sketch shows that, too, but it makes an additional alteration, indicating that Manet had changed the position of Maximilian's sombrero, pushing it back on his head so that it somewhat resembles a halo. These two changes were transmitted to the Mannheim painting. The first change qualifies the chain of cause-and-effect of the image, replacing a slumping image of the effect of having-been shot to a thrown-backward image of being shot. The second change reinforces metaphorically, and thereby discloses, the element of Christian iconography that could have been surmised only by those familiar with the sequence of Manet's paintings discussed in this respect in the preceding chapter.

We will remember that the London painting showed Maximilian and Miramón holding each other's left hand. Both the lithograph and the oil sketch show that, too. (The X-ray is inconclusive.) What seems peculiar to the lithograph is that Maximilian's right hand is holding Mejía's left; yet Mejía appears to have an additional left hand at his waist. (These areas cannot be seen clearly in the loosely painted sketch.) These prominent left—that is to say, sinister—hands have occasioned the suggestion of an intended death symbolism in these features.[36] Of course, Manet liked hidden jokes, but it is hard to know quite why he would need to symbolize death when he illustrates it happening in so clear and gruesome a manner. More plausibly, Manet needed a double-left handgrip for Maximilian and Miramón pictorially, in order to turn the latter into view. He did not need the

additional left hand of Mejía, which presumably preceded his decision to have Maximilian and Mejía also holding hands; neglecting to erase it in the lithograph, he did so in the Mannheim painting (if not in the oil sketch; we cannot tell). The changes should alert us to Manet's focus on hands in this composition.

THE OFFICERS IN THE LITHOGRAPH AND THE OIL SKETCH

Manet was certainly attentive to the right, lower hand of the NCO, which would raise the hammer of the musket, readying it to fire. In the London painting, we have noted, the right hand originally had been in the active position of doing just that; only Manet had changed it to a passive position and showed the NCO holding his musket slightly away from his body, as if (I have argued) disclaiming possession of the weapon. In both the lithograph and the oil sketch, Manet returned to the original position, and did so boldly; the oversized hand is a single, vivid, pale shape in both works. This closes the space between the weapon and the body of the NCO, who in other respects seems unchanged from the London painting. This is the figure that will appear in the Mannheim painting.

A major surprise in the lithograph and the oil sketch is that the sword officer is now visible, moved to the right from his almost invisible position in the London painting at the middle rear of the squad of soldiers to a position between the squad of soldiers and the NCO. In moving him, Manet raised his sword to a steeper angle. Interestingly, the original (London) position and angle of his sword closely corresponds to a feature in the lithograph—the diagonal division of light and dark behind the squad of soldiers—which may suggest that it was while working on the lithograph that Manet made this change and transferred it to the oil sketch.[37] However, the X-ray of the oil sketch (which already shows the final position of the sword) reveals a space between the back of the sword officer and the NCO that is not there in either the completed oil sketch or the lithograph. The early state of the oil sketch, recorded by the X-ray, therefore, preceded the lithograph in this particular feature of compositional change. If these suppositions are correct, Manet moved back and forward between the lithograph and the oil sketch as he shaped the appearance of the sword officer. He replicated this figure in the Mannheim painting and then painted him out. I shall defer discussion of possible reasons for the appearance and disappearance of this officer until we arrive at the Mannheim painting itself.

THE SETTING IN THE LITHOGRAPH AND THE OIL SKETCH

The final change that the lithograph and oil sketch made to the London composition was the addition of a wall in the background, with spectators and landscape elements visible behind it. This may have first appeared in the lithograph because the bottom edge of the wall, behind the firing squad, closely corresponds to the horizon line that divides land from sky in the London painting.[38] And yet, the early state of the oil sketch recorded by the X-ray reveals what may be a short wall above the heads of the victims. That feature may show Manet again returning to the original, Boston composition, for there, a horizontal above Maximilian's head and a receding diagonal beside Mejía possibly could indicate a wall behind the victims at the left of the landscape. What may well have happened is that the lithograph was begun with a landscape background (like the London painting), then Manet added a short wall to the oil sketch (like the Boston painting) and then transferred that wall to the lithograph to form the short, receding wall at the left. Then, he had the problem of where that receding wall should end and decided to abut it to a second wall, which he shaped above the horizon line that remained from replication of the London landscape.

In the completed oil sketch, there is only the one, continuous horizontal wall, which both closes off the composition in a Davidian manner and has been lowered sufficiently to give more room for, but does not detail, the figures and landscape elements that had been specified in the lithograph. This feature would be repeated in the Mannheim painting, and we must wonder why Manet did not do that for the lithograph as well. However, the two walls that, if I am correct, had emerged in the intuitive process of invention were worth preserving rather than changing to one. As Jean C. Harris has surmised, working in a black-and-white medium, Manet needed two walls in order to create a contrast of lighting: the dark, left wall as a backdrop to the white smoke, shirts, and sombrero; the right, lighter wall as a foil to the dark uniforms of the squad. And, following the same logic: a light ground zone at the left, beneath the victims' dark trousers; a dark ground zone at the right, beneath the soldiers' white spats.[39]

A cemetery wall had been mentioned in early accounts of the execution,[40] so could well have been adumbrated in the Boston painting. And photographs were in circulation of a low adobe wall before which the execution did apparently take place (fig. 56). However, the explicit, tall, horizontal divider in the lithograph and the oil sketch is quite another matter. Boime has plausibly suggested that

Manet would have been interested in Jean-Léon Gérôme's *The Execution of Marshall Ney,* shown at the Salon of 1868 (fig. 57). The dead body of Ney—an updating of the figure in Gérôme's *The Death of Caesar* (fig. 16), a source of Manet's *The Dead Toreador* (fig. 15)—lies face down before the wall against which he had been executed, while the firing squad marches away.[41] Gérôme had been reprimanded for the impropriety of showing a "juridical assassination," and political commentators had compared the executions of Ney, Napoleon I's associate, and Maximilian, the present emperor's. (A crossed-out graffito reading "Vive l'Empereur" is pictured on the wall.) However, Manet's wall does not replicate the actual wall of execution, although it may have done so when it was only the short wall at the left. And the principal source of this feature is not Gerôme but Goya.

The early accounts had also mentioned curious spectators,[42] but hitherto Manet had not included any. Indeed, a principal change from the Boston to the London paintings had been to strip the scene of topicality in order to place the execution in a timeless landscape that was carried within the bold caesuras that punctuate the figural groupings. Now, a scene from which witnesses had been excluded has been provided with witnesses borrowed from Goya's *Tauromaquia* prints (fig. 59) and from paintings that Manet himself had made after their example, notably *Incident in a Bullfight* (fig. 12), the painting begun after the French defeat on the fifth of May of 1862 (see p. 40), and *Bullfight* of 1865–66 (fig. 58), which Manet painted after seeing a real bullfight in Madrid—"one of the finest, most curious and most terrifying sights to be seen," he wrote to Baudelaire.[43]

This latter painting also prominently includes a bullfighter, seen from the back, pointing his sword at a bull as the soldiers, seen from the back, point their muskets at the victims of the execution.[44] We saw, in the first chapter, how Manet made paintings that referred to Spain and France that may also refer to Mexico. Now, he transformed a composition that referred to Mexico and France to make it also refer to Spain. In doing so, however, it seems unlikely that he was intending to place the execution of Maximilian by Napoleon in the country of birth of his empress, who had encouraged the folly that had come to this. More likely, he was reengaging

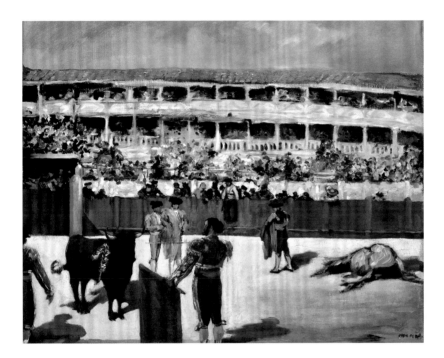

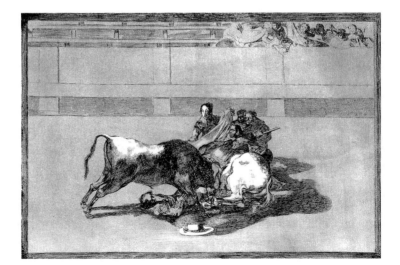

Goya, whose *The Third of May* had prompted the Boston painting, after he had engaged David in the London painting. He probably wished to heighten the terror of the event by alluding to the *corrida*, after having dignified the composition by alluding to a timeless, featureless place. (Writing to Duret of the lithograph, Manet began to say that it represented a "massacre" before changing the word to read "execution."[45]) This allusion is stronger in the lithograph because its more distant walls place the execution inside a walled space[46] whereas the more proximate wall of the oil sketch seems to place it outside one[46] —especially since the freely painted area above the wall does not, for certain, indicate spectators.

THE BANNING OF THE LITHOGRAPH

As we heard earlier, by February 7, 1869, Manet had painted a "Death of Maximilian," which *La Chronique des arts et de la curiosité* pronounced to be "excellent"; he had been unofficially informed that it would probably be rejected if he tried to exhibit it at the Salon; and he had made a lithograph of this picture, which had also been censored.[47]

The prohibition of the lithograph, which unfolded dramatically over January and February of 1869, has been documented by Wilson-Bareau and does not need to be retold in detail.[48] Basically, Manet sent the lithographic stone to the printer Lemercier, who presented the image for official registration, and Manet was told unofficially that the authorities refused to allow the image to be published for sale (indeed, even to be printed), despite its not yet bearing a title that would have specified the subject. However, Manet did receive three trial proofs, and Lemercier, fearing that he would not be paid for them, refused to return the stone to Manet and threatened to efface it. The artist then published a letter of protest in *La Chronique des arts,* which, in exactly a week, reported, "The printer Lemercier has advised him that his lithographic stone, representing 'The Execution of the Emperor Maximilian' or, if one prefers to remain vague, a 'Shooting in Mexico,' is at his disposal."[49] Manet had won a Pyrrhic victory.

But this affair had a true journalistic triumph in the form of a wonderful, heavily ironic piece by Zola, published on February 4, 1869, under the title "Coups d'épingle" ("Pinpricks"). It said that, if Manet had wanted a success, he should have shown "Maximilian alive and well, with his happy, smiling wife at his side. Moreover, the artist would have to make it clear that Mexico has never suffered a bloodbath and that it is living and will long continue to live under the blessed rule

of Napoleon III's protégé." Zola then drolly claimed that he could not at first understand why the censors had banned the lithograph, until he noticed something:

> I noticed that the soldiers shooting Maximilian were wearing a uniform almost identical to that of our own troops. Fanciful artists give the Mexicans costumes from comic opera. M. Manet, who truly loves truth, has drawn their real costumes, which closely resemble those of the Vincennes infantrymen.
>
> You can understand the horror and anger of the gentlemen censors. What now! An artist dared to put before their eyes such a cruel irony: France shooting Maximilian![50]

THE WELL-KNOWN END: THE MANNHEIM PAINTING

In making the Mannheim painting, Manet followed the oil sketch, clarifying its summary treatment. Then, he made a noticeable, major change to the composition. It is a huge painting, 8' 3 $^3/_{16}$" x 9' 10 $^7/_8$" (252 x 302 cm) in size (fig. 43), larger than the Boston painting and probably larger than the London painting was before it was cut down. Therefore, the clarification required to enlarge a 48 x 58 cm. oil sketch called for many decisions on Manet's part, even though he had the London painting to refer to. The sum of these decisions produced an altered work: not only was it a much larger one but it was also a more definitive one, more firmly committed than a sketch could be to the inflections of detail and emphasis that articulate its surface. And it produced a work that, I shall argue, altered the story told by the painting in very significant ways. One of these ways required the noticeable, major change to the composition: the return of the sword officer to a concealment even greater than that from which he had only just appeared.

THE APPEARING AND DISAPPEARING OFFICER

It is evident, even to the naked eye and especially when looking at the Mannheim painting in raking light, that Manet had fussed with the area to the left of the NCO (fig. 61). There are ghosts of pentimenti that curve away from the point of the NCO's shoulder and, further down, follow the curve of the adjacent soldier's back. These have been confirmed by an X-ray (fig. 60), and reveal that Manet had carried the NCO further to the right in the oil sketch and lithograph and pulled the

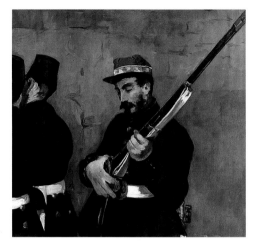

sword officer into even greater visibility than in those preceding compositions.[51]

 Why did Manet reveal this figure, then make him more prominent, then finally delete him? One answer to the question of his appearance, which was initiated (I suggested earlier) in the lithograph, is that the medium of lithography suggested it. The small size, grainy hatching, and especially the restriction to monochrome of the medium would have made a repeat of the London image look very confusing, as the black-and-white 1883 photograph of the London painting demonstrates (fig. 51). Moreover, the intended wide distribution of the lithograph required not only clarity but also polemical boldness, and what Fried calls a "vivid and particular . . . image of executive agency" does that.[52] (So does another innovation of the lithograph I mentioned earlier: Manet's replacement of a slumping image of Mejía having been shot with a thrown-backward image of his being shot.)

 Of course, the medium of lithograph cannot be thought a reason for the appearance of the sword officer in the Mannheim painting. Indeed, we cannot securely argue that Manet found its use in the lithograph persuasive enough to want to repeat it. As we have seen, the lithograph was described on February 7, 1869, as "a sketch of this picture." Therefore, unless this was an overly casual description (which is very possible), the sword officer must have been in the Mannheim painting before, or more or less simultaneously with, his appearance in the lithograph. This suggests that he was added to the painting to enlarge its polemical force, and Manet found the boldness to be appropriate to the lithograph but not, eventually, to the painting. It is unknown when Manet removed the figure from the painting. As late as 1876, he apparently referred to it as an unfinished canvas.[53] But by December 1879, when a photograph of it appeared on a handbill promoting its exhibition in New York, the sword officer had disappeared and the painting was in the state in which it has remained.[54]

 To add the sword officer to the painting was an even bolder polemical act

60 Composite X-ray of Manet's **The Execution of Emperor Maximilian** in the Kunsthalle, Mannheim

61 **EDOUARD MANET**
The Execution of Emperor Maximilian (detail) Kunsthalle, Mannheim (see fig. 43 for entire painting)

than adding him to the lithograph: his red trousers very clearly resembled those of a French soldier, thereby, as Zola had said, putting before the eyes of the public a "cruel irony: France shooting Maximilian!"[55] If he had been added for this reason and was, indeed, removed in the late 1870s, he was probably removed because Napoleon III had long been deposed and the polemic would only date the painting. And yet, the painting was going to be shown in the United States, where that polemical note might be welcomed by those who had shared in Manet's dislike of the late emperor's Mexican intervention. So the sword officer may well have been removed earlier and for another reason, for that removal was critical to the conceptual integrity of the Mannheim painting.

Another reason for removing the sword officer, it has been suggested, was that his position was illogical: the squad could not possibly see his sword command and, besides, his elevated sword that gives the command is at odds with the fact that the muskets have already fired.[56] But such a position for a sword officer, and a sword still elevated during the fusillade, was not uncommon in prints of executions; Paul Revere's famous print of the so-called Boston massacre is but one.[57] And Manet was never picky about things like this.

A more persuasive reason for what happened, suggested by Fried, is that, given the "vivid and particular . . . image of executive agency" that the sword officer represents, "by all but eliminating him Manet greatly reinforced the mood of implacable mechanism presiding over the painting as a whole."[58] All but eliminating him: because it was important that this mood not be equated with the painting's "truth"—that the painting should not be read as simply an illustration of mechanism in action. So, Manet returned to the London solution of showing a fragment of the officer's red cap behind and between two of the soldiers' dark caps—a slightly larger fragment, actually; with good reason, because he had eliminated all traces of the sword that could help to locate the officer. He additionally left a streak of red paint between the legs of the soldier on the right (fig. 62). This, Fried claims, "absolutely resists being assimilated to the work of representation."[59] True, it is too far to the right to belong to the officer and, therefore, resists being assimilated to the work of depiction. Yet, the color both of his uniform and of blood, it tells us that Manet is there and what his executive agency has achieved. It is, therefore, a "remainder" not only of the artist's task of representation, as Fried has it, but also of the officer's act of representation, the sign that he gave, and its consequences. And just as, in *The Dead Toreador*, the pink cloth that had

been used to direct the bull becomes a displaced sign of death, aided by its association with similarly imperceptible flecks of blood, so here do the red caps of this officer and the NCO.[60] Their signification gains force by the contrast of the red, across the painting, with the peculiar color triangle formed by the victims' clothing: Miramón is wearing green trousers, Mejía is in blue trousers, and Maximilian wears a pale yellow sombrero.[61]

As Fried rightly says, a theme of secrecy is hinted at by the almost concealed sword officer and by the vague traces of his earlier position. If we remember, from the preceding chapter (pp. 80–81), the first image in the chain of replications that produced the sword officer, namely, the *Boy with a Sword* (fig. 34), perhaps we may be willing to consider that a secret that this painting has been said to hide may also be concealed in its (briefly revealed) replication, a secret that depends upon identification of the sword officer with the putative son of the artist. If the sword officer may be thought to act on the artist's behalf, to please him, as one interpretation had the boy with the sword doing, he becomes an agency of aggression on the artist's behalf. (This will reinforce Fried's suggestion that the figure of the NCO "might almost be an image of a painter standing back and partly turned away from his painting while he mixes colors on his palette."[62]) And, if the sword officer may be thought to act on his own behalf against the emperor, as another interpretation had the boy with the sword acting against his father, he places the artist in the position of the emperor. I think, with Fried, that we must allow that Manet may be associated, as a target of aggression, with Maximilian and, as an instigator of the aggression, with the two officers—in both cases hiding the instigator of violence in the composition of the painting.

Manet pulled out and looked at *Boy with a Sword* while he was working on the Mannheim painting, for he sent it to an exhibition in Marseilles that opened on December 1, 1868.[63] So he may well have thought of it while pulling out the sword officer from his concealment. He sent another painting to Marseilles, one of the two that comprised his 1861 Salon debut, *The Spanish Singer* (fig. 63). Manet had been criticized for showing a left-handed guitarist playing a guitar strung to be played with the right hand but, according to Proust, Manet said that correctness was inconsequential. "Instead, Manet placed importance on the speed and compositional exigencies of his execution."[64] Whether he said these precise words is inconsequential, but their meaning, and perhaps this very image, has obvious relevance to the figure of the NCO in the Mannheim painting.

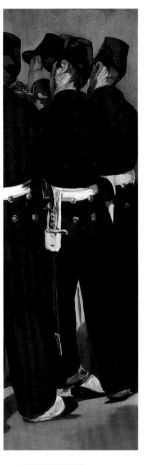

62 EDOUARD MANET
The Execution of Emperor Maximilian (detail)
Kunsthalle, Mannheim (see fig. 43 for entire painting)

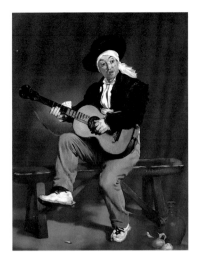

THE MOMENT OF EXECUTION

63 EDOUARD MANET
The Spanish Singer. 1860
Oil on canvas, 58 x 45"
(147.3 x 114.3 cm)
The Metropolitan Museum of Art,
New York. Purchase, Gift of
William Church Osborn, 1949
(49.58.2)

Stéphane Mallarmé spoke of "the fury that hurled him [Manet] on the empty canvas."[65] "But I often have to start all over again," Manet said, "and then it takes several days."[66] A painting was done as speedily as possible, parts erased, repainted as speedily, until the painting conveyed an effect of instantaneousness of execution although, in fact, comprising an accumulation of parts that recorded (and often could be seen to record) the separate moments of their execution. Manet's accumulation of quotations, discussed in the previous two chapters, functioned similarly. This is to say that the making of a painting from colored paint and from documentary or art-historical images was a matter of building instants of the compositional process, and of the instants that they described, into a unity, but without confining them by a unifying principle; instead, providing some representation of the instantaneous, a fusillade perhaps, to anchor them.

At the end of the preceding chapter, I suggested that the constraint on narrativity imposed by the suddenness of such an event as the fusillade of an execution accorded well with the constraint on the depiction of narrativity—of temporally distinct or extended moments—that was traditionally thought to characterize painting as a visual art. The classic account of this constraint, in Lessing's *Laokoon,* argued that since painting was required to depict arrested actions, its best recourse would be to show "the pregnant moment" of action stopped at a climactic moment; ideally, at a moment that implied, although it could not show, the preceding and following moments. As Fried has explained, David's *Oath of the Horatii* broadly follows Lessing's conception in its variation recommended by Denis Diderot, affording "the depiction of a single, indefinitely brief, psychologically charged, and morally exemplary moment" in a larger narrative that his audience would have immediately understood.[67]

The painting that was Manet's model for the Boston painting, Goya's *The Third of May,* of 1814, also shows what looks like a pregnant moment, just before the muskets fire. However, its instantaneity is temporally specific in a way that the moment recorded by David is not. It seems a mere fraction of a moment, not only

because we infer that the rifles will fire immediately, but also because of how we infer it: from Goya's juxtaposition of the abbreviated moment of imminent execution with something temporally extended, namely, the equivalent of a narrative frieze in the apparently endless line of figures awaiting, suffering, and having already died from execution. In both cases, though, the viewer's understanding of the implied narrative depends upon an imaginative engagement with the temporal implications of figural gesture and posture. But in both cases, the narrative is seen to possess a self-sufficiency that distances the viewer.[68]

When Lessing, Diderot, and others recommended that paintings should depict pregnant and morally exemplary moments because (except in specialized forms) the visual arts were unable to depict temporally distinct or extended moments, they also meant: because the visual arts were unable to depict temporally distinct or extended *movements*. It was because the subject of David's painting was a plausibly suspended movement in oath-taking that it seems well-suited to the arrestedness of a visual depiction. And it was because the suspended movements of both the line of the victims and their executions in Goya's are, obviously, *merely* suspended that its arrestedness seems so futile.

In these terms, the new composition that Manet invented in the London painting, and replicated in the remaining works, conflates the approaches of David and Goya. Yet, it has nothing of the exemplary, frozen moment of gestural movement of the David, nor of the futile, momentary pause in the line of figural movement of the Goya. In fact, it takes the frozen movement of the soldiers from the Goya and treats it like the frozen gesture in the David. That frozen movement of the (implicitly first) fusillade depicts the cause of a killing, and implies further killings. However, the action of killing is represented neither as a pregnant moment nor as a morally exemplary one. How could it? A depicted moment can only be thought to be pregnant with a meaningful causality or be morally exemplary if, first, it suspends a posture or gesture in mid-movement, and, second, if imagination of preceding and continuing moments of that movement stimulates the creation of a narrative around it. (And, as one critic observed of *Le Déjeuner sur l'herbe,* "one would seek in vain for the indication of a movement" in a painting by Manet.[69])

These conditions are not fulfilled by the mechanized moment of killing, but they are by the gesture of the sword officer as seen in the lithograph and the oil sketch. This was another reason why making this figure visible added polemical force to the image; it revealed a causal gesture within a narrative that the audi-

ence could quickly be expected to understand. The sword alone, as in the London painting, hardly did that; the removal of the sword, and the hiding of the officer and the sword, as in the Mannheim painting, did not do it at all. Therefore, in the case of the London and especially the Mannheim painting, it must be not to the action of killing (or the signal that caused it) but, rather, to the reaction to that action that we need to look for the meaningfully causal and morally exemplary.

A celebrated account of these paintings by Georges Bataille tells us that we would look in vain. Although refuting the traditional claim that Manet was "indifferent" to the meaning of his subject matter because he was only interested in formal concerns, Bataille nonetheless argued that Manet stripped the subject (or text) of a painting of its expected significance. He produced an effect of "indifference" to the text, but he did so because he performed a repudiatory, destructive operation upon it: "The picture *obliterates* the text, *and the meaning of the picture is not in the text behind it but in the obliteration of that text.*"[70] Speaking of the Mannheim painting, therefore, he asserted: "On the face of it, death, coldly, methodically dealt out by a firing squad, precludes an indifferent treatment; such a subject is nothing if not charged with meaning for each one of us. But Manet approached it with an almost callous indifference that the spectator, surprisingly enough, shares to the full."[71]

Both as an inference from Bataille's understanding of Manet's process and as a description of the affect (or lack of it, rather) produced by the painting, this is a very dubious statement. (It is illogical to claim that a work whose textual meaning has been obliterated in its painting was necessarily painted in the grip of, or produces the affect of, a numbing absence of meaning.[72]) An earlier viewer of the painting was probably reacting rather than describing when he said, "It is incontestable that the effect is prodigiously terrifying."[73] But even to present-day viewers, exposed regularly to far more violent imagery than Manet's audience was, the painting is hardly, for those who will give it time, the anesthetizing experience that Bataille suggests. In fact, time spent before the painting reinforces Bataille's claim of an "effacement" of textual meaning—of the nominal meaning being eroded and therefore changed in the experience of viewing—but without supporting his conclusion as to its visual result.[74]

I have suggested that Manet's attempt to depict an extended duration in the Boston painting proved to be a failed experiment. The London painting, therefore, may be (and has been) thought to represent the artist's decision to set aside that

kind of Goya-inspired temporal reading and turn for inspiration, rather, to the instantaneous clarity of David's composition. However, as we learned earlier, Goya's *The Third of May,* which inspired the Boston painting, had itself been inspired by David. Therefore, in turning to David, Manet turned to him not only after Goya but also by looking back through Goya. In Brush's words, "Following the experience of the Boston painting, he found it expedient to bypass certain aspects of Goya and return to the 'father' painting in order to solicit further support for his changed conception of the *Execution* as a *histoire.*"[75] I want to suggest, however, that of the aspects that he did not choose to bypass, one of them was the element of duration in the Goya, which Manet refashioned in a manner compatible with the anchoring, Davidian instantaneity of his new version of history painting.

Such a juxtaposition, or conflation, of temporality and instantaneity was not, of course, new to Manet. As Fried observes, in a number of his paintings of the early 1860s, a dislocated, part-to-part composition that requires a temporal read-ing seems suddenly to be stopped by a motif—the bullfinch in flight in *Le Déjeuner sur l'herbe,* in his example—with the function of "emblematizing the notion of a representational act so lightning fast in its attack . . . as to perfectly capture a bird in midflight."[76] The lightning-fast fusillade may be thought to have the same func-tion, as well as being metaphorical of the "strikingness" of the paintings that dis-plays it. But what of the temporality in the London and Mannheim paintings? Of the latter, Fried speaks of "a structure marked by an internal division between still-ness and its opposite," having in mind movements that describe a very narrow temporal range (for example, the upward drift of smoke as opposed to that, and the flames, below it), and thereby "determinedly [draw] attention to the inevitably aporetic nature of the fiction of instantaneousness even as it appeals to that fic-tion for its basic structure."[77]

This is to say, a concise narrative of present or slightly later, less or more protracted, coincident or separated, moments that belong to, and extend, the "text" of the execution adds plausibility to the single moment of the fusillade by locating it within a defining temporal envelope. This concise narrative was, per-haps, implicit in the London painting but was explicated only in the lithograph and the oil sketch as changes were made in the wall that forms its background. (As we shall see, the depth of the spatial envelope enclosed by that wall also effects the shaping of this narrative.) Thus, the text of the execution lingers in these small, disparate moments. Lingering, though, its instantaneity becomes vulnerable. How

far may a moment be stretched before it extends, beyond a moment or two, into a temporal stream? And how may such a stream be channeled and constrained?

THE TIME OF THE EXECUTION

As matters now stand, Manet's preoccupation with the duration of the execution, initiated in the Boston painting and curtailed in the London painting, has reemerged in the lithograph and the sketch, and has been elaborated in the Mannheim painting in the form of a narrow temporal extension of the narrative text in small, disparate moments. But that is not all that happens in the Mannheim painting insofar as duration is concerned. Two additional things happen. First: Manet invades the time-span of this extension of the text with small, disparate *distractions* that float free of the text, and its time-span, instead being subject to and directing of the temporal perception of the painting. That is to say, he builds into his painting motivators of perceptual mobility that urge us around the composition along tracks sometimes quite contrary to the direction of execution. Second: Having thus eroded the temporal sequencing of the narrative text, Manet builds into his painting larger perceptual movements that describe an additional, parallel text to that of the action of execution.

By putting it like this, I do not mean to suggest either that he did the first of these things, then the second, or that they serve entirely separate functions. Self-evidently, they emerged simultaneously in the inflections of detail and emphasis that transformed the imagery of the oil sketch into that of the Mannheim painting. And, as we shall see, the work of eroding and rebuilding the text of the execution belongs to both the more detailed and the larger motivators of perceptual movement. However, the work of these motivators is located in separable pictorial functions (and serves separable strategies), the first largely belonging to the shaping of space and the second to the shaping of viewing; therefore, I shall consider them in turn.

SHAPING SPACES

One of the tasks that Manet inherited from the preceding large, London composition was the careful adjustment of figure and ground, in this case, of the figural groupings against the two, abutted, parallel zones of sandy floor and gray wall. These zones and the zone of landscape above the wall divide the height of the

painting into segments that have approximately a two-to-three-to-one relationship. Therefore, while the wall occupies approximately one-half of the height of the painting, the vertical center of the painting falls low on the wall, at about the upper hand of the NCO. Its horizontal center runs up the caesura within the firing squad (fig. 64), a caesura that rises to point to the left, at an angle opposite to that of the NCO's rifle, and terminates at a soldier's hand, holding a rifle that points at the victims. Already, we can see how clearly and carefully things are arranged. The oil sketch and the lithograph had followed the London painting in shaping this caesura. Now, in the Mannheim painting, it has an animate quality that, contrasted against the dark uniforms of the soldiers, causes it to perform as a reversible fig-ure, switching backward and forward in the time of our viewing between a nega-tive space and a positive shape. We also can see that arranging things clearly and carefully does not necessarily mean arranging them unambiguously.

One reason why this caesura can switch in identity from ground to figure is that it points toward another single figure, the isolated soldier, and away from the main body of the firing squad, which comprises (I said of this feature in the London painting) a composite figure. Now the latter has been cut entirely free from the single soldier, and is even more a newly invented body with fewer legs and even fewer arms than its number of heads logically calls for. Being a multi-human compilation, it is a grotesquely inhuman one.

Another reason why the caesura to the left of the composite figure acts is because it is strongly contrasted against the ocher ground. The ocher is brighter in the central caesura than anywhere else, next brightest to the left of that isolated soldier, and then next brightest at the sides of the painting, shading in the fore-ground into a brown darkness that increases to the right-hand side of the painting. (This left-to-right contrast of the foreground is, of course, reminiscent of the litho-graph.) These discontinuities are enlarged by those along the horizontal division between the ground and the wall; it steps up to the right at each caesura. Additionally, the shadows cast onto the ground are inconsistent in their direction: those cast by the victims and by the soldier nearest to them point toward and would converge at the right hand of the NCO; those cast by the most distant sol-dier and the NCO point in the opposite direction, and would converge below the squad at the bottom edge of the painting. These features, which had progressive-ly been defined in the development of the compositions, serve to urge upon us subtle emphases in our attention, which include arresting our vision, however

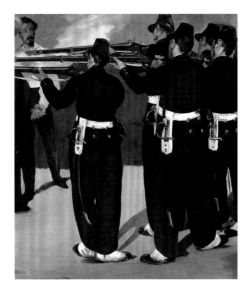

momentarily, at the central caesura and offering an opposite visual momentum to that of the fusillade.[78]

As we shall see, the caesura between the squad and the NCO also forms a reversible figure (fig. 66), but since its contrast of figure and ground is weaker, it is initially the less-noticeable of the two. So, let us follow Manet's direction and stop first at the bolder, central caesura (fig. 64). We see that he had to pay a price for shaping its left-hand turn in order to point us back in the direction of the fusillade. It meant reducing the height of the soldier to its left. He now looks oddly small: compared to the preceding compositions, the brim of his cap has dropped from above to almost below the uppermost of the muskets; compared to him, the already very large adjacent soldier now looks enormous. However, lowering him has had the advantage of allowing Manet to add space between the muskets, thereby making them more clearly visible. So we see that these three muskets illogically increase in length from top to bottom.[79] Less clearly seen is that the three fully visible swords of the soldiers increase in curvature from right to left. But if we glance away in that direction, attracted perhaps by the glitter of the sword handles against the white straps that hold the scabbards, we may be returned to the action of shooting by another falling white vertical, the sleeve that ends in Maximilian's and Miramón's clasped hands.[80]

In the London painting, there had been as large a caesura to the left of this first soldier in the squad, but it had been closed in the sketch and the lithograph. Now, in the Mannheim picture, Manet has introduced a sliver of space between this soldier and Miramón, thus making him an independent figure again, although he is still visually closer to the victims than to the rest of the squad. Therefore, he, with the victims in the left half of the composition, corresponds to the NCO with the rest of the firing squad in the right half, which introduces an element of causality into their relationship. The NCO, as an individual, will have to walk over to an even greater proximity with the victims and do what this soldier now does

as a member of the squad. (The NCO is readying his musket to do just that.)

This soldier is linked to the victims by the smoke and flames of the fusillade. The cloud that rises away from Miramón to reach the soldier—a fraction of a moment after the muskets fired, we presume—reveals an intricate jigsaw of spatially superimposed planes, most intriguingly a triangle above the soldier's bent arm, vertically divided into dark-and-light and horizontally bisected by a yellowish thread, components that refuse to separate into their spatially appropriate, nominative positions (fig. 64). This triangle, like the reversible figure of the caesura, assumes a strangeness observed in perceptual reality and an anomalous disruption in the fictive realm of the painting, a reminder of the shaping work of the painter. So, too, is the metaphorical association of the falling white verticals in different spatial planes. The effect of the darker, flame-streaked smoke around Mejía and Maximilian is more descriptive, gruesomely so, seeming as if to decapitate the former and to float off the head of the latter. Yet these effects depend upon our willingness to read overlapping or abutting planes in a twofold manner, as spatially separated or adjacent. In the case of the whole arc of smoke, our willingness to separate it from both victims and soldiers will make it a cloudy visual barrier that separates the more blurred features of the victims from the greater clarity of those of the soldiers.

Nonetheless, the bodies of the victims form a solid, united group in the stable shape of a triangle, upturned from the unstable one above the soldier's bent arm, that is solidly braced by the outer legs of Mejía and Miramón. It therefore comes as a shock to see that the two soldiers closest to the victims, those in the foreground, lift the toes of their shoes as they balance themselves while firing (fig. 64). It is an oddly casual posture, seeming improperly nonchalant for such a serious business, more appropriate to a dance floor than a killing field. As such, it would seem to support the familiar claim of Manet's "indifference" in his treatment of the subject; an impatient tapping of the feet, perhaps.[81] I am not sure that it does. If we acknowledge an element of impropriety in the deportment of these soldiers in the field of action, this makes their action seem all the more reprehensible. And if we either or also acknowledge an effect of nervousness in their deportment, this qualifies the mechanism of their action.

Certainly, there is a nervous fluttering to be seen in the ground area around the soldiers. The effect of reversibility in the triangle above the forward soldier's bent arm is multiplied in the shoes and spats of the soldiers, and in their relation-

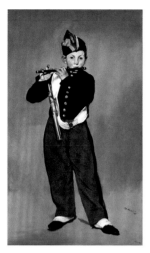

65 EDOUARD MANET
The Fifer. 1865–66
Oil on canvas, 63 3/8 x 38 3/16"
(161 x 97 cm)
Musée d'Orsay, Paris

ship to reciprocating shards of light ground and dark shadow around them. This tessellation of the ground into areas that offer conflicting clues of depth, and that can reverse spontaneously in depth, creates a disturbance of multistability that adds to the restlessness of the raised toes to produce a sort of muted visual patter beneath the rigidly immobile firing squad.

These movements, at once the products and the activators of perceptual mobility, are distractions to our concentration on the action of execution, pulling us away from the direct path of anecdote to the shifting and skipping courses of saccadic impulsiveness. Manet's process of shaping and clarifying that transformed the composition of the oil sketch into that of the Mannheim painting may, therefore, be seen to be a shaping and clarifying not only of the narrative of the execution but also of ambiguities that complicate, even oppose, that narrative. These perceptual ambiguities are concentrated around the fixity of the firing squad; so are the inconsistencies in level of finish and in the description of costume that Manet maintained from the London painting.[82] That is to say, they are concentrated around the compositional feature that remained more or less set in place from the London painting onward. It could remain thus because it was not the medium of narrative exposition (as, say, the oath-taking figures are in David's painting), but only the ground over which it unfolded. In fact, the more that these soldiers reminded viewers of toy soldiers in the cartoons of *Incident in a Bullfight* the better; the more evident it was that they were for the purposes of diversion, to distract as well as attract the viewer's attention. The patterns of light and dark provided by the soldiers' uniforms indubitably contribute to the distraction, but only because of their dislocation in Manet's complex figural overlappings. Witness, in contrast, the far more stable effect of his previous depiction of a similar military uniform in *The Fifer* of 1865–66 (fig. 65), whose comfortably balanced pose is reused in reverse here not for a soldier but for one of the victims, Miramón.

THE VICTIMS IN THE MANNHEIM PAINTING

I said earlier that if we are to look for the meaningfully causal and morally exemplary in the London and, especially, Mannheim paintings, we must look not to the mutely mechanical action of killing but, rather, to the reaction to that action. And I said that Bataille's account of these paintings tells us that we would look in vain in so emotionally "indifferent" a composition. So let us now look at where we would

normally expect that reaction to be registered—in the posture, gesture, or appearance of the victims—and see what we find.

Like the main body of the firing squad, the victims comprise not only a single group but also a collective figure, in this case a reassembly of three figures into a newly invented figuration. Fried has claimed that Maximilian and his generals, executed at point-blank range that replicates a typical viewing distance before a painting, may be thought to be metaphorical of Manet's art and the fusillade of the spectatorly aggression that it had provoked and received.[83] Viewed as one single figure in a plane, like a single painting, the group better supports this claim. As a planar unit inscribed with a big triangular composition of three figures, the group is reminiscent of Manet's own *The Dead Christ and the Angels* (fig. 18).

We read, in the first chapter, of the genealogy of the victims in Manet's earlier compositions. However, it was not until the Mannheim painting that they could all clearly be seen. Miramón's face was visible in the London painting; he has now been given a somewhat darker skin but he continues to look curiously, albeit with a somewhat dazed curiosity, across the composition. The pose and features of Mejía we saw in the lithograph; although their drama has been somewhat tempered, the sudden, reactive movement and lifeless eyes express the emotion of having literally been taken aback.[84] Between the two generals, Maximilian, whose features were barely adumbrated in the lithograph, is now seen to be of an extremely pale face beneath his halolike sombrero. He seems to embody indifference, looking down with his eyes almost closed, like the NCO, the only additional figure in the action whose face is fully visible.[85]

The contrast of the pale, therefore European, aloof Maximilian with the two darker, therefore Mexican, generals, both showing affect, may seem at first to carry a cultural message, an unwelcome reminder of how France viewed the *races latines*. Yet, such an interpretation does not hold. Maximilian is privileged, of course, and in that respect isolated, and if his sombrero is a mark of his adopted Mexicanness as well as a saintly halo, he is still "out of place" in this setting.[86] And yet, the three victims are so bonded and so reciprocal within their collective figure as to remind one, rather, of the sorrowing and dazed angels on either side of the figure of Christ in the earlier composition. However, one of the means of their bonding is curious. They appear to hold hands, but Mejía's left hand is only visible by the fall of the cuff of his white shirt (unless the flash of white is intended as a handkerchief held by Maximilian), while Maximilian's and Miramón's left-handed

grip reveals hands that are already bloody, as if in anticipation of their being shot.[87] The strangeness of this depiction of their hands draws attention to other hands in the painting, taking us from the human contact of their hand-holding to the non-human contact of the soldiers holding their muskets to the unnaturally enlarged right hand of the NCO as he prepares the *coup de grâce*. Imagine the painting without the contrast of oddly painted hands—all visibly patches of colored paint—and we see that these small and scattered reminders of touching qualify its visual matter-of-factness. And we also see that the reaction to the action of the fusillade, in the touching gesture of the victims, backs up across space and in time to find a reaction in the previously set, closed grips on the muskets, then turns to the future as the hand of the NCO stretches open to pull back the firing hammer of his musket.

What happens here is rather different from what happens in the almost subliminal pattern of fluttering movements, produced by reversible and multistable elements of composition, that we have noticed. These movements, focused around the soldiers, are distractions to our concentration on the action of execution. The attention that Manet draws to the hands does that, too, but it also suggests the possibility of a narrative parallel to that of the anecdote of execution, the text of which now seems slowly to be eroding in the process of viewing.

THE MOMENTS OF EXECUTION

Arguing for the vitality of the Boston painting, Reid claimed that the London painting serves to "de-implicate the viewer and so to re-establish his traditional beholder status outside the action of the event proper."[88] I have argued that, in the case of the Boston painting, the viewer is implicated in a mobile surface that seems almost and sometimes entirely independent of the illustration; therefore, its story material and the means of its telling are effectively disengaged. What is more, its means tell of an undifferentiated, unshaped temporality, which is why I was able to compare it to a helplessly recurring dream image. A critical innovation of the London painting was that it shaped a differentiated temporality. It did so by inventing a narrow temporal envelope for the action of the fusillade, one that would be refined through to the Mannheim painting in the small, disparate, lingering moments that Fried described.

This narrow temporal envelope tends to distance the viewer in the manner that Reid argues. However, the perceptual distractions that I have described invade it, while the narrative of the hands confuses it; in both cases, the effect is to break

down its causal, temporal sequence. Manet, I am now ready to conclude, re-establishes this on a different basis by doing what he has done before, by positing a narrative that places the viewer before the canvas and then encourages the viewer to follow and join in relationships of *looking* that move to and fro, as if ricocheting over the surface.[89]

The Boston painting solicits us to place ourselves before the one facing figure (at the right), as do other paintings by Manet with facing figures. The London painting also invites us to occupy that position in front of the NCO, but also to place ourselves before the isolated soldier seen from the back, the only figure unequivocally seen from the back and, therefore, a figure whose position we can most easily imagine ourselves occupying. We quickly see, by comparison with the collective figurations shaped by the group of victims and the main body of the firing squad, that these are the only two entire, single figures in the painting. (There are, of course, two entire, *reversible* figures, one on each side of the main body of the squad.) In the lithograph and the oil sketch, Manet flirted with canceling the autonomy of the single soldier by moving the victims right up to him, only to restore to him his autonomy in the Mannheim painting, albeit in a somewhat reduced form, for a reason I shall come to presently.

This single soldier is the one who is closest to the victims, specifically to Miramón. But, in the London painting, he shoots past Miramón (we see that from the 1883 photograph; see fig. 51), thus making it clear that Miramón has, for the present, been spared. Miramón is the only person in the painting who is doing what we are doing: looking. As we have seen, in later compositions, too, he has been spared and is the only curious observer.

What we see, looking at the London and Mannheim paintings, may be described as a flashback (analepsis): this is literalized in the flash of the fusillade that we are seeing in the present and that we understand to be happening in the past. Miramón does not see the flash of the fusillade because he is not looking at the squad firing; he is looking at something, or someone, who we cannot see. He has to be looking at the sword officer, and, having seen the command to shoot (to shoot Mejía presumably), is waiting between past and future, between the past moment that caused the first fusillade and the future that will see the next. If anyone in the painting is of the present, it is he, for he is alert, the past is nothing to him, and he has no future. (He is, in this respect, the very medium of presentness.)

But we, looking at the Mannheim painting, do see into the future. In the

66 EDOUARD MANET
The Execution of Emperor
Maximilian (detail)
Kunsthalle, Mannheim (see
fig. 43 for entire painting)

London painting, the sword may be being raised again for the second command to shoot, but that is uncertain. What is certain, in both the London and Mannheim compositions, is that we see someone who Miramón cannot see. Just as the squad shields the sword officer from us, it shields the NCO from Miramón. And seeing the NCO means that we are shown a flash-forward (prolepsis): we see something that is about to happen (the *coup de grâce*) in (this present representation of) the past. As we look to the left, the fusillade is firing; as we look back to the right, the NCO is waiting to fire later. Miramón directs us to what we cannot see, the reason the fusillade fires, the reason for what is happening now; and we see what he cannot: the NCO preparing the ending. Those who, like Manet, had read the news reports would know that it would be a painfully protracted ending.

The solid, planted quality of the NCO's figure (like that of the collective figure of the victims) makes the area immediately to his left seem all the more liquid; it shapes a reversible figure (fig. 66), that is, if anything, more bizarre than that on the other side of the main grouping of the squad. The two reversible figures are both odd, displaced echoes of the single figures beside them. However, this one faces the NCO with an occluding contour of the rearmost soldier in the squad that is shaped to suggest a common contour where the NCO could have been attached to the squad. This makes his detachment all the more vivid. But there is more. From below the handle of the NCO's musket, which just touches the opposite, occluding contour, there falls a curious strip or ribbon that, changing color beneath a dark diagonal shadow, seemingly slides from an upright position onto the ground in anthropomorphic form. It resembles a face and it rests on another shadow, which falls into the space of the painting and must, therefore, be the shadow of a person standing in the viewer's position.

I said that the Boston painting set the pattern for the series in placing the viewer before both the NCO and the single soldier. Now, in the Mannheim painting, Manet seems to be privileging the NCO over the single soldier by placing our shadow in front of him. (The artist has helped himself by qualifying the autonomy of the single soldier through elimination of the caesura of the London painting between him and the victims; that was why he fussed with that space in the lithograph and the oil sketch.) Across the canvas from this shadow, our shadow, well beyond the single soldier, appears Manet's signature and the date of the execution, "19 Juin 1867."

Is Manet telling us that he has painted what we could not see on June 19, 1867, by painting what was visible to an original viewer who occupied our position,

rather in the way of *The Dead Christ and the Angels*? If so, Manet locates us before the NCO as he located us before the figure of Christ, whose place in the narrative came later than the event described. Now, the NCO's face in the Mannheim work is softer than that of the London painting; a trifle blurred. This is a mark not of incipient Impressionism,[90] but of withdrawal from a too-vivid present-ness, as befitting his future role. Manet thereby pitches the future extent of the narrative against the immediacy of the depiction of the execution that was recent-ly made all the more striking by the changed image of Mejía, now reacting to being shot. The other recent change, in the position of the single soldier, tempers the prominence of that soldier and allows the NCO, while still his partner in reverse position, also to partner with Mejía. And the contrast of these figures—at opposite ends of the painting, above the shadow of the viewer and above the artist's inscription of name and date—is a contrast of two men shown as con-scious only of their action or reaction: the NCO shown as absorbed in the action of preparing his musket for killing; Mejía shown as conscious only of the shock of being struck by bullets. The NCO's action prepares him for a later moment of the narrative than that of the muskets firing and Mejía lurching backward in response; even later than the smoke that then rises against the wall and the glance that Miramón takes toward the sword officer. Only Maximilian, his eyes closed, and the firing squad itself are "indifferent" to the narrative that is unfolding around them.

This is all very strange, this implicit narrative of cause and action across a composition that first and foremost offers us the sudden shock of the fusillade. But there is something that makes it appear even stranger, something amiss in the painting that comes as a second sudden shock when we see it.

Attentive readers will remember that I said that the oil sketch was unclear on an issue of enormous importance to the credibility of the depiction of execu-tion: whether the muskets are inclined backward into fictive space, as in the Boston painting, or set parallel to the picture plane, as in the London painting and lithograph. Careful readers will have noticed that, in my descriptions of the two most vivid, most descriptively moving features of the Mannheim painting, I have spoken of Manet showing the suddenness and violence of the mechanical moment of fusillade and of his showing the suddenness and violence of the human reac-tion of Mejía to being shot. But I have not spoken of the two as causally connect-ed, and I wonder whether they are. The muskets fire in plane, surely, and the most distant member of the squad, the tallest, cannot securely be placed on a plane

with the nearest member of the victims, Mejía, the shortest. Of course, the inference of the painting is that the depicted fusillade causes the depicted effect of death; that a sudden, violent, mechanical moment causes a sudden, violent, human moment. Because the painting allows that inference, it would be wrong to say that Manet does not depict a shooting death. (The painting does not, I think, allow the inference that the squad is so inept that it missed hitting Mejía.) And yet, it does not exactly depict Mejía being hit by the fusillade, although it does show him reacting as if he had been.[91]

Even at the most critical, climactic moment of the narrative, Manet thus disengages the propulsion of causality that is traditional to narrativity. He allows—does not urge, but allows—that the temporal momentum that leads to the killing might be thwarted. What I have called the parallel narrative, provided by actions of looking performed across and between painting and viewer, is an enactment of reactions to and temporal extension of the execution. Additionally, this rift of cause and effect—or skepticism of the verisimilitude and, therefore, veracity, of the representation of the cause having produced the effect—allows for, and then urges, reenactment. It urges a replay as surely as the Boston painting, but more shockingly; and as surely it urges disbelief that so shocking an event occurred. And, even while delivering this human message, Manet delivers the message that he has taken this humanly moving subject, broken it apart, and reestablished it on a different basis. As Bataille correctly says, to take liberties with the subject is not to neglect it. "After all, the subject in Manet's pictures is not so much 'killed' as simply overshot, outdistanced; not so much obliterated in the interests of pure painting as transfigured by the stark purity of that painting."[92]

WITNESSING THE EXECUTION

The temporal play and replay of cause and action, and reaction divorced from cause, is a play and replay of narrative time in the pictorial time of our viewing, in the pictorial time that Manet used to structure the Mannheim painting. It gains intensity due to the compressing shallowness of the spatial envelope, virtually a corridor, across which it unfolds. The landscape of the London painting has the sense of a backdrop to provide an effect of enclosure. It has many admirers, for the report of the execution may be thought to echo, unwitnessed, across a silent, ancient, but incredible landscape, to deeply mysterious effect.[93] For Manet, though,

67 EDOUARD MANET
The Execution of Emperor
Maximilian (detail).
Kunsthalle, Mannheim (see fig.
43 for entire painting)

we have to wonder what he came to think of this report of the present in the past. From what happened subsequently, we may infer that it seemed insufficiently contemporary; that its overall quality of a performance seemed to overwhelm, and flatten, the individual nuances of depicted performance necessary to unfold the pictorial story; and that its landscape seemed not enclosing enough.

As we heard earlier, Manet returned to Goya (and his own, earlier interpretations of Goya) and, in the lithograph, replaced the landscape with a distant two-part wall that placed the execution within an enclosed arena, like a *corrida*. I take it that Manet brought the wall forward in the oil sketch because he recognized the need for a narrower corridor of space in order to intensify the action. However, by doing that, he sacrificed the sense of a space with enclosure enough to allude to a bullring. This was a great sacrifice, for the reference to a place dedicated to the ritual killing of animals made the depiction of the execution all the more shocking.[94] In the Mannheim painting, Manet retained the nearer wall of the oil sketch, but created an allusion to the *corrida* by making it clear that there are witnesses looking over the wall (fig. 67) who resemble those looking into the bullring in etchings by Goya and in his own Goya-influenced bullfight paintings of 1862 and 1865. Once again, the present in Mexico is described in terms of the past in Spanish painting, and once again in the space of the *corrida*.

Within the narrow corridor of space, Manet sets up an alignment of perception and conception, visuality and narrativity, and then he dislocates that alignment. The narrowness of the space layers the figures, of whom some are themselves layered, against the wall like a frieze. The encouragement to a temporal reading that this provides aligns narrative and the pictorial time in the initial reading of the painting. In this first reading, the narrow space affords a sense of inescapability to the scene, which is reinforced by the sense of inevitability provided by the shots firing against, in the face of, a traditional left-to-right pictorial reading.[95] But, then, narrative and pictorial time pull apart in the extended viewing of the parallel narrative that I have described, and in that extended viewing the narrowness of the space of narration becomes not merely inescapable but a space of entrapment. The high wall closes off the scene, even pushes it toward the viewer, an effect suggested by the press of the crowd against the far side of the wall, and by the way that the landscape slopes down steeply toward the wall, without giving any sense of continuing behind it, just as the ground below it slopes down steeply toward the viewer.[96]

And, since the landscape with figures above the wall thus seems sutured onto the cornice of the wall, it connotes, at once, the background of the drama, the support of the canvas,[97] and—since it is more loosely painted than anything else—a painted backdrop. Below, Manet pitches the hard, matter-of-fact painting of the soldiers against the soft, matter-of-fact painting of the victims, in reinforcement of the narrative. Above, he pitches the extreme painterliness of the backdrop against everything below it, to provide yet another constraint to the verisimilitude and, therefore, veracity of the representation—and another rift of cause and effect, because we cannot judge the effect of the witnesses of the execution. They have been said to show horror and dismay, like the victims of Goya's *The Third of May*.[98] They are, indeed, of a type with those victims. But the point, surely, is that Manet needed that resemblance in order to subvert it. In the Goya, as Bataille properly observed, "the eloquence, the rhetoric of painting has never been carried further"; in contrast, Manet's painting is "the negation of eloquence."[99] Only one of the figures, the man with a raised hand, may unquestionably be said to show emotion,[100] and he looks suspiciously like someone parodying the now invisible signal for the squad to shoot. As for the rest, some show curiosity, certainly; others bafflement, perhaps; more than that is hard to tell. The woman at the apex of the shallow triangle speaks for all of them when, hiding behind her fan, she reveals nothing at all. The tiny, easily missed note of aloofness and silence that she brings to the composition is the note that reverberates throughout the composition.[101]

In the London painting, Manet had drawn attention to the narrative association of the sword officer and the NCO by means of the prominent, opposing diagonals in that highly orthogonal composition of their exaggeratedly long sword and musket, the latter seemingly extending beyond the right edge of the canvas. Removing the sword made the NCO's musket an even more visible sign that the execution would be thus painfully extended. But, then, Manet needed the crowd, looking down, to direct our attention to Miramón looking across to the almost invisible sword officer. Indeed, he needed a representation of looking that belonged as much to the viewer as to the composition.

The principal functions of this small group of figures are that it has come to see the execution; it does not belong to the narrative that describes it; and, therefore, it is composed of independent witnesses. They all look, as well as they can from their elevated, rearward position, at what is happening to the victims. (Their looking directs ours, from the opposite side of the painting, and helps to set up its

initial reading.) Therefore, both owing to their position and to the direction of their sight, they cannot see, neither can they be implicated in, the subsequent, parallel narrative of looking that the viewer of the painting sees and in which he or she becomes implicated. But they can see, presumably, whether Mejía has or has not been struck by the fusillade. However, it is simply impossible to tell from their reactions whether or not he has. We cannot rely on these independent eyewitnesses to tell us.[102] As such, they may be said to allegorize a failure, a confounding of vision in its reportorial function.

As for the triangular arrangement, it is "not a carefully arranged pose, but a natural disorder arrived at by chance."[103] The same sense of natural disorder, and indistinctness of function, shapes the two crowds on the hillside. "Behind the prisoners, higher on the hill, were the people, almost all of them poor Indians," an October 10, 1867, report in *Le Mémorial Diplomatique* had stated.[104] The distant miniaturization of these figures emphasizes that, while they also do not belong to the narrative that describes the execution, they are not witnesses to it. Rather, they hang back from that function, as if too cautious or frightened to come to see. It is their function to stamp onto the background an explicit representation of both awaiting in the distance (as this news had awaited Manet to paint it) and of the impossibility of seeing across it.

And they are not only too distant to see properly; they are also too distant to be heard or to hear. The quality of silence that they evoke, when noticed, also imposes a more general silence. And so does, especially, the strange cemetery to the left of the void in front of these crowds. Its white puzzle of tomb shapes is a visual distraction from the instantaneous flash of death below, which it seems to mute in its very own definitive silence.[105] We do not need to know that the cemetery derives from Manet's painting of the funeral of Baudelaire (fig. 68) to catch that pun, but we do need to know that for another: that "the transitory, the fugitive, the contingent" applied not only to modernity on the morning of June 19, 1867, when the squad fired and the NCO walked over to Maximilian.

Early on this morning of June 19, 1867, Maximilian and his generals have been taken from the convent where they were imprisoned, and marched to the top of the hill called Cerro de las Campanas.[106] Some say that poor Indians called out to

68 EDOUARD MANET

The Funeral. c. 1867
Oil on canvas, 28 ⅝ x 35 ⅝"
(72.7 x 90.5 cm)
The Metropolitan Museum of Art,
New York. Catharine Lorillard
Wolfe Collection, Wolfe Fund,
1909 (10.36)

them in sympathy;[107] others that soldiers and the dregs of the local population insulted them and, worse, pelted them with dirt and excrement.[108] There may have been benches with wooden crosses, placed against a cemetery wall, and priests in attendance;[109] and it is possible that Mejía and Miramón were turned around to be shot in the back as traitors,[110] and that there were separate firing squads for each victim.[111] Different witnesses have different stories. Maximilian could well have ceded the central position to Miramón.[112] He almost certainly gave money to the soldiers to encourage them to aim well.[113] The NCO waited, apart, as they stepped up to three or four paces before the victims, raised their muskets, and, on the sword command, fired.

For the NCO in the painting, the story ends here. He continues to wait, apart, in a halted world, where the squad holds its position, immobile; the fusillade fires silently; and the smoke continues to cling in the same place around the victims and to hang thinly against the back wall. For the NCO in Querétaro, though, his task now begins. We may imagine him starting at the deafening blast of the muskets.

The smoke clears to reveal a scene of chaos. Miramón has dropped, killed immediately, but Mejía remains standing, his arms flailing, until a shot in the ear delivered by another of the soldiers finishes him. (By now, the squad has broken ranks and is standing around the victims.) Maximilian has fallen backward but obviously is not dead. So the NCO steps over Maximilian's body to deliver the *coup de grâce*; only, he bungles a close-up shot, hitting him in the right lung. This not only fails to kill him but also aggravates the problem because the flames of the musket ignite Maximilian's vest, and someone has to throw water on him to extinguish them. He is now writhing on the ground, pulling at his vest, and all is in confusion. Some say that two other soldiers try in turn to end his suffering but each fails; the muskets misfire, one after the other. The NCO is now so nervous and upset that he drops the cleaning rod of his musket before finally managing to reload it, and again he shoots at point-blank range. This time he hits his target. And it is all over.

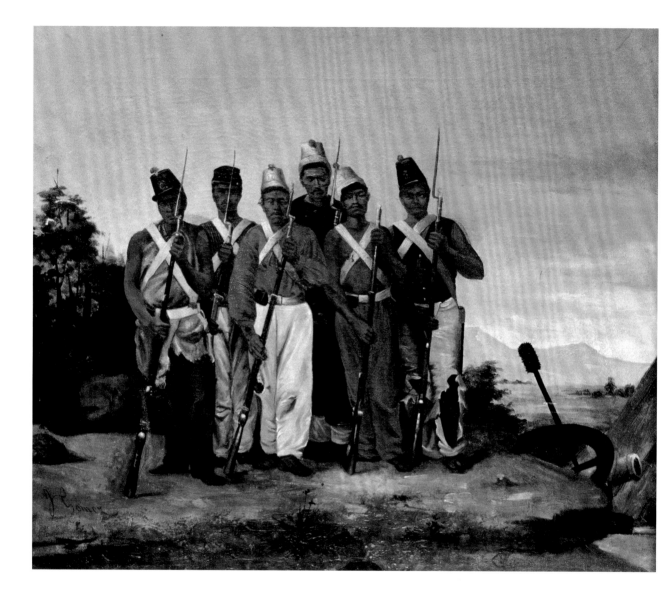

POSTSCRIPT

After the execution at Querétaro, the body of Maximilian was embalmed; reports of what happened are unreliable, contradictory, and tend to the sensational. Something may have gone amiss with the process, requiring that his eyes had to be substituted with glass eyes taken from a statue of the Virgin. The process may have had to be repeated in Mexico City, and yet again in Veracruz. The coffin may have been too small for his tall frame and, therefore, his legs may have had to be broken. In the meantime, Aubert and his colleagues were hard at work, diligently making photographs of the bloody clothes (figs. 1, 44), of more than a single coffin, and of the embalmed corpse itself (figs. 72, 98, 104). One photograph draws the attention of curious viewers to the placement of the vital organs of the former emperor of Mexico in wooden compartments on either side of his legs. This was truly a cruel irony for his dismayed relatives: now a French photographer shooting Maximilian.

Maximilian's brother, Emperor Franz Joseph, cancelled plans to visit Paris when he learned of the execution, which left Napoleon no option other than to go with Eugénie to Austria, in August 1867, to express their sympathy to the emperor and the empress Elizabeth. Maximilian's mother, Archduchess Sophia, refused to be at the meeting. Needless to say, the mad Charlotte was not present either. Finally, in January 1868, the now well-publicized body of Maximilian was shipped from Veracruz to Europe, to be committed to a tomb in the Hapsburg crypt beneath the Augustiner Church in Vienna. Meanwhile, Juárez had returned to Mexico City to be reelected president, and to become a national hero before he died in office in July 1872. He, therefore, had the pleasure of learning how the diplomatic ineptitude of Napoleon finally undid the French emperor: Napoleon's opposition to a Prussian succession to the Spanish throne unwisely prompted his declaration of war against Prussia, which led to the rout of the French at Sedan in September 1870, and his being taken prisoner, the consequence of which was an insurrection in Paris and the overthrow of the Second Empire. Napoleon died in exile in England in 1873. Manet died a decade later, in March 1883, at only fifty-one, after the amputation of a leg from complications of syphilis. Charlotte lingered on in her

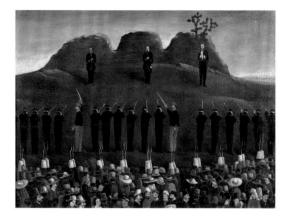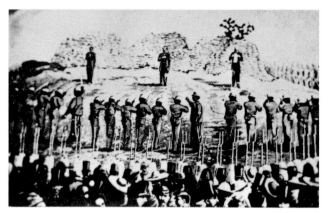

madness until the age of eighty-seven, dying in 1927, sixty years after her husband and, to the end, it is not entirely clear if she understood her husband's fate.

In 1900, the Mexican government agreed to a request from the Austrian government to build a small memorial chapel on the Cerro de las Campanas. Many years later, in 1967, an enormous statue of Juárez that utterly dwarfs it was erected on the very top of the hill. But the events of June 19, 1867, are not much mentioned in Querétaro today. Guides to the beautiful Convent of La Cruz, which was Maximilian's headquarters and then his prison, do not mention his name, while the civic museum on the Cerro de las Campanas largely passes over what happened there, alluding to how the city's support of Maximilian during the interventionary period required a period of rehabilitation. Clearly, the fact that Juárez was impelled to execute a European aristocrat there is not a reason for civic pride. The hillside is now a favorite spot for picnics and wedding parties.

In Mexico City, the execution of Maximilian is a less-sensitive subject, and the fascinating Museo Nacional de las Intervenciones offers an appropriately extensive display on the French intervention, which includes a rare painting of the execution squad by a Mexican artist of the nineteenth century (fig. 69). Details of the career of this artist, J. Gómez, and of the date and circumstances of the production of this work appear not to be known. Nonetheless, it is an intriguing work, which shows the squad in tattered clothes that do not appear in the known photographs of the squad, although they do in contemporaneous photographs of other soldiers.[1] It is also a commanding work, which shows the artist adopting a friezelike composition and finding a patterned clarity in the motif in a way that is not so distant from Manet. The only other known painting thought to be Mexican, but is not necessarily, that pretends to documentation is a work by an anonymous artist that was formerly in the famed Arensberg Collection, along with the Duchamps and Brancusis, and is now in the Philadelphia Museum of Art (fig. 70). It is, in fact, a copy of a photograph of 1867, which is itself a copy of a painted reconstruction of the execution by an unknown artist, which is in turn based on

70 UNKNOWN MEXICAN ARTIST
The Execution of
Maximilian. 19th century
Oil on canvas, 14 ⁷/₈ x 20 ¹/₄"
(37.8 x 51.5 cm)
Philadelphia Museum of Art
The Louise and Walter
Arensberg Collection, 1950

71 ANONYMOUS
The Execution of
Maximilian. c. June 19, 1867
Carte-de-visite photograph
(composite?), 2 ¹/₈ x 3 ⁹/₁₆"
(5.4 x 9 cm)
Courtesy of The Hispanic
Society of America, New York

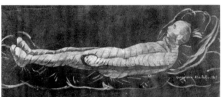

photographs by Aubert as well as on popular illustrations (see figs. 71, 100,101).[2]

Another, and this time very famous work that also draws on a contemporaneous photograph, is the mural by José Clemente Orozco in the Museo Nacional de Historia in Mexico City (fig. 73). This work incorporates an image of the embalmed Maximilian, taken from a photo-collage, beside a representation of the fallen Napoleon and a gigantically triumphant head of Juárez. However, this and similar images (for example, the Diego Rivera mural in the National Palace in Mexico City)[3] are, in the first place, much later creations; in the second, they are part of broad, commemorative narratives of Mexican history; and, in the third, they partake—albeit in modernized form—of the rhetorical methods of posture, gesture, and expression that Manet had rejected some sixty years before. These are stirring, even brilliant compositions, to be sure; nonetheless, their artists sidestepped the deadpan example of Manet's reinvention of history painting. But so did almost everyone else.

Manet persisted, but only to sidestep himself. He continued to deal with violent subjects after witnessing some of the horrors of the crushing of the Paris Commune in May 1871. (The Commune had defied the government, now in Versailles, for its acceptance of humiliating peace terms with Prussia.) Manet created the lithograph, *Civil War,* of 1871–73, by recycling his *Dead Toreador* (fig. 15) into an image of a dead soldier in front of a barricade with just a passing resemblance to the adobe wall at Querétaro. And he traced, in reverse,[4] the outlines of the figures in his lithograph of *The Execution of the Emperor Maximilian* (fig. 41), reversing them back to create the gouache, *The Barricade,* of 1871 (fig. 74), then re-reversing them to create an 1871–73 lithograph of the same title. In both of these latter compositions, set amid the rubble of a barricade in a Paris street, the Querétaro firing squad, now attired in greatcoats as befitting the change of climate, faces three victims: the one at the center defiantly raises his hat above the muskets' smoke; the one at the left slumps; and the one at the right is already dead on the ground.[5] In the gouache, a flurry of diagonal hatchings above a Paris

lamppost recalls the drift of smoke that hangs in the air before the wall in the Mannheim painting (fig. 43). But the freedom of the gouache more closely corresponds to the Boston painting (fig. 21); this makes one wonder whether it might replicate an early conception of that painting, which may now show only two standing victims because the third was originally depicted as already executed.

The gouache also resembles the Boston composition in conveying the emotional drama of the scene, which it, in fact, amplifies by the conventionally rhetorical gesture of the defiantly raised arm. This gesture—and a scene that uncannily resembles Manet's lithograph of Maximilian's execution—appears in an 1871, contrived, composite photograph by Eugène Appert of the imminent execution of a Communard in the courtyard of a prison (fig. 75). We do not know whether Appert knew of either the *Maximilian* or the *Barricade* lithographs or whether Manet knew of Appert's photograph. Interestingly, we do know that Manet witnessed a triple execution of Communards at a military camp near Versailles in 1871.[6] Yet Appert's photograph of the setup of the Versailles execution shows a very different scene of three squads positioned opposite the three victims in a wide, open field (fig. 76). We are reminded, yet again, that Manet was extremely selective in the sources that he used.

In any event, Manet had himself regressed from his own deadpan example in making these Communard images, which engage us with their reportorial spontaneity but at the expense of becoming illustrational. He would continue to make equally free paintings of political subjects.[7] However, his only later work devoted to a violent subject, at least to a violent subject with a firearm in it, that has the poker-faced strangeness of the Mannheim painting is *Pertuiset, The Lion Hunter* (fig. 77). Eugène Pertuiset, with a huge, presumably dead lion behind him, has pointed his gun at viewers of the painting since the Salon of 1881. Long thought to be a joke, it nonetheless does become sinister.[8]

74 **EDOUARD MANET**
The Barricade. 1871
Silverpoint, black ink, watercolor, and gouache on two joined sheets of paper, 18 3/16 x 12 13/16" (46.2 x 32.5 cm)
Szépművészeti Múzeum, Budapest

75 **EUGENE APPERT**
Assassination of Gustave Chaudey at Ste Pélagie, May 25, 1871
Photograph, 3 3/4 x 5 1/2" (9.6 x 14 cm)
Music Division, The New York Public Library for the Performing Arts. Astor, Lenox and Tilden Foundations

Reproduction interdite.

E. APPERT Phot. Expert. Déposé.

EXÉCUTION de ROSSEL BOURGEOIS et FERRÉ

Le 28 Novembre 1871 à Satory.

By the early 1880s, not only Manet but also other avant-garde painters in Paris had settled into freely painted, "impressionist" styles. But when the Boston and Mannheim paintings (as they would become known) were finally exhibited in Paris at the Salon d'Automne of 1905, painting styles had changed, and the star of Paul Cézanne was rising high among ambitious young artists. The special exhibition of thirty-one of Manet's works was twinned with one of sixty-eight by Ingres; when Manet was not still being attacked as a *pasticheur*,[9] the artists were linked as classics of the French tradition.[10] The surprise, then, is that the more painterly, Boston work appears to have been preferred; pathos once again won out over the lead soldiers.[11] But the scandal of the 1905 Salon d'Automne was the group of what seemed at the time to be extremely violently painted works by Henri Matisse, André Derain, and their colleagues, dubbed *Fauves,* or wild beasts, for that reason. Perhaps, it was only in contrast to these that what seemed at the time to be a poignant *esquisse* was to be favored.

What did the *Fauves,* and other artists, make of Manet, and the *Maximilian* paintings in particular? We know that Pablo Picasso borrowed explicitly from Manet's *The Old Musician* (fig. 33) to create his *Family of Saltimbanques* (National Gallery of Art, Washington, D.C.),[12] and that Matisse would become almost as well known for his use of blacks as Manet was.[13] More broadly, Manet taught that generation about sheer wall power. As Edmond Duranty had observed in 1870: "In any exhibition, at a distance of 200 paces, there is only one painting that stands apart from the others; it is always a painting by Manet."[14] Matisse's *Bathers with a Turtle* (St. Louis Art Museum) of 1908 similarly stands apart, and recalls the London painting in its silhouetted figures set against a blue-and-green banded landscape. (One has to wonder whether Matisse saw the London painting when it was in Degas's studio.) Still, if this is a borrowing, it is a well-assimilated one. Many years later, in 1951, Picasso decided to make a mythicized, partly nude version of the

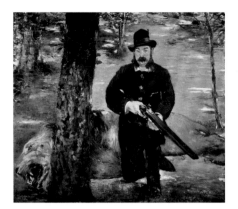
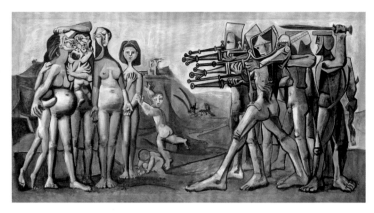

77 EDOUARD MANET
Pertuiset, The Lion
Hunter. 1880–81
Oil on canvas, 59 $^{1}/_{16}$ x 66 $^{15}/_{16}$"
(150 x 170 cm)
Museu de Arte, São Paulo

78 PABLO PICASSO
Massacre in Korea. 1951
Oil on plywood, 43 $^{3}/_{8}$" x
6' 10 $^{5}/_{8}$" (110 x 210 cm)
Musée Picasso, Paris

Maximilian composition as a protest against the Korean War (fig. 78). For an artist who had made the most celebrated antiwar painting of the twentieth century by imagining the victims of the Guernica bombings in the slaughter of a *corrida* by Goya, and had reprised its bleak monochrome in an even more generalized World War II *Charnel House* (The Museum of Modern Art, New York), this was not a particularly wise move. It sidestepped Manet's achievement as surely as the Mexican muralists did, but without the compensating celebration of national pride.[15]

 If the most inventive painter of modern art could not do anything with Manet's reinvention of history painting, who could? No early modernist painter could, is the answer; or better, perhaps, none really tried. The minority of such painters who did look out onto public events rather than into private imperatives, and the minority of these who addressed violent subjects—among them, Umberto Boccioni and Wyndham Lewis; George Grosz and Max Beckmann—seemed far more interested in making generalizing statements than depicting very specific, momentary events. There have been recent artists who have chosen to work in a dramatically illustrative manner in order to depict acts of violence, some of whom have looked back to Manet, and beyond him, to Goya for inspiration. (Leon Golub and Sue Coe are two such artists.) But none, to my knowledge, has sought to depict, as Manet did, the instantaneous moment of death, which means calling to our attention (to turn Fried's description into a condition), "the inevitably aporetic nature of the fiction of instantaneousness even as it appeals to that fiction for its basic structure."[16]

 There are recent works that fulfill something like that condition. For example, Roy Lichtenstein's *Whaam!* of 1963 (fig. 79) represents, and allows the viewer to keep on replaying, an incident in a battle of two fighter jets by showing on separate, but abutted panels, first the cause ("I pressed the fire control . . .") and the almost instantaneous effect ("Whaam!") of the destruction of one of them. But here, while it may be inferred that death is the succeeding effect of that "Whaam!" and its accompanying burst of flames, that inference is no sooner made than it is denied by the liveliness of the comic-book modality of the representation. In contrast, Vija Celmins's *Gun with Hand #1* of 1964 (fig. 80) appeals to the fiction of

instantaneousness by doing what Manet has been said to have done, "depicting a split second no bystander could possibly have registered . . . to mock the more extreme Realists' pretension to truth."[17] But Manet did not precisely, or entirely, make visible something impossible to see; to do so, as Celmins demonstrates, is to invoke an unreality that quells the illustrated violence, the quality of a mental rather than a physical event. It also, of course, invokes a photograph. Another recent work, Chris Burden's *Shoot*, of November 19, 1971 (fig. 81), is, in fact, a photograph that refers to a physical event, being a documentation of a perform-ance during which the artist arranged to be shot in the arm. However, it too exhibits the staging of an image of violence from which antagonism slips away (away from the protagonist, at least) as we acknowledge the consensuality of the performance and, with it, that while a performance is indeed an action, it is also (merely) an imitation of one.

Still, there are more recent works that overtly address, and in very different ways, the continuing problem of making history paintings. The most celebrated of these is Gerhard Richter's epic, fifteen-part composition of 1988, *October 18, 1977,* which depicts, in individual, monochrome canvases, members of the so-called Baader-Meinhof gang in life, during arrest, and in death, together with scenes of locations in their narrative.[18] That is to say, it divides their narrative into its component parts. It concentrates more on existents—principally, on the people; secondarily, on the places and things—than on events. When events are depicted (fig. 82), the canvas is treated with an even greater blurring than for existents (fig. 83), which makes it impossible to identify any existent within an event and, therefore, the event as well. The artist thereby pries apart the event from the exis-tents that occupy it, and demonstrates the impossibility of representing the event without the existent.

In its privileging of the representation of existents and in its nonrepresenta-tion of events, Richter's project differs from Manet's and resembles, rather, Manet's documentary sources. It relates to Manet's painting as well as to these sources in the witnessed quality of its description, its adoption of the discourse space of these sources, as I described this quality on pages 89–93. Thus it, too, offers a

sense of the accidentally real rather than the essentially real. True, it uses the device of blurring to withdraw the work from the world of the physically real, rather as Celmins does; only, the blur invites scrutiny, and the relentless succession of the fifteen ominous images renews the invitation to continuingly dismaying effect.

The two final paintings that I shall mention were both created in direct response to Manet's project and could hardly be more different. Of R. B. Kitaj's *The Killer Critic Assassinated by His Widower, Even,* of 1997 (fig. 84), it may be better to say that it belongs to an extremely personal project, for which Kitaj enrolls Manet to help him transpose it from his own life to the life of the painting.[19] Kitaj's composition was created in direct response to disgracefully virulent criticism, amounting to personal hatred, that had appeared during the artist's 1994, solo exhibition at the Tate Gallery. This criticism also deeply affected his wife, who suddenly, unexpectedly died of an aneurysm on the brain. Kitaj had been attacked, writes Marco Livingstone, "for a multitude of presumed sins: his literary proclivities and love of words, his cultural references and citations from the work of great artists, his tendency to self-dramatization, his blatant emotionalism, even his sexual explicitness . . . he throws all this and more back in the face of the 'killer-critic' pictured as a big-headed monster spouting bilious prose."[20]

Most of the references in Kitaj's painting are self-evident. I shall draw attention only to four that are most relevant to the present context:[21] the artist's self-representation as both a Manet soldier and Manet after the amputation of a leg; the punning phrase, "Manet and His Critics," in the lower right margin;[22] a witness from the Mannheim painting enclosed in the red rectangle above the cornice of the wall; and, just below the cornice, the statement, "Art is the escape to [replacing the deleted 'from'] personality," an altered misquotation from T. S. Eliot's "Tradition and Individual Talent." What Eliot wrote was something with which Manet would have agreed; therefore, Kitaj's raging, revengeful painting speaks against Manet, at once remove, even as it follows him. Not only does Kitaj's work borrow from the Mannheim painting, but it also composes a painting from a multitude of other artists' images. Eliot says: "Poetry is not a turning loose of emotion, but an escape from emotion; it is not the expression of personality, but an escape from personality.

80 VIJA CELMINS
Gun with Hand #1. 1964
Oil on canvas, 24 1/2 x 34 1/2"
(62.2 x 87.6 cm)
The Museum of Modern Art, New York. Gift of Edward R. Broida in honor of John Elderfield

81 CHRIS BURDEN
Shoot
At 7:45 p.m. I was shot in the left arm by a friend. The bullet was a copper jacket 22 long rifle. My friend was standing about fifteen feet from me.
F Space, Santa Ana, California, November 19, 1971, performance in which the artist is shot in the arm.
©Courtesy Chris Burden

82 GERHARD RICHTER
Arrest 2 (Festnahme 2). From October 18, 1977. 1988
Oil on canvas, 36 1/2 x 49 3/4"
(92 x 126.5 cm)

83 Man Shot Down 2 (Erschossener 2). From October 18, 1977. 1988
Oil on canvas, 39 1/2 x 55 1/4"
(100.5 x 140.5 cm)
The Museum of Modern Art, New York. The Sidney and Harriet Janis Collection, gift of Philip Johnson, and acquired through the Lillie P. Bliss Bequest (all by exchange); Enid A. Haupt Fund; Nina and Gordon Bunshaft Bequest Fund; and gift of Emily Rauh Pulitzer

But, of course, only those who have personality and emotions know what it means to want to escape from these things."[23]

These statements often seem to apply to Jasper Johns; however, without knowing that his *Catenary (Manet–Degas)* of 1999 (fig. 85) refers to Manet's London painting, it would be difficult to understand what it was of himself that he surrendered to Manet or Degas.[24] A catenary (the curve assumed by a flexible line hung freely from two fixed points) is at once a materialization of suspension and a linkage; here, it hangs before a puzzlingly dark canvas that only eventually reveals four dark, collaged canvas fragments that correspond to the jigsaw puzzle that Degas put together from the salvaged remains of Manet's painting. If Richter's work draws upon the modalities of the photographic image to make a past tense signifier of present actuality, Johns may be said to offer a present tense signifier of past actuality. He goes back to Manet's London painting through Degas's reconstruction of it, only to do to its image precisely what Manet did to it, Bataille said, namely, perform a repudiatory, destructive operation upon it. Here, truly, "The picture *obliterates* the text, *and the meaning of the picture is not in the text behind it but in the obliteration of that text.*"[25] An image of death—coldly, methodically dealt out by a firing squad—is, of course, unfavorable to so indifferent a treatment. It is a subject charged with meaning, giving rise to violent feelings. But Johns has not merely painted it as if insensible; he has painted it out.

Even without claiming that the rectangles collaged onto the canvas are like blinds drawn down after a death, we cannot but view this as a work of remembrance. Like the Richter, it is ex post facto. For images that build on Manet's work in offering a vivid sense of (the fiction of) instantaneity, we must turn to photography. The album at the conclusion of this text (pp. 154–59) offers but a few of the many records of violence in the medium that Manet's work not only drew upon but

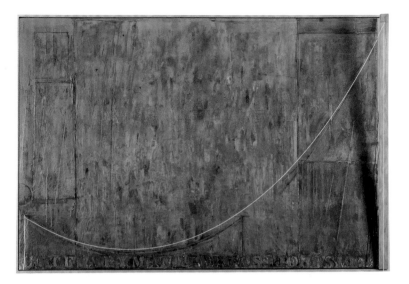

required for the continuation of its imperatives. I shall not comment on these individually, but only offer these general remarks by way of an ending.

An extraordinary story of an execution, "The Secret Miracle" by Jorge Luis Borges, tells of Jaromir Hladik, condemned to death by firing squad in 1943, to whom God grants the wish that in his mind a year will go by between the order to fire and the bullets striking. It is, itself, a fitting sequel to Manet's conflation of the instantaneous and the temporal, and in it, there is a reference to photography. It comes when Hladik is brought out for execution: "The squad formed and stood at attention. Hladik, standing against the barracks wall, waited for the volley. Someone pointed out that the wall was going to be stained with blood; the victim was ordered to step forward a few paces. Incongruously, this reminded Hladik of the fumbling preparations of photographers."[26]

In the 1860s, it would have been impossible to record an execution photographically; even in bright light, the length of the exposure (and, hence, of the time of holding a pose) would be too great.[27] But patiently holding a pose, which once had alluded to academic practice, now also alluded to photography; the frozenness of the poses in Manet's painting does.[28] He had himself been photographed, notably by Nadar (see fig. 5), so he would have known what it felt like. Perhaps he had been photographed, or seen others photographed, with the magnesium flash that was used in the 1860s, producing a loud noise, a bright flash of light, and some smoke. It was not used outdoors, but perhaps, facing it, it sounded and looked just a bit like muskets firing. In any event, it is possible that Manet, referring to photographic sources when he made the paintings that we

have been looking at, also thought of the fumbling preparations of photographers.

Because photography could not yet achieve effects of spontaneity, the photographic sources that Manet consulted recorded a squad that is not shooting, victims that are not dying, a landscape that is not filled by an execution; that is an unknown blank in their account. In the Mannheim painting (fig. 43), Manet filled that blank with the white smoke that overlays the two white shirts of the generals. Across Mejía, the smoke clusters in tight, seemingly stirred brushstrokes, compacted and shading to an ugly, dark gray to convey the thud of the bullets. Beyond Miramón, it drifts, dispersing in looser diagonal strokes, made by the artist's arm rather than his hand, and of a thinner white, at times transparent to the wall behind, from within whose pale gray Manet has coaxed a fading reflection of the flame of the muskets.[29] We may well be reminded not only of Borges's story of a moment miraculously extended in the mind, but also of another great writer, the poet Wallace Stevens, who would famously speak of the choice offered to the mind between the moment of an experience and the resonance of that experience:

> I do not know which to prefer,
> The beauty of inflections
> Or the beauty of innuendos,
> The blackbird whistling
> Or just after.[30]

In the juxtaposition of these two areas of smoke (across the figure of Maximilian), Manet contrasts the instantaneous and the extended moment—the bullets whistling, and just after—and, because these areas of smoke are, in fact, areas of paint brushed into compactness and into expansion, the artist also contrasts the directness of his own painterly attack and its reactive elaboration.[31] They may also, more broadly, be thought to allegorize the temporal distinction between the initial "strikingness" of Manet's painting (to use Fried's term),[32] namely, the intense, immediate impression it makes, so as to fully enter the beholder's mind immediately, and the resonance of that first impression, which continues even as the beholder continues to contemplate the image, indeed, even after he has ceased to contemplate it.[33] But it is more than the first impression that thus resonates. By aligning the strikingness of the painting and the strike of the execution, Manet allows the inference that his composition records a moment of perception, but he

then qualifies it, as the smoke and the paint drift up against the wall, and the first impression is expanded even as it is stored in the mind.

Ostensibly, a photograph of the late 1860s recorded a moment of perception although actually it recorded suspended moments that had coalesced over the time of the exposure. Painting and photography were, therefore, as one in that their effects of instantaneity could not be instantaneously achieved. But not until photography truly could record an instant of time—could capture a temporal and spatial site simultaneously—was it able to represent (the temporality of) events in addition to (the spatiality of) existents. It is, perhaps, because we are accustomed to see existents occupied and occupying events, both in worldly life and in visual and verbal fictions, that the figures in the early photographs seem not merely immobile but immobilized, uncannily bereft of the possibility of action.[34] (This primitive, pretemporal condition of photography is what Celmins and Richter emulate in their paintings.) Manet's Mannheim painting may be thought to allude to this condition of photography by picturing the inflections of a willful immobilization. The densely compacted smoke around Mejía reinforces such an interpretation. However, the rising smoke speaks of the future, writing innuendos on the wall.

Insofar as the smoke in this painting signifies the moments of the execution indexically, by showing its traces, it recalls photography, the new, indexical way of signifying events pictorially.[35] The figure of Mejía signifies the execution in the old way, shaping a suspended, theatrical moment in the action. From the muskets that point at him issues the smoke that signifies in the new way. But lest we conclude that this is an allegory of photography shooting painting, let us ask of the photographs that follow, one after the other, whether they show the beauty of inflections or the beauty of innuendos—or both, as Manet did.[36]

86 PETER CARROLL / ASSOCIATED PRESS
Placing Markers for
Execution Squad. May 28, 1945
Gelatin silver print, 6¹/₂ x 8¹/₄"
(16.5 x 20.9 cm)
The Museum of Modern Art,
New York. The New York Times
Collection

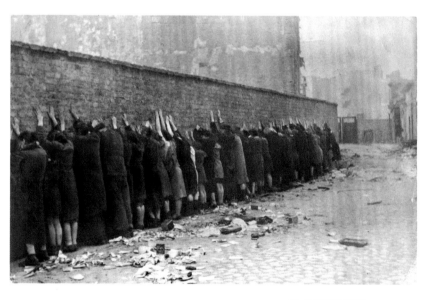

87 STROOP REPORT
Warsaw Ghetto. April–May
1943
Gelatin silver print, 7¹¹/₁₆ x 12"
(19.6 x 30.5 cm)
The Museum of Modern Art,
New York. The New York Times
Collection

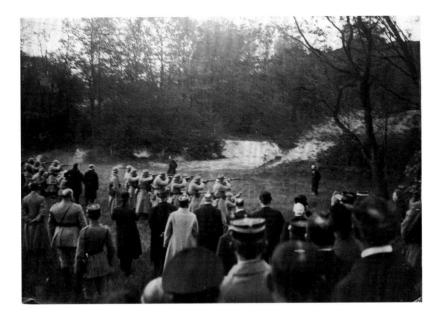

88 UNDERWOOD AND UNDERWOOD
Firing Squad, Vicennes,
France. May 16, 1920
Gelatin silver print, 4 $^{9}/_{16}$ x 6 $^{1}/_{2}$"
(11.6 x 16.6 cm)
The Museum of Modern Art,
New York. The New York Times
Collection

89 EDDIE ADAMS / ASSOCIATED PRESS
Moment of Execution. February 1,
1968
Gelatin silver print, 6 $^{5}/_{8}$ x 8 $^{5}/_{8}$"
(16.8 x 21.9 cm)
The Museum of Modern Art, New York
The New York Times Collection

90 WALTER H. HORNE

Execution of Francisco Rojas. 1916

Gelatin silver print, 3 1/2 x 5 1/2" (8.9 x 14 cm)

New Mexico State University Library,

Las Cruces, New Mexico. Archives

and Special Collections

91 BOB JACKSON

The Moment of Impact

November 24, 1963

Gelatin silver print, 7 1/16 x 9 1/2"

(17.9 x 24.2 cm)

The Museum of Modern Art, New York

The New York Times Collection

a.

b.

c.

93 ABRAHAM ZAPRUDER / LIFE MAGAZINE, TIME INC.

Stills from the *JFK Assassination Film*. November 22, 1963
Gelatin silver print, 13 $^1/_2$ x 7 $^{15}/_{16}$"
(34.3 x 20.1 cm)
The Museum of Modern Art, New York
The New York Times Collection

92 RON EDMONDS / ASSOCIATED PRESS

a. U.S. President Ronald Reagan winces and raises his left arm as he was shot by an assailant while leaving a Washington hotel, Monday, March 30, 1981, after making a speech to a labor group. The president was shot in the upper left side.

b. The president looks up before being shoved into his limousine by secret service agents.

c. A secret service agent places a hand on the president's shoulder and pushes him into his limousine.

94 ROBERT CAPA
Spanish Soldier Drops Dead
with a Bullet through His Head,
July 12, 1937. 1937
Gelatin silver print, 7 1/8 x 9 3/8"
(18.1 x 23.8 cm)
The Museum of Modern Art, New York
Gift of Edward Steichen

95 BORIS YARO
The Shooting of Robert F.
Kennedy. 1968
Gelatin silver print, 11 1/4 x 9"
(28.5 x 22.9 cm)
The Museum of Modern Art, New York
Samuel J. Wagstaff, Jr. Fund

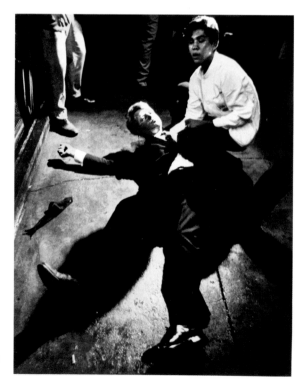

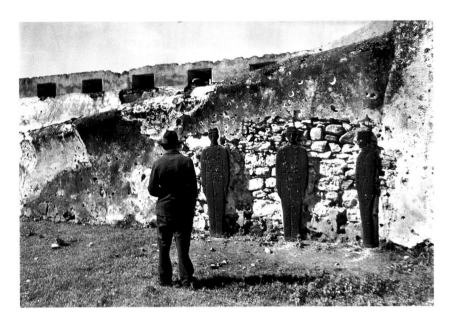

96 HENRI CARTIER-BRESSON
Puebla, Mexico. 1934
Gelatin silver print, printed in 1986,
9 ¹/₂ x 14 ³/₁₆" (24.1 x 36 cm)
The Museum of Modern Art, New York
Gift of the photographer

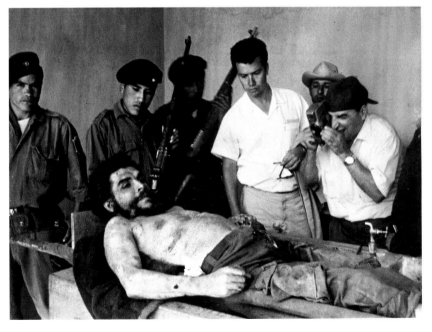

97 BILL PARSONS / NANCY PALMER AGENCY
Revolutionary's End. 1967
Gelatin silver print, 6 ¹⁵/₁₆ x 9 ⁷/₁₆"
(17.6 x 24 cm)
The Museum of Modern Art, New York
The New York Times Collection

NOTES
to the
TEXT

"INTRODUCTION: REMEMBERING QUERÉTARO"
pp. 15–23

1 This embarrassment, which, to make matters worse, took place on the Champ de Mars, where the French military academy is also located, was, in fact, the second crisis of this excessively magnificent exhibition. The first was the attempted assassination of a visiting dignitary, Tsar Alexander of Russia, by a Polish extremist on June 6. See Alan Krell, *Manet and the Painters of Contemporary Life* (London: Thames and Hudson, 1996), p. 83.

2 Juliet Wilson-Bareau et al., *Manet: The Execution of Maximilian; Painting, Politics and Censorship*, exh. cat. (London: National Gallery Publications in association with Princeton University Press, 1992). (Of the four paintings, therefore, only the first, Boston composition has ever been seen outside Europe since 1879–80.)

3 On Emilie Ambre, see Therese Dolan, "*En garde:* Manet's Portrait of Emilie Ambre in the Role of Bizet's *Carmen*," *Nineteenth-Century Art Worldwide: A Journal of Nineteenth-Century Visual Culture* 5, no. 1 (Spring 2006). In order to bolster a fading career, Ambre had decided to go to America in the role of *Carmen* and asked Manet, whom she had recently met, to paint her in that role. It was apparently her idea to take with her *The Execution of Maximilian*, which had been in Manet's studio since its proscription in 1869. See Beth Archer Brombert, *Edouard Manet: Rebel in a Frock Coat* (Boston: Little, Brown, 1996), pp. 378–79.

4 Prince's Club, Knightsbridge, London, *Exhibition of International Art*, 1898, no. 16 (lent by Durand-Ruel).

5 Jean C. Harris, *Edouard Manet: Graphic Works; A Definitive Catalogue Raisonné* (New York: Collectors Editions, 1970), pp. 151–52, no. 54. See also Michael Fried, *Manet's Modernism or, The Face of Painting in the 1860s* (Chicago and London: The University of Chicago Press, 1996), pp. 348–50; Nils Gösta Sandblad, *Manet: Three Studies in Artistic Conception* (Lund: C.W.K. Gleerup, 1954), pp. 153–55; Juliet Wilson-Bareau, note and provenance to cat. no. 105, *The Execution of Maximilian*, in Françoise Cachin and Charles S. Moffett, *Manet 1832–1883*, exh. cat. (New York: The Metropolitan Museum of Art, 1983), pp. 277–80; and Juliet Wilson-Bareau, "Manet and The Execution of Maximilian," in Wilson-Bareau et al., *Manet: The Execution of Maximilian; Painting, Politics and Censorship*, p. 69. For letters by Manet concerning the printing of the lithograph and its censoring by the French authorities, see Juliet Wilson-Bareau, ed., *Manet by Himself: Correspondence & Conversation; Paintings, Pastels, Prints & Drawings* (Edison, N.J.: Chartwell Books, 1991), pp. 50–51. For more on the artistic importance of the lithograph within Manet's series on the execution, see Sandblad, *Manet: Three Studies in Artistic Conception*, pp. 139–43.

6 See Postscript, p. 145.

7 For provenance and for exhibition history of the works up to 1992–93, see Wilson-Bareau et al., *Manet: The Execution of Maximilian; Painting,*

Politics and Censorship, pp. 112–13. Exhibition histories since 1993 are as follows. Boston painting: *Manet/Velázquez: The French Taste for Spanish Painting*, Musée d'Orsay, Paris, and The Metropolitan Museum of Art, New York, Sept. 16, 2002–June 29, 2003; *Manet en el Prado*, Museo Nacional del Prado, Madrid, Oct. 13, 2003–Jan. 11, 2004; London painting [the fragments of the painting were reassembled on one canvas in January 1992]: *Degas as Collector*, The National Gallery, London, May 22–Aug. 26, 1996; Copenhagen painting: *Manet, Gauguin, Rodin: Masterpieces of Ny Carlsberg Glyptotek*, Musée d'Orsay, Paris, Oct. 2, 1995–Jan. 21, 1996; *De Glade Givere: Museernes Bedstebilleder*, Louisiana Museum of Modern Art, Humlebaek, Dec. 10, 1999–Mar. 26, 2000; *Manet en el Prado*, Museo Nacional del Prado, Madrid, Oct. 13, 2003–Jan. 11, 2004; Mannheim painting: *Picasso, Tradition and Avant-Garde*, Museo Nacional del Prado, Madrid, June 6–Sept. 3, 2006.

8 See Bibliographical Note, pp. 179–80.

9 Some aspects of the reception of the Maximilian paintings are discussed in the Postscript on pages 145–50.

10 Paul Ricoeur, "Narrative Time," in W.J.T. Mitchell, ed., *On Narrative* (Chicago and London: The University of Chicago Press, 1981), p. 185.

11 Albert Boime, "New Light on Manet's *Execution of Maximilian*," *Art Quarterly* 36, no. 3 (1973): 174. In 1985 another writer, Gwyn A. Williams, wrote similarly of Francisco Goya's *The Third of May, 1808*, Manet's principal source for his first Maximilian painting: "It

could be anywhere; it could be My Lai" (*Goya and the Impossible Revolution* [New York: Pantheon Books, 1976], p. 1), discussed in Stephen Bann, "The Odd Man Out: Historical Narrative and the Cinematic Image," *History and Theory* 26, no. 4 (December 1987): 48. Williams continues to remark that Goya's painting represents the first "people's war" of modern history, which associates it with Manet's representation of the results of popular opposition to an imposed regime change, and with recent, similar events.

12 Francis Fukuyama, "After Neoconservatism," *New York Times Magazine*, sec. 6, February 19, 2006, p. 62.

———

"I. ART OF INTERVENTION"
pp. 25–59

1 Manet is reported to have said this while a student in Couture's studio. Antonin Proust, *Edouard Manet: Souvenirs* (Paris: A. Barthélemy, 1913), pp. 29–30; English translation in Juliet Wilson-Bareau, ed., *Manet by Himself: Correspondence & Conversations; Paintings, Pastels, Prints & Drawings* (Edison, N.J.: Chartwell Books, 1991), p. 26.

2 Paul Ricoeur, "Narrative Time," in W.J.T. Mitchell, ed., *On Narrative* (Chicago and London: The University of Chicago Press, 1981), p. 165.

3 See Gérard Genette, "Vraisemblance et motivation," *Communications* (1968): 5–21.

4 The sources from which my account of the political and military events is derived are given in the Bibliographical Note on p. 179. In the present notes, I provide references only for quotations and very particular facts.

5 Proust, *Edouard Manet: Souvenirs*, p. 30; English translation in Wilson-Bareau, ed., *Manet by Himself*, p. 26.

6 Ricoeur, "Narrative Time," p. 166.

7 Here, I draw upon Bridget Riley's brilliant account of Titian's *Bacchus and Ariadne*, in "The Colour Connection, in conversation with Robert Kudielka" (1989), in Robert Kudielka, ed., *The Eye's Mind: Bridget Riley. Collected Writings 1965–1999* (London: Thames & Hudson in association with the Serpentine Gallery and De Montfort University, 1999), p. 145.

8 Interestingly, Manet would have heard of such an arrangement from his mother, Eugénie-Désirée Fournier, whose father, Joseph, was living in Sweden when a successor to its throne was being sought because the heir presumptive had died unexpectedly in 1810. Since no suitable Swedish candidate could be found, Napoleon I had been consulted and unofficially recommended one of his generals, Jean-Baptiste-Jules Bernadotte, who duly became crown prince that year, and then, in 1818, King Charles XIV of Sweden. When Eugénie was born in 1811, her father had asked the new crown prince to be her godfather. Proust, *Edouard Manet: Souvenirs*, pp. 1–2. Discussed in Beth Archer Brombert, *Edouard Manet: Rebel in a Frock Coat* (Boston: Little, Brown, 1996), pp. 3–4.

9 There is confusion in the secondary literature on the subject of when, in December 1848, Manet left France. His departure date has been given as December 8 or 9 (in Brombert, *Edouard Manet: Rebel in a Frock Coat*, p. 17; and "Chronology," in Françoise Cachin and Charles S. Moffett, *Manet 1832–1883*, exh. cat. [New York: The Metropolitan Museum of Art, 1983], p. 504, respectively). There is a letter from Manet to his father dated December 15 in both *Edouard Manet: Lettres de jeunesse, 1848–1849, Voyage à Rio* (Paris: Louis Rouart et Fils, Éditeurs, 1928), n. p.; and Juliet Wilson-Bareau, ed., *Manet by Himself*, p. 18, in which he says he is "quite definitely leaving at nine o'clock tomorrow." However, it seems as though this letter has been erroneously dated a week too late by the editors of both texts, as Napoleon III was elected on December 10, and there is a later letter from Manet to his father from the boat to Rio (dated January 10 in Wilson-Bareau's text), in which he writes, "We've not had the luck to meet a French mailboat which could end our anxiety about what's happening and what has happened in Paris, we can only guess what consequences the election of one president or another might have" (p. 22). The first published letter in which Manet mentions Napoleon's election is dated February 26, 1849, by Wilson-Bareau (see n. 10), implying that he did not know of the election until at least early 1849. Therefore, Manet left on December 9, the day before Louis-Napoleon was elected president. I am indebted to Jennifer Field for resolving the confusion on this issue.

10 Manet, *Lettres de jeunesse 1848–1849*, n.p.; English translation of letter dated February 26, 1849, in Wilson-Bareau, ed., *Manet by Himself*, p. 24.

11 See Manet, *Lettres de jeunesse 1848–1849*, p. 62; English translation of letter dated March 11, 1849, in Wilson-Bareau, ed., *Manet by Himself*, p. 24.

12 Manet, *Lettres de jeunesse 1848–1849*, n.p.; English translation in Wilson-Bareau, ed., *Manet by Himself*, p. 25.

13 Manet had taken and failed the entrance examination to the Ecole navale in 1848. Boys could reapply after six months at sea, during which time they were coached; hence Manet's trip to Rio de Janeiro, after which he again failed the examination. Adolphe Tabarant, *Manet: Histoire catalographique* (Paris: Editions Montaignes, 1931), p. 10; and Adolphe Tabarant, *Manet et ses oeuvres* (Paris: Gallimard, 1947), p. 10. See also Vivien Perutz, *Edouard Manet* (Lewisburg: Bucknell University Press, and London and Toronto: Associated University Presses, 1993), p. 19, and Brombert, *Edouard Manet: Rebel in a Frock Coat*, p. 15.

14 Edmond Bazire, *Manet* (Paris: A. Quantin, 1884), p. 8ff.; English translation in Brombert, *Edouard Manet: Rebel in a Frock Coat*, p. 63.

15 Memorandum of Aimé du Bosc, Marquis de Radepont, to Count Walewski, communicated to the emperor, October 1856, Radepont Papers, cited by Nancy Nichols Barker in "Monarchy in Mexico: Harebrained Scheme or Well-Considered Prospect?", *Journal of Modern History* 48, no. 1 (March 1976):

52, n. 3, Harvard College Library, Houghton Library, Cambridge, Mass.

16 Thomas Hobbes, *Leviathan*, ed. Richard Tuck (Cambridge: Cambridge University Press, 1991), p. 89.

17 Jasper Ridley, *Maximilian and Juárez* (London: Constable, 1993), pp. 265 and 41.

18 Moffett, cat. no. 10, *The Spanish Singer* or *Guitarrero*, in Cachin and Moffett, *Manet 1832–1883*, pp. 63–67; Michael Fried, *Manet's Modernism or, The Face of Painting in the 1860s* (Chicago and London: The University of Chicago Press, 1996), p. 7, and p. 473, n. 65; and Carol Armstrong, *Manet Manette* (New Haven and London: Yale University Press, 2002), p. 96, and p. 343, n. 64.

19 Theodore Reff, *Manet's* Incident in a Bullfight (New York: The Frick Collection, 2005), pp. 21–23.

20 Mathieu de Fossey, *Le Mexique* (Paris: Henri Plon, Éditeur, 1857). The importance of this publication, and its dedication to Eugénie, are discussed in Barker, "Monarchy in Mexico: Harebrained Scheme or Well-Considered Prospect?", p. 56.

21 Nancy Nichols Barker, *Distaff Diplomacy: The Empress Eugénie and the Foreign Policy of the Second Empire* (Austin and London: University of Texas Press, 1967), p. 131.

22 Francis Fukuyama, "After Neoconservatism," *New York Times Magazine*, sec. 6, February 19, 2006, p. 66.

23 Meredith J. Strang, "Napoleon III: The Fatal Foreign Policy," in Edouard Manet and the *Execution of Maximilian*, exh. cat. (Providence: Department of Art, Brown University, 1981), p. 90. Also in Douglas Johnson, "The French Intervention in Mexico: A Historical Background," in Juliet Wilson-Bareau et al., *Manet: The Execution of Maximilian; Painting, Politics and Censorship*, exh. cat. (London: National Gallery Publications in association with Princeton University Press, 1992), p. 21.

24 Ridley, *Maximilian and Juárez*, p. 94.

25 Moffett, cat. no. 26, *Gypsy with Cigarette* or *Indian Woman Smoking*, and provenance in Cachin and Moffett, *Manet 1832–1883*, p. 94.

26 On Manet's "Spanishicity," see Juliet Wilson-Bareau, "Manet and Spain," in Gary Tinterow and Geneviève Lacambre et al., *Manet/Velázquez: The French Taste for Spanish Painting*, exh. cat. (New York: The Metropolitan Museum of Art, 2003), pp. 203–51, and Armstrong, *Manet Manette,* pp. 77–88, 93–98. See below, pp. 79–80 for discussion of the latter print and the related painting (fig. 32).

27 Reff says this of Manet's *Incident in a Bullfight*, citing Janis A. Tomlinson, "Goya's *Tauromaquia*: The Bullfight as Political Allegory," unpublished paper delivered at the 71st annual meeting of the College Art Association, Philadelphia, February 17–19, 1983. (See Reff, *Manet's* Incident in a Bullfight, p. 24.) My suggestion that *Mlle V.* may allude to Mexico derives from Reff's argument that *Incident in a Bullfight* does.

28 Anne Coffin Hanson, "Manet's 'Compositional Difficulties'" in Hanson, *Manet and the Modern Tradition* (New Haven and London: Yale University Press, 1977), pp. 197–205.

29 Paul de St. Victor, "Beaux-arts: Société des Aquafortistes; Eaux-fortes modernes, publication d'oeuvres originales et inédites (I)," *La Presse*, 28ᵉ année, April 27, 1863. English translation in Armstrong, *Manet Manette,* p. 97, n. 69.

30 Reff, *Manet's* Incident in a Bullfight, p. 11.

31 Charles Asselineau, "Salon de 1864," *Revue Nationale et Etrangère Politique, Scientifique et Littéraire* (Paris, 1864), p. 287. English translation in Reff, *Manet's* Incident in a Bullfight, p. 13. My account of this painting is indebted to Reff's brilliant, recent account. See also Susan Grace Galassi, *Manet's* The Dead Toreador *and* The Bullfight: *Fragments of a Lost Salon Painting Reunited* (New York: The Frick Collection, 1999).

32 Proust, *Edouard Manet: Souvenirs*, p. 47.

33 Reff points out that *Mlle V.* was painted over another work. (*Manet's* Incident in a Bullfight, p. 11.) Manet's practice of continual reworking will figure large in chapters two and three of this publication.

34 Ibid.

35 Ibid.,11–12. Reff is referring to Mallarmé's report in *Art Monthly Review* (London), September 30, 1876, which continues: "One of his habitual aphorisms then is that no one should paint a landscape and a figure with the same knowledge, or in the same fashion; nor what is more, even two landscapes or two figures. Each work should be a new creation of the mind. The hand, it is true, will conserve some of its acquired secrets of manipulation, but the eye should forget all else it has seen and learn anew from the lesson before it. It should abstract itself from memory, seeing only that which it looks upon, and that as for the first time; and the hand should become an impersonal abstraction guided only by the will, oblivious of all previous cunning." English translation in Perutz, *Edouard Manet,* p. 79. "Les Impressionnistes et Edouard Manet," *Gazette des Beaux-Arts*, November 1975, reprinted by Philippe Verdier, pp. 148–56.

36 Reff, *Manet's* Incident in a Bullfight, p. 12.

37 Ibid., p. 25.

38 Wilson-Bareau has proposed that this image also relates to that of a fallen general in an Epinal print of June 1863 that represents the recapture of Puebla (Wilson-Bareau, "Manet and The Execution of Maximilian," in Wilson-Bareau et al., *Manet: The Execution of Maximilian; Painting, Politics and Censorship*, pp. 43–44). If that image is judged a plausible and necessary source for Manet's dead toreador in *Incident in a Bullfight,* it would place the commencement of that painting after that date and not in 1862 as Reff argues. Since it is difficult to see why Manet would wish to recycle an image celebrating a French imperialist victory, Reff's account seems preferable.

39 Tabarant, *Manet et ses oeuvres*, pp. 75 and 80; and Reff, *Manet's* Incident in a Bullfight, p. 25.

40 According to Moffett in the catalogue note for *The Dead Man (The Dead Toreador)*, no. 73, the measurements of the original composition were 49 ⁵/₈ x 66 ¹/₈" (126 x 168 cm). (Cachin

and Moffett, *Manet 1832–1883*, p. 98.) The measurements of *The Dead Toreador* are given by both Moffett and Galassi as 29 $^7/_8$ x 60 $^3/_8$" (75.9 x 153.3 cm) and the measurements of *The Bullfight*, according to Galassi, are 18 $^7/_8$ x 42 $^7/_8$" (47.9 x 108.9 cm).

41 Théophile Thoré, "Salon de 1864," in *Salons de W. Bürger 1861 à 1868* (Paris: Librairie de Ve Jules Renouard, 1870), p. 98; mentioned in Reff, *Manet's Incident in a Bullfight*, pp. 26–27, and Wilson-Bareau, "Manet and The Execution of Maximilian," pp. 41–43.

42 That is to say, no documentation is known that would verify this suggestion. On the contingency and multiplicity of interpretations of Manet's paintings, see David Carrier, "Manet and His Interpreters," *Art History* 8, no. 3 (September 1985): 320–35.

43 Christopher Ricks, *Dylan's Vision of Sin* (New York: HarperCollins, 2004), pp. 7–8. This is not a casual comparison: Bob Dylan's poetic art of assembling fragments, disconnected from an immense pool of verses, into new, strange combinations, expressive of displacement, is derived from modernist procedures that go back to Manet as well as from the (sometimes, obliquely modernist-influenced) folk-lyric form that first came together in the United States in precisely the period that Manet was working. (See Greil Marcus, *The Old Weird America* [New York: Picador, 1997], pp. 115–18.)

44 A special case is such a painting as Manet's *Port of Bordeaux*, which requires knowledge of its context to understand that it is more than simply a port scene. See Juliet Wilson-Bareau and David Degener, *Manet and the Sea* (Philadelphia: Philadelphia Museum of Art, 2003), pp. 75–76.

45 For possible intimations of *Mlle V.*, see Moffett, cat. no. 33, *Mlle V... in the Costume of an Espada*, in Cachin and Moffett, *Manet 1832–1883*, pp. 110–14; Reff, *Manet's* Incident in a Bullfight, pp. 21–23; and Armstrong, *Manet Manette,* pp. 146–50.

46 Reff, *Manet's* Incident in a Bullfight, pp. 16–18.

47 Michael Podro, *Depiction* (New Haven and London: Yale University Press, 1998), p. vii.

48 This, too, simplifies the issue, for to list these analogous oppositions is to imply, if not analogous dislocation between them, then a continuum of dislocation. Experience of *Mlle V.,* certainly, may unfold in this oscillating manner, yet it returns to the stark, frozen singleness of the image.

49 Hayden White, "The Value of Narrativity in the Representation of Reality," in W.J.T. Mitchell, ed., *On Narrative* (Chicago and London: The University of Chicago Press, 1981), p. 20.

50 See Riley, "The Colour Connection, in conversation with Robert Kudielka," p. 145.

51 White, "The Value of Narrativity in the Representation of Reality," p. 20.

52 Riley, "The Colour Connection, in conversation with Robert Kudielka," p. 145.

53 White, "The Value of Narrativity in the Representation of Reality," p. 12. Also quoted and informatively discussed in Wendy Steiner, *Pictures of Romance: Form Against Context in Painting and Literature* (Chicago and London: The University of Chicago Press, 1988), p. 33.

54 "Lettres d'un bourgeois de Paris," *La Gazette de France*, July 21, 1863. Cited by Michael Fried in a discussion of Manet's violence, to which my account is deeply indebted. (English translation in *Manet's Modernism,* p. 294.)

55 Fried, *Manet's Modernism,* p. 357.

56 Ibid., pp. 404–07.

57 Manet is referring to his 1880 portrait of Proust (fig. 17). The reference to Minerva as a heroic image is puzzling, for she was a goddess associated with household arts and, by extension, with craftsmen, actors, and intellectuals, and, therefore, also the goddess of inspiration. Perhaps Manet (or Proust) had meant to say Mars, the traditional opposite partner to Venus. Brombert, *Edouard Manet: Rebel in a Frock Coat*, p. 247. Original in Proust, *Edouard Manet: Souvenirs*, p. 123.

58 Brombert, *Edouard Manet: Rebel in a Frock Coat*, p. 418.

59 Ann Perkins, "Narrative in Babylonian Art," in Carl H. Kraeling, ed., *Narrative in Ancient Art: A Symposium* (Chicago:

Oriental Institute, 1955), p. 55, quoted in Steiner, *Pictures of Romance,* p. 22.

60 This is the lithograph titled *The Balloon*, no. 23 in Jean C.Harris, *Edouard Manet: Graphic Works; A Definitive Catalogue Raisonné* (New York: Collectors Editions, 1970), pp. 81–82. The political implications are discussed in Perutz, *Edouard Manet*, p. 46.

61 Ridley, *Maximilian and Juárez*, p. 138.

62 Barker, "Monarchy in Mexico: Harebrained Scheme or Well-Considered Prospect?," p. 67, n. 63: "Letter from Stefan Herzfeld to De Pont, London, December 12, 1863, carton 6, no. 80s. Wyke gave a frank account of his conversation with the emperor to Herzfeld, confidant of the archduke."

63 Tabarant, *Manet: Histoire catalographique*, pp. 118–19.

64 Nancy Locke, *Manet and the Family Romance* (Princeton and Oxford: Princeton University Press, 2001), p. 136.

65 This is Locke's suggestion of Léon Leenhoff's paternity (ibid., pp. 116–18). He could, however, have been Manet's or his brother's son. A more prosaic reason for Manet's decision to paint a religious subject could be that thirty-eight percent of the fine-arts budget was spent for religious works, and while most of these were copies, the possibility of being able to sell the painting cannot be discounted as a motivation. (See Patricia Mainardi, *The Art and Politics of the Second Empire* [New Haven and London: Yale University Press, 1987], p. 38); also cited in Brombert, *Edouard Manet: Rebel in a Frock Coat*, p. 123.

66 Wilson-Bareau, note to cat. no. 142, "Edouard Manet: *The Dead Christ and Angels*," in Tinterow and Lacambre et al., *Manet/Velázquez*, p. 493.

67 Thoré, "Salon de 1864," p. 99. There have been many, unsatisfactory explanations of the meaning of the snake. See Hanson, *Manet and the Modern Tradition*, p. 108.

68 Jacques-Emile Blanche, *Propos de Peintre: de David à Degas* (Paris: Emile-Paul Frères, Editeurs, 1919), p. 143. Mentioned in Locke, *Manet and the Family Romance*, pp. 99–100:

"A fellow painter who knew Manet in his later years remembered that 'Manet adored puns, which are now so out of fashion.'"

69 It is tempting to speculate whether Manet could and would have read descriptions or seen illustrations of the famous blue feather headdress of Montezuma, which Cortés may have received as a gift from the Aztec ruler as early as 1519 and which he, in turn, probably passed on to the king of Spain, Don Carlos of Austria. It appears to have changed hands several times, passing through various European royal collections, before entering the Museum of Ethnology in Vienna in 1880.

70 For the art-historical sources of this painting, see Jane Mayo Roos, "Edouard Manet's *Angels at the Tomb of Christ*: A Matter of Interpretation," *Arts Magazine* 58, no. 8 (April 1984): 83–91; Moffett, cat. no. 74, *The Dead Christ and the Angels*, in Cachin and Moffett, *Manet 1832–1883*: pp. 199–203; *Manet en el Prado*: pp. 230–35, 456–57; and Fried, *Manet's Modernism*, p. 91, and p. 493, n. 153.

71 Gustave Courbet, in a letter in the journal *Courrier du Dimanche*, published December 25, 1861. Reprinted in Charles Léger, *Courbet* (Paris: Les Editions G. Crès, 1929), p. 87. English translation in Linda Nochlin, *Realism and Tradition in Art 1848–1900: Sources and Documents* (Englewood Cliffs, N.J.: Prentice-Hall, 1966), p. 35.

72 In a conversation with Ambroise Vollard in 1865, printed in Ambroise Vollard, *Auguste Renoir (1842–1919)* (Paris: Les Editions G. Crès, 1920), p. 44.

73 If they are not real, how can one judge whether or not their representation is plausible? But we do know that some of Manet's representations of things real and existing were judged to be implausible, so the answer should probably be that he treated the real and the unreal in a similar manner.

74 For example, one critic wrote: "Do not miss M. Manet's Christ or *The Poor Miner pulled out of a peat bog*; painted for M. Renan." *La Vie Parisienne*, May 1, 1864. English translation in

Brombert, *Edouard Manet: Rebel in a Frock Coat*, p. 151.

75 Ernest Renan, *La Vie de Jésus*, trans. Charles Edwin Wilbour (New York: Carleton, 1864), p. 357. The relevance of this celebrated book has been discussed by Roos in "Edouard Manet's *Angels at the Tomb of Christ*: A Matter of Interpretation," pp. 83–91; Hanson, *Manet and the Modern Tradition*, pp. 104–07; and Jennifer M. Sheppard, "The Inscription in Manet's *The Dead Christ, with Angels*," *Metropolitan Museum Journal*, no. 16 (1982): 199–200.

76 On the subject of contemporaneous discussions about dreams and hallucinations, see Locke, *Manet and the Family Romance*, pp. 25–26.

77 Famously, one reader, Charles Baudelaire, observed that Manet had placed the wound of Christ incorrectly on the left side, and counseled him to change it. In fact, while from early times artists have tended to favor the right side, the Gospels are not explicit as to where the lance pierced Christ, and there were artistic precedents for the wound's placement on the left. Whether Manet knew of a traditional reason for the left placement, that Christ's blood flowed from his sacred heart; whether he opposed the common right placement for the reason of creating a discrepancy between text and painting; or whether he did not think about this matter, are continuing subjects of debate. See Alfred Cobban, *A History of Modern France*, 3 vols. (Harmondsworth: Penguin Books, 1965); Vladimir Gurevitch, "Observations on the Iconography of the Wound in Christ's Side, with Special Reference to Its Position," *Journal of the Warburg and Courtauld Institutes* 20 (July 1957). In the case of the illogical announcement on the rock that Christ is not present, Manet had to know that it drew attention to the discrepancy between the text and the painting. Did he want to draw attention to a contrast between a textual statement of absence with a pictorial statement of presence, however improbable?

78 See Seymour Chatman, *Story and Discourse: Narrative Structure in*

Fiction and Film (Ithaca and London: Cornell University Press, 1978), pp. 26–31, for a basic account of this polarity and its variants.

79 Does, perhaps, Christ in Manet's depiction anticipate this incident by opening His hands and extending His feet to show their wounds?

80 René Démoris, "Chardin and the Far Side of Illusion," in *Chardin* (London: Royal Academy of Arts, and New York: The Metropolitan Museum of Art, 2000), p. 99.

81 Fried, *Manet's Modernism*, pp. 311, 313, 318.

82 M.G. Flaherty, *A Watched Pot: How We Experience Time* (New York: New York University Press, 1999); see the summary in Christof Koch, *The Quest for Consciousness: A Neurobiological Approach* (Englewood, Colo.: Roberts, 2004), p. 267.

83 Fried noted that a letter from Manet's friend Baudelaire in 1864 refers to "Christ Resuscitating Attended by Angels" (*Manet's Modernism*, p. 95). Charles Baudelaire, *Correspondance*, vol. II (Paris: Gallimard, 1966), letter to Philippe de Chennevières, March 1864, pp. 350–51.

84 When this work was painted, the U.S. Civil War was in its third year, and both France and England were covertly helping the Confederates by allowing their ships to be refitted in their ports, which the U.S. government reasonably viewed as serious breaches of neutrality. Manet's painting depicts the Confederate privateer, the *Alabama*, being sunk by the Union corvette, the *Kearsarge*, after having come out of haven at Cherbourg. This painting is discussed in detail in Juliet Wilson-Bareau with David D. Degener, *Manet and the American Civil War: The Battle of U.S.S. Kearsarge and C.S.S. Alabama* (New York: The Metropolitan Museum of Art, 2003), pp. 41–49. The historical details of the battle are covered on pp. 19–39.

85 *Testimonios Artisticos de un Episodio Fugaz*, exh. cat. (Mexico City: Museo Nacional de Arte, Instituto Nacional de Bellas Artes, 1995), pp. 172–73.

86 Ridley, *Maximilian and Juárez*, p. 189.

87 There are conflicting reports about this. Some say that Carlotta was told

about Maximilian's death and did comprehend it on some fundamental level. Others say she did not. Whether she understood it or not has not been definitively confirmed.

88 See Ridley, *Maximilian and Juárez*, pp. 255–62; Gene Smith, *Maximilian and Carlota: The Habsburg Tragedy in Mexico* (London: Harrap, 1973), pp. 245–64; and Joan Haslip, *Imperial Adventurer: Emperor Maximilian of Mexico* (London: Weidenfeld and Nicolson, 1971), pp. 462–98.

89 American correspondent, "The United States," in *The Times*, Tuesday, June 25, 1867, p. 6. Quoted in Ridley, *Maximilian and Juárez*, p. 276.

————

"II. RESONANCE OF EXECUTION"
pp. 61–93

1 Paul Valéry, *Manet, Morisot: The Collected Works of Paul Valéry*, Bollingen Series XLV, vol. 12, ed. Jackson Matthews, trans. David Paul (Princeton: Princeton University Press, 1960), pp. 25–26.

2 Valéry's understanding of Manet as an artist whose work is driven by its pictorial process bears comparison with Emile Zola's comment about "the difficulty that [Manet] encounters in execution. . . . I mean that his hand is not equal to his eye. . . . When he starts out, one never knows how he will reach the end, or even if he will reach it at all." This is discussed perceptively by Jean Clay, who says of Manet: "In order to *bring forth* the painting, we see him accepting—better still, arousing—the risks of the pictorial process." And: "The work is spread out in time, *deferred,* as though to encourage productive discrepancies" ("Ointments, Makeup, Pollen," trans. John Shepley, *October* 27 [Winter 1983]: 28). Manet's resonance of execution may thus be thought to depend upon the risky headlong attack that will engage the pictorial process and defer completion and be succeeded by subsequent headlong attacks, one after the next. Certainly, reports from sitters for portraits express amazement at how Manet would reject one canvas after the next (Antonin Proust speaks of seven or eight) or erase and repaint the face (Eva Gonzalès's daughter says twenty-five times) in order to repeat, rather than revise, the impulsive attack. See Antonin Proust, *Edouard Manet: Souvenirs* (Paris: A. Barthélemy, 1913), p. 101, and Denis Rouart, *Correspondance de Berthe Morisot* (Paris: Quatre Chemins-Editart, 1950), pp. 33–34. English translation of preceding texts in Vivien Perutz, *Edouard Manet* (Lewisburg: Bucknell University Press, and London and Toronto: Associated University Presses, 1993), p. 79. In the case of a series of compositions, however, a related but second kind of deferral (of completion) obtains, one that spreads out in time a chain of possible endings, none of which (not even the final ending) either has access to all the properties of the chain or has a stable meaning that is independent from the chain of replications to which it belongs. (I discuss a similar issue with respect to Henri Matisse's early arcadian figure compositions in "Moving Aphrodite: On the Genesis of *Bathers with a Turtle* by Henri Matisse," *Saint Louis Art Museum Bulletin* 22, no. 3 [Fall 1998]: 23–24.) I hardly need say how not merely punning but pertinent is the subject of (the suddenness of) execution to this theme. Stéphane Mallarmé observed how Manet began "as though he had never painted before" and continued thus "all over again each time" (Stéphane Mallarmé, "Médaillons et Portraits: Edouard Manet," in *Oeuvres complètes*, ed. Henri Mondor and G. Jean-Aubry [Paris: Librairie Gallimard, 1945], p. 532). English translation in Clay, "Ointments, Makeup, Pollen," p. 31.

3 Théodore Duret, *Edouard Manet et son oeuvre* (Paris: H. Floury, 1902), p. 71. English translation in Juliet Wilson-Bareau, "Manet and The Execution of Maximilian," in *Manet: The Execution of Maximilian; Painting, Politics and Censorship,* exh. cat. (London: National Gallery Publications in association with Princeton University Press, 1992), p. 48.

4 See p. 25.

5 The principal studies that have advanced knowledge of Manet's potential documentary sources appear in the Bibliographical Note, pp. 179–81. Given my skepticism, apparent in this chapter, of accounts that causally match the appearance, and the changes in appearance, of Manet's paintings solely or principally to the information in newspaper reports, I wish to be clear that knowledge of these sources is, nonetheless, indispensable to our understanding of the chronology and character of these painting. What follows is deeply indebted to those who have done the research on this, and on their conclusions, especially the authors of the Brown University catalogue, Wilson-Bareau, and Anna Swinbourne, who selected the newspaper excerpts on pages 182–91. What is more, knowledge of these sources is critical to an understanding of Manet's pictorial practice. As Walter Benjamin pointed out when speaking of Manet's friend Charles Baudelaire, the characteristic comparative figure is the ragpicker, the collector and recycler. (Walter Benjamin, *Charles Baudelaire: A Lyric Poet in the Era of High Capitalism* [London: New Left Books, 1973], pp. 35, 79–80ff.)

6 Pamela M. Jones, "Structure and Meaning in the *Execution* Series," in *Edouard Manet and the Execution of Maximilian,* exh. cat. (Providence: Department of Art, Brown University, 1981), p. 10.

7 See Hayden White, "The Value of Narrativity in the Representation of Reality," in W.J.T. Mitchell, ed., *On Narrative* (Chicago and London: The University of Chicago Press, 1981), pp. 1–23, esp. p. 10.

8 Manet in a letter to Zola, dated between January and May 1867(?), published for the first time in "Letters from Manet to Zola," ed. Colette Becker, in Françoise Cachin and Charles S. Moffett, *Manet 1832–1883,* exh. cat. (New York: The Metropolitan Museum of Art, 1983), p. 520.

9 Letter from Edmond Duranty to Alphonse Legros, reproduced in Marcel Crouzet, *Un Méconnu du Réalisme: Duranty (1833–1880), L'Homme, Le Critique, Le Romancier*

(Paris: Librairie Nizet, 1964), p. 232.

10 See Joel Isaacson, "Observation and Experiment in the Early Work of Monet," in John Rewald, ed., *Aspects of Monet: A Symposium on the Artist's Life and Times* (New York: Harry N. Abrams, 1984), pp. 22–23.

11 Kermit Champa, "Preface," in Edouard Manet and the *Execution of Maximilian,* exh. cat. (Providence: Department of Art, Brown University, 1981), p. 5. In this vein, the Boston painting may be thought to be a supreme example of what Hanson describes as Manet "perversely avoiding the kind of aesthetic resolution which might endanger the vitality of his art" (Anne Coffin Hanson, *Manet and the Modern Tradition* [New Haven and London: Yale University Press, 1977], p. 204).

12 See note 2, above, on Manet's working methods. Here, and in later attempts to date these compositions, all that can be proposed are the time slots during which they were painted. Of course, Manet was working on other paintings during this same period.

13 Manet had taken a seaside vacation that summer, a fact that will be thought unsurprising if we remember that he had opened a major solo show in mid-May, but that may be thought surprising if he had just embarked on a major new composition. Unfortunately, we do not know precisely when he was away. At least we do not know when Manet went on vacation. One scholar says July, but without explanation (Françoise Cachin, note for cat. no. 104, *The Execution of the Emperor Maximilian,* in Cachin and Moffett, *Manet 1832–1883,* p. 273). If it were July, it presumably had to have been fairly late in the month if Manet's early biographer, Adolphe Tabarant, is correct in saying that it was "towards the middle of the summer" that the artist first went to Boulogne-sur-Mer with his family, then to Trouville, where Antonin Proust spent a few days with him (Adolphe Tabarant, *Manet et ses oeuvres* [Paris: Gallimard, 1947], p. 139). Proust, who should know, wrote in a letter of 1867 that those few days were in August (see *La Revue blanche,* 1897, pp. 174–75, and Proust, *Edouard*

Manet: Souvenirs [1913], pp. 55–56). To complicate matters, the 1897 publication of this letter states that the two were together in Trouville; the 1913 publication, in Boulogne. Proust also says that Manet hurriedly broke off his vacation to return to Paris for Baudelaire's funeral on September 2. In any event, if Manet did indeed begin the Boston painting within a week or so after the July 8 report, and modified it after the August 11 report, he either carried it through entirely before going on vacation in late August, or he completed the first stage, went on vacation, and did not modify it until after returning to Paris for Baudelaire's funeral.

14 Such grounds were used because it is more difficult to balance colors against white grounds and because of the beneficial effect of colored grounds on especially white and gray superimpositions. (Thin whites can be made to appear cold against warm ground, and vice versa, while midgrays can simply look insipid without color beneath them.) See especially Hanson, *Manet and the Modern Tradition,* on technical aspects of the Boston painting, pp.167–70.

15 However, Manet did not follow the traditional practice of adding multiple layers to refine the image. He would scrape out or remove by washing with soap an unsatisfactory section and repaint it, many times for some paintings, it is said. See note 2, above.

16 Hanson, *Manet and the Modern Tradition,* p. 170.

17 See pp. 82–83 and fig. 31 in this publication.

18 As Wilson-Bareau points out, Manet could have seen guerilla costumes in authorized souvenir prints of the execution, one of which was issued on August 23 (see Wilson-Bareau, "Manet and The Execution of Maximilian," p. 51), but he could also have seen them in other, earlier prints and photographs unrelated to this event, where he could additionally have seen images of soldiers in regular uniforms. Given Manet's longstanding interest in the events in Mexico, it is shortsighted only to seek illustrative sources from 1867. See "François Aubert en

México," special issue, *Alquimia,* no. 21 (May–August 2004), published by the Sistema Nacional de Fototecas.

19 This is suggested by Wilson-Bareau, "Manet and The Execution of Maximilian," p. 51, who associates it with a post holding a victim in a famous etching from the *Disasters of War* series by Goya; see p. 74 and fig. 27 in this publication.

20 In the former respect, Wilson-Bareau uses this doubtful reading to support a comparison with Diego Velázquez's *Surrender at Breda* and an Epinal print issued on August 23, 1867. In the latter, she asks us to ponder the unanswerable question whether the overpainting in the background covers such anecdotal motifs as coffins and crosses, bells, and a cemetery wall (See Ibid.).

21 Letter to George and Thomas Keats, December 28, 1817, in H. Buston Forman, ed., *The Complete Works of John Keats,* vol. IV, Letters 1814 to January 1819 (Glasgow: Gowans & Gray, 1901), p. 50.

22 For details of the information in these early reports, see Appendix, pp. 183–85.

23 For example, the leader of the Mexican revolution of 1810, Father Manuel Hidalgo, was executed by firing squad in a badly botched execution; another priest, José Morelos, was shot after being defeated in the 1815 rebellion; and General Agustín de Iturbide, who had suppressed the Hidalgo revolt, was eventually himself defeated and shot by Mexican liberals. See Jasper Ridley, *Maximilian and Juárez* (London: Constable, 1993), pp. 12–13.

24 Ibid., pp. 282–84.

25 Appendix, *Le Figaro,* July 5, 1867, p. 184, and Pamela M. Jones, "Appendix: Documentation" in Edouard Manet and the *Execution of Maximilian,* p. 116 (P. Boutet, "Dernières Nouvelles," *Le Mémorial Diplomatique,* July 6, 1867, pp. 777–78 [front page]).

26 Appendix, *Le Figaro,* July 8, 1867, pp. 184–85, and Jones, "Appendix: Documentation," pp. 116–17 (Alphonse Duchesne, "Courrier Politique," *Le Figaro,* July 8, 1867, pp. 1–2).

27 The mystery of this account is that its basic accuracy was confirmed by later, authorized, and verified accounts; see Appendix, *Le Mémorial Diplomatique,* October 10, 1867, p. 191.

28 Appendix, *Le Figaro,* July 7, 1867, p. 184, and Wilson-Bareau, "Manet and The Execution of Maximilian," p. 49.

29 Martin Davies, "The Literature of Art: Recent Manet Literature," *Burlington Magazine* 98 (May 1956): 170.

30 Sandblad's pioneering study of the press reports argued for the importance of a report published in *Le Mémorial Diplomatique* on August 10, 1867 (P. Boutet, "Mexique," *Le Mémorial Diplomatique,* pp. 942–45; excerpt reprinted in Jones, "Appendix: Documentation," p. 120). Davies, who had unearthed the July 8 report, insisted, to the contrary, that "it is unlikely that he [Manet] touched it [the Boston painting] after 10ᵗʰ August" ("The Literature of Art: Recent Manet Literature," p. 170). Then Jones uncovered the August 11 report (Albert Wolff, "Gazette du Mexique," *Le Figaro,* p. 1; reprinted in Jones, "Appendix: Documentation," p. 120) and her argument of its importance was adopted by Wilson-Bareau ("Manet and The Execution of Maximilian," p. 52), and is followed here as well.

31 See Julius Meier-Graefe, *Edouard Manet* (Munich: Piper, 1912), pp. 183, 186. Also noted in Jones, "Structure and Meaning in the *Execution* Series," p. 15, and in *Picasso: Tradition and Avant-Garde,* exh. cat. (Madrid; Museo Nacional del Prado and Museo Nacional Centro de Arte Reina Sofia, 2006), pp. 286–87.

32 See letter from Manet to Henri Fantin-Latour in Gary Tinterow, "Raphael Replaced: The Triumph of Spanish Painting in France," in Gary Tinterow and Geneviève Lacambre et al., *Manet/Velázquez: The French Taste for Spanish Painting,* exh. cat. (New York: The Metropolitan Museum of Art, 2003), pp. 51, 231. Original printed in Pierre Courthion, ed., *Manet raconté par lui-même et ses amis* (Geneva: Pierre Cailler Editeur Vésenaz, 1945), pp. 42–44.

33 Michael Fried, *Manet's Modernism or, The Face of Painting in the 1860s*

(Chicago and London: The University of Chicago Press, 1996), pp. 350–51.

34 Carol Armstrong, *Manet Manette* (New Haven and London: Yale University Press, 2002), p. 16. See also Carol Duncan, *The Pursuit of Pleasure: The Rococo Revival in French Romantic Art* (New York and London: Garland Publishing, 1976), p. 109.

35 Michael Fried, "Manet's Sources: Aspects of His Art, 1859–1865," *Artforum* 7 (March 1969): 72–73. See also Elizabeth A. Reid, "Realism and Manet," in Edouard Manet and the *Execution of Maximilian,* exh. cat. (Providence: Department of Art, Brown University, 1981), p. 73.

36 First published by H. Plon, Paris. For more on the influence of Goya's *The Third of May, 1808,* on Manet's *Execution* painting, see Nancy Locke, "Unfinished Homage: Manet's 'Burial' and Baudelaire," *Art Bulletin* 82, no. 1 (March 2000): 74. See also note 31, above.

37 This painting is discussed by John House in "Manet's Maximilian: History Painting, Censorship and Ambiguity," in Wilson-Bareau et al., *Manet: The Execution of Maximilian; Painting, Politics and Censorship,* p. 97, but without associating it with Goya or with Manet. We should note that Manet followed the practice of specifying the precise date of the historical event depicted in the inscribed date of the final, Mannheim composition.

38 Did the artist consider the implication of this allusion, which was to compare Russian to French troops, allowing the inference that France could be blamed for Warsaw? Probably not.

39 This series of prints had just been issued in 1863. See Tinterow and Lacambre et al., *Manet/Velázquez,* note for cat. nos. 33–37, Francisco de Goya y Lucientes, *The Disasters of War,* p. 425.

40 Kathryn L. Brush, "Manet's *Execution* and the Tradition of the *Histoire,*" in Edouard Manet and the *Execution of Maximilian,* exh. cat. (Providence: Department of Art, Brown University, 1981), p. 42.

41 Wilson-Bareau, "Manet and The Execution of Maximilian," pp. 38–40,

where it is noted that Beaucé, who had been in Mexico from 1863 through 1865, was featured in the *Album Autographique* of August–September 1867 with a portrait of Maximilian and sketch of a band of Juaristas; that he is known to have worked from photographs taken by François Aubert and Auguste Mérille in Mexico, which he had brought back to France; and that Manet may have known this artist personally, obtaining details of Mexican military attire from him.

42 Knowledge of the later compositions in the series tells us that Manet, too, represents about to be, being, and having been executed victims. But this is not clear from the Boston painting itself.

43 Champa, "Preface," in Edouard Manet and the *Execution of Maximilian,* p. 5.

44 George P. Mras, *Eugène Delacroix's Theory of Art* (Princeton: Princeton University Press, 1966), p. 60. Reproduced by Nancy A. Austin, cat. note for no. 10, *Arabs on Voyage,* in Edouard Manet and the *Execution of Maximilian,* exh. cat. (Providence: Department of Art, Brown University, 1981), p. 170.

45 See Fried, *Manet's Modernism,* p. 69, n. 97, also pp. 262, 302, 343–44; and Reid, "Realism and Manet," p. 70. For more on this subject, see also Michael Fried, *Courbet's Realism* (Chicago: The University of Chicago Press, 1990), and Linda Nochlin, *Realism and Tradition in Art 1848–1900: Sources and Documents* (Englewood Cliffs, N.J.: Prentice-Hall, 1966).

46 See Fried, *Courbet's Realism,* p. 79. See also Reid, "Realism and Manet," p. 79.

47 See Reid, "Realism and Manet," p. 77, who correctly speaks of Manet's reference to the work of his own master, Couture, in his less-formal moments, as well as of Géricault.

48 This photograph was illustrated in Douglas Johnson, "The French Intervention in Mexico: A Historical Background" in Juliet Wilson-Bareau et al., *Manet: The Execution of Maximilian; Painting, Politics and Censorship,* exh. cat. (London:

National Gallery Publications in association with Princeton University Press, 1992), p. 23, fig. 10, but without suggesting it as a source.

49 See Albert Boime, "New Light on Manet's *Execution of Maximilian*," *Art Quarterly* 36, no. 3 (1973): 187–88, fig. 17 for the 1863 engraving; Nils Gösta Sandblad, *Manet: Three Studies in Artistic Conception* (Lund: C.W.K. Gleerup, 1954), p. 125, fig. 39 for the 1865 engraving.

50 For *The Little Cavaliers* and its replications, see Wilson-Bareau, note for cat. no. 37, *Little Cavaliers, after Velázquez*, in Cachin and Moffett, *Manet 1832–1883*, pp. 120–21; Wilson-Bareau, note for cat. no. 129, *The Little Cavaliers, Copy after Velázquez*, in Tinterow and Lacambre et al., *Manet/Velázquez*, pp. 483–84; notes for cat. nos. 17–18, *The Little Cavaliers, copy after Velázquez*, in *Manet en el Prado*, ed. Manuela B. Mena Marqués (Madrid: Museo Nacional del Prado, 2003), pp. 426–27; and Beth Archer Brombert, *Edouard Manet: Rebel in a Frock Coat* (Boston: Little, Brown, 1996), pp. 101–02. For discussion of replication and reversal in Manet's printmaking, see Armstrong, *Manet Manette*, pp. 77–88. For these replications in *The Old Musician* and hence in the *Execution*, see Elizabeth Carson Pastan, "Manet's Stylistic Development of the 1860s," p. 65, and cat. no. 35, *Little Cavaliers*, in Edouard Manet and the *Execution of Maximilian* (Providence: Department of Art, Brown University, 1981), p. 200. The relevance of the *Little Cavaliers* to the Boston painting is reinforced by the fact that Manet wrote of his intention to repair the copperplate of the print, which he did, in a letter thought to have been written on June 10, 1867, that is to say, about a month before he began to work on the Boston painting. (See Cachin and Moffett, *Manet 1832–1883*, pp. 62, 120–21.)

51 This comparison does not appear in the accounts given in the previous note.

52 Similarly, the figures separated at the right of the central group may be said to compare to the two officers in the Boston painting.

53 See Fried, "Manet's Sources: Aspects of His Art, 1859–1865," pp. 29–34; and Jones, "Structure and Meaning in the *Execution* Series," pp. 14–15.

54 See Fried, *Manet's Modernism*, p. 353.

55 Ibid. Hence, while the identities of the two victims in the Boston painting are as yet uncertain, Fried's statement may be held to be true insofar as one is light-skinned, thereby inferring the French-appointed Maximilian, and the other dark-skinned, thereby inferring one of the Mexican generals.

56 In addition to the association, mentioned below, of Gilles, and therefore the boy in white in *The Old Musician*, with Christ, there is another possible Christian association to this painting. Since the figure bisected by its right-hand edge was posed by a man whom Manet referred to as an "old Jew with a white beard," Reff proposes that this figure "thus represents the popular figure of the Wandering Jew" (Reff, *Manet and Modern Paris* [Washington, D.C.: National Gallery of Art, 1982], p. 174). Accepting this proposal, Jones points out that the Wandering Jew figure is understood to be one who mocked Christ on the road to Calvary, and suggests that this association also accrues to the sword carrier in the Boston painting, which replicates this figure. (Jones, "Structure and Meaning in the *Execution* Series," p. 15.) This association may or may not throw light on *The Old Musician*, but it is difficult to understand with what purpose it could attach to the sword carrier.

57 Jones, "Structure and Meaning in the *Execution* Series," p. 15; see also Meredith J. Strang, "Napoleon III: The Fatal Foreign Policy," in Edouard Manet and the *Execution of Maximilian,* exh. cat. (Providence; Department of Art, Brown University, 1981), p. 97.

58 Oskar Bätschmann, "L'artiste exposé," trans. Jean-François Poirier, in *Traverses* (Fall 1992): 54–55. See also Jules Michelet, *Histoire de France au dix-huitième siecle: La Regence* (Paris: Chamerot, Librairie-Editeur, 1864), p. 352, and Fried, *Manet's Modernism*, p. 596, n. 222.

59 Jones, "Structure and Meaning in the *Execution* Series," p. 15; and Jones, "Appendix," in Edouard Manet and the *Execution of Maximilian*, p. 118; "Nouvelles du Mexique," *L'Indépendance Belge*, July 15, 1867, p. 3.

60 Appendix, *Le Mémorial Diplomatique*, August 24, 1867, p. 190, and Jones, "Structure and Meaning in the *Execution* Series," p. 15; and Appendix in Brown catalogue, pp. 120–21; P. Boutet, "Mexique," *Le Mémorial Diplomatique*, August 10, 1867, pp. 942–45.

61 Theodore Reff, "The Symbolism of Manet's Frontispiece Etching," *Burlington Magazine* 104, no. 710 (May 1962): 185.

62 Nancy Locke, *Manet and the Family Romance* (Princeton and Oxford: Princeton University Press, 2001), pp. 121–23.

63 Appendix, *L'Indépendance Belge*, July 22, 1867, pp. 186–87.

64 Appendix, *L'Indépendance Belge*, July 31, 1867, pp. 188–89, and Wilson-Bareau, "Manet and The Execution of Maximilian," p. 55.

65 Appendix, *Le Mémorial Diplomatique*, July 31, 1867, p. 189.

66 Appendix, *L'Indépendance Belge*, July 31, 1867, pp. 188–89; and Jones, "Structure and Meaning in the *Execution* Series," p. 11.

67 Appendix, *Le Figaro*, August 11, 1867, p. 189; Jones, "Structure and Meaning in the *Execution* Series," pp. 13–14; and Wilson-Bareau, "Manet and The Execution of Maximilian," p. 52. The three attempts were that of the firing squad and two attempts required by the NCO. But see p. 139 of this publication for the possibility that even more attempts were required.

68 See Wilson-Bareau, "Manet and The Execution of Maximilian," figs. 53 and 54, p. 54.

69 Ibid., p. 52.

70 Wilson-Bareau argues that the Wolff article marks the point at which Manet began to alter his painting, and that even the belated addition of the NCO and one additional officer on the right may have been a response to it, before he had the idea of altering

uniforms ("Manet and The Execution of Maximilian," p. 53). However, there was evidence enough in the earlier reports for the addition of this pair, and if they were added after the Wolff report, why were they dressed in guerilla costume?

71 Ibid.

72 Jones, "Structure and Meaning in the *Execution* Series," p. 14, and Sandblad, *Manet: Three Studies in Artistic Conception*, p. 132.

73 Hanson, *Manet and the Modern Tradition*, pp. 169–70.

74 An example of this is Manet's *Christ Mocked* in the Art Institute of Chicago, painted on very thin canvas, which now reveals a horizontal indentation across Christ's chest that seems to have been caused by his working on top of thick underlying paint while it was stiff but not yet dry and against the direction of the underlying brush-strokes, thus pushing the paint into a ridge. Additionally, heavy working on a fine canvas would stretch and distort the fabric; nonetheless, Manet persist-ed in this instance, presumably because he liked to be able to apply a smooth stroke uninterrupted by the canvas weave. (I am grateful to Kristin Lister, paintings conservator at the Art Institute, for these suggestions.) Additionally, Jacques-Emile Blanche noted in 1931 that Manet preferred "a white canvas, very fine, with no grain . . . [which he] seems to have coated . . . with a thin layer of oil, which he wipes before attacking that part" (*Les Arts Plastiques* [Paris: Les Editions de France, 1931], p. 53). English translation in Clay, "Ointments, Makeup, Pollen," p. 32. Of course, Manet also did set canvases aside to begin again on a new surface, but not because they were preliminary *ébauches* (see note 2, above). Jean C. Harris, *Edouard Manet: Graphic Work; A Definitive Catalogue Raisonné* (New York: Collectors Editions, 1970), pp. 155–76 is essential reading on the sub-ject of Manet's picture construction.

75 There are many reports of how slow-ly Manet worked, and how he "labored greatly on the pictures he sent to the Salon, yet they looked like sketches. Manet rubbed out and repainted

incessantly" (Blanche, *Les Arts Plastique,* pp. 53 and 57–58; English translation in Hanson, *Manet and the Modern Tradition,* p. 160).

76 Reid, "Realism and Manet," p. 77.

77 See Juliet Wilson-Bareau and David Degener, *Manet and the Sea,* exh. cat. (Philadelphia: Philadelphia Museum of Art, 2003), pp. 57–61.

78 Reid, "Realism and Manet," p. 80.

79 Ibid., p. 78.

80 See Appendix, *Le Figaro,* August 11, 1867, p. 189, and Jones, "Structure and Meaning in the *Execution* Series," p. 13. See also Sandblad, *Manet: Three Studies in Artistic Conception,* pp. 130–32.

81 See Reid, "Realism and Manet," pp. 78–79.

82 For Freud's understanding of *Nachträglichkeit* (deferred action or deferred activation), see L. Laplanche and J.-B. Pontalis, *The Language of Psycho-Analysis,* trans. Donald Nicholson-Smith (New York and London: Norton, 1973), pp. 111–13.

83 Reid, "Realism and Manet," p. 78.

84 In conversation with the author. Related to its quality of picturesque is the Boston painting's deployment of the traditional methods of chiaroscuro to create a pool of light below the vic-tims, dramatizing them. Stephen Bann notes how chiaroscuro is used along-side iconography and physiognomy in Goya's source painting to "give it that kind of generality and fixity within the historical process which is also implied by the title: *The Third of May*" (Stephen Bann, "The Odd Man Out: Historical Narrative and the Cinematic Image," *History and Theory* 26, no. 4 [December 1987]: 59). The dramatic counterpoint of light and dark in the Boston painting pushes it in that direction, which Manet must ultimately have found unsatisfactory, as well.

85 Juliet Wilson-Bareau, ed., "Documents Relating to the 'Maximilian Affair': Remarks by Emile Zola under the head-ing 'Coups d'épingle' ('Pinpricks'), in *La Tribune,* Thursday, February 4, 1869, no. 35," in *Manet 1832–1883,* pp. 531–32. Reproduced in *Emile Zola: Salons,* ed. F.W.J. Hemmings and Robert J. Niess (Geneva: Librairie E. Droz; Paris: Librairie Minard, 1959), p. 22.

86 Brush, "Manet's *Execution* and the Tradition of the *Histoire*," p. 44.

87 House, "Manet's Maximilian: History Painting, Censorship and Ambiguity," pp. 91–92.

88 See Jean Sutherland Boggs et al., cat. entry for no. 45, *Scene of War in the Middle Ages,* erroneously called *The Misfortunes of the City of Orléans,* in *Degas,* exh. cat. (New York: The Metropolitan Museum of Art; Ottawa: National Gallery of Canada, 1988), pp. 105–07. An interesting connection between this painting and Manet's project is that Degas's painting was probably begun in 1863, which was the date of the publication of the edi-tion of Goya's *Disasters of War* that Degas purchased (ibid., p. 106).

89 Maxime DuCamp, *Les Beaux-arts à l'Exposition Universelle et aux Salons de 1863, 1864, 1865, 1866 et 1867* (Paris: Jules Renouard [Librairie], 1867), pp. 22–23; and House, "Manet's Maximilian: History Painting, Censorship and Ambiguity," pp. 94–95.

90 House, "Manet's Maximilian: History Painting, Censorship and Ambiguity," p. 95.

91 In addition to the work discussed here, there is at least one other such photo–collage, the gruesome, Max Ernst–like conflation of an engraving of the embalmed body of Maximilian and a portrait head (see fig. 72 in this publication). Of course, the technical conditions of photography in this peri-od made it impossible for there to be a photographic record of the execu-tion itself. (Hence, Aubert made a sketch of the execution, which bears a dubious inscription claiming that he witnessed it; see Wilson-Bareau et al., *Manet: The Execution of Maximilian; Painting, Politics, and Censorship,* p. 30, fig. 21.) However, the fact of pho-tography implies that such an event could be recorded authentically in a manner that resembled a photograph. (See Bann, "The Odd Man Out: Historical Narrative and the Cinematic Image," pp. 57–58.) See also Postscript, pp. 151–53, for further discussion of this subject.

92 Seymour Chatman, *Story and Discourse: Narrative Structure in*

169

Fiction and Film (Ithaca and London: Cornell University Press, 1978), p. 21.

93 George Eliot, *Adam Bede,* ed. Valentine Cunningham (Oxford and New York: Oxford University Press, 1996), p. 313. Quoted by Chatman, *Story and Discourse,* p. 96.

94 Chatman, *Story and Discourse,* p. 96.

95 Ibid., p. 21.

96 Martin Heidegger, *Being and Time,* trans. John Macquarrie and Edward Robinson (San Francisco: Harper & Row, 1962), p. 417. Quoted in Paul Ricoeur, "Narrative Time," in W.J.T. Mitchell, ed., *On Narrative* (Chicago and London: The University of Chicago Press, 1981), p. 169.

97 Ibid., p. 169.

98 Ibid.

99 Ernest Chesneau, *L'Art et les artistes modernes en France et en Angleterre* (Paris: Didier, 1864), p. 189. English translation in Fried, *Manet's Modernism,* pp. 282–84.

100 Ricoeur, "Narrative Time," p. 183.

101 On Lessing, see W.J.T. Mitchell, *Iconology: Image, Text, Ideology* (Chicago and London: The University of Chicago Press, 1986).

"III. SENSE OF ENDING"
pp. 99–139

1 Paul Ricoeur, "Narrative Time," in W.J.T. Mitchell, ed., *On Narrative* (Chicago and London: The University of Chicago Press, 1981), p. 175.

2 Marc de Montifaud, in Arsène Houssaye, ed., *L'Artiste, revue du XIX^e siècle: Histoire de l'art contemporain* (May 1, 1868) (Paris: H. Plon), p. 253.

3 Manet showed instead the recent *Portrait of Emile Zola* of 1868 (Françoise Cachin and Charles S. Moffett, *Manet 1832–1883,* exh. cat. [New York: The Metropolitan Museum of Art, 1983], cat. no. 106, pp. 280–85) together with an earlier painting, *Woman with a Parrot* of 1866 (Cachin and Moffett, *Manet 1832–1883,* cat. no. 96, pp. 254–58), probably because Zola had particularly admired it in his first article on Manet's work—and perhaps because Zola is shown reading

and the woman knowingly dangles a man's monocle. Interestingly, the Salon of 1868 did include two, presumably sentimental paintings (neither has been traced) of scenes related to the execution by Jules-Marc Chamerlat, but neither of the execution itself. (See John House, "Manet's Maximilian: History Painting, Censorship and Ambiguity," in Juliet Wilson-Bareau et al., *Manet: The Execution of Maximilian; Paintings, Politics and Censorship,* exh. cat. [London: National Gallery Publications, in association with Princeton University Press, 1992], p. 106.)

4 This image was found in an album of photos by Lochard, given to the Bibliothèque Nationale by Etienne Moreau-Nélaton. Reproduced in Wilson-Bareau et al., *Manet: The Execution of Maximilian; Paintings, Politics and Censorship,* p. 64, fig. 71.

5 Ambroise Vollard, *Degas: An Intimate Portrait,* trans. Randolph T. Weaver (New York: Greenberg, 1927), pp. 122–23. In one of Degas's notebooks, he wrote: "This picture, which for years had remained rolled up at Mme Manet's home at Genevilliers, was cut up and sent for sale, most probably by her brother Leenhoff. At first the canvas, already cropped on the left, was deposited for a long time with [the dealers] Mme Martin and Camentron. Then it was cut up. The sergeant loading his rifle, behind the firing soldiers, was hawked about and eventually sold for 500 francs to Portier who let me have it" (English translation by John Leighton and Juliet Wilson-Bareau, "The Maximilian Paintings: Provenance and Exhibition History," in Wilson-Bareau et al., *Manet: The Execution of Maximilian; Paintings, Politics and Censorship,* p. 112). See also *Growing Up with the Impressionists: The Diary of Julie Manet,* trans. and ed. by Rosalind de Boland Roberts and Jane Roberts (London: Sotheby's Publications, 1987), p. 54; and Ann Dumas, "Degas as a Collector," in Ann Dumas et al., *The Private Collection of Edgar Degas* (New York: The Metropolitan Museum of Art, 1997), pp. 20–24, n. 112.

6 *L'Indépendance Belge* of July 31,

1867, stated: "They also allowed him [Maximilian] to die between his generals, holding their hands" (see Appendix, p. 188). Presumably, the London painting also showed Maximilian and Mejía holding hands, but we cannot be certain.

7 Albert Boime, "New Light on Manet's *Execution of Maximilian,*" *Art Quarterly* 36, no. 3 (1973): 188–89.

8 Manet would have known Delacroix's painting from its controversial appearance in his 1855 retrospective after its removal from the storage in which it had laid since 1848. See Patricia Mainardi, *Art and Politics of the Second Empire: The Universal Expositions of 1855 and 1867* (New Haven and London: Yale University Press, 1987), pp. 52–54.

9 Théodore Duret, *Edouard Manet et son oeuvre* (Paris: H. Floury, 1902), p. 71. See also Juliet Wilson-Bareau, "Manet and The Execution of Maximilian," in Wilson-Bareau et al., *Manet: The Execution of Maximilian; Paintings, Politics and Censorship,* p. 55, n. 59; Adolphe Tabarant, *Manet: Histoire catalographique* (Paris: Editions Montaigne, 1931), p. 172; and Tabarant, *Manet et ses oeuvres* (Paris: Gallimard, 1947), p. 141. This sort of reconstructive study recalls, of course, that of Géricault while working on *Raft of the Medusa.*

10 See Wilson-Bareau, "Manet and The Execution of Maximilian," p. 58 and fig. 59, p. 56. Duret, however, merely stated that Manet "altered" the heads of the friends he asked to pose for Miramón and Mejía and that only the head of Maximilian was painted from a photograph (*Édouard Manet et son oeuvre,* p. 71). Of course, Manet had recently painted a model wearing a soldier's uniform for *The Fifer* of 1865–66 (fig. 65); its blend of Velázquez and *Japonisme* informs the treatment of the soldiers in the London painting, especially, but so does its costume details, notably the white belt and spats.

11 Wilson-Bareau says that these are yatagan swords ("Manet and The Execution of Maximilian," p. 57). But yatagan swords do not have cross-pieces and are Turkish-looking. The

swords in Manet's painting resemble the sword shown in documentary photographs of Mexican soldiers (e.g., p. 83) as well as recalling the seventeenth-century sword that Manet borrowed in 1861 to paint his *Boy with a Sword* (fig. 34).

12 See Wilson-Bareau, "Manet and The Execution of Maximilian," pp. 55–57, n. 62.

13 Emile Zola, *Salons*, ed. F.W.J. Hemmings and Robert J. Niess (Geneva: Librairie e Droz; Paris: Librairie Minard, 1959), p. 125. English translation in Wilson-Bareau, "Manet and The Execution of Maximilian," p. 55 and n. 61 on p. 84.

14 Wilson-Bareau observed this of the X-ray but without raising this doubt ("Manet and The Execution of Maximilian," pp. 58 and 64).

15 Vivien Perutz, who makes this observation, quotes Stendhal on the subject of the ideal disinterestedness of the boulevardier, even faced with imminent death: "Society, as we know it, forbids all passionate gestures. M. de L[avallette] is condemned to death: at the moment when his sentence is pronounced, he is content to pull out his watch, apparently to see how many hours of life remain to him. The society in which we live permits nothing more; if the painter or sculptor gives a more marked gesture to an illustrious person hearing his death sentence, I feel immediately that the artist's figure is not a man like me; and what is more, if the event is one of our time, if this man is my contemporary, I despise him somewhat as a vulgar type" (*Edouard Manet* [Lewisburg: Bucknell University Press, and London and Toronto: Associated University Presses, 1993], p. 125, nn.181,182). Original in Stendhal, *Du romantisme dans les arts* (Paris: Hermann, 1966), p. 164.

16 Bridget Riley speaks of how, in Titian's *Bacchus and Ariadne*, "in effect, figures are broken up and reassembled in a new plastic anatomy which I call . . . 'collective figuration'" (Bridget Riley, "The Colour Connection, in conversation with Robert Kudielka" (1989), in Robert Kudielka, ed., *The Eye's Mind: Bridget Riley. Collected Writings 1965–1999* (London: Thames & Hudson in association with the Serpentine Gallery and De Montfort University, 1999), pp. 147–48. Jean Clay, speaking of how "the unity of the form no longer coincides with that of the object," observes: "Several objects show a tendency to merge in the same form, giving rise to unexpected configurations: puddles of people, couples combining to form a single spot or area. These composites, these new signifying areas, are also produced by the surface" ("Ointments, Makeup, Pollen," trans. John Shepley, *October* 27 [Winter 1983]: 19).

17 On the changes in this figure, but without the suggestion of somnolence, see Wilson-Bareau, "Manet and The Execution of Maximilian," p. 55.

18 Pamela M. Jones, "Structure and Meaning in the *Execution* Series," in Edouard Manet and the *Execution of Maximilian*, exh. cat. (Providence: Department of Art, Brown University, 1981), p. 17 and p. 102, n. 48. See also Michael Fried, *Manet's Modernism or, The Face of Painting in the 1860s* (Chicago and London: The University of Chicago Press, 1996), n. 235 on pp. 598–99; and Nils Gösta Sandblad, *Manet: Three Studies in Artistic Conception* (Lund: C.W.K. Gleerup, 1954), p. 137.

19 Miramón's spatial position may be deduced from the visible tip of his left toe in the painting, and is very clear from the 1883 photograph; he is on the same plane as the more distant members of the firing squad. Therefore, the group of victims had been brought forward a great deal from their position in the Boston painting. We know that Maximilian was very close to Miramón: the break in the latter's hair at the left of the canvas marks the curve where Maximilian's sombrero originally overlapped his head; it was filled in early on with a strip of canvas cut from the sky. (See Michael Wilson, *Manet at Work: An Exhibition to Mark the Centenary of the Death of Edouard Manet 1832–1883*, exh. cat. [London: The National Gallery, 1983], p. 28.) We may deduce from the similarly close-in position of the Mejía figure in the Boston painting, and of Mejía in the post-London compositions, that he was probably similarly close in the London painting, but whether yet with the outstretched arm and thrownback head of the later composition cannot be known.

20 It is uncertain whether the numerical status of the figural sequence would have attracted attention (i.e., that the number of the compacted five soldiers equals that of the other figures in the composition) and, if so, to what consequence. Manet's narrativization of the beginning and ending of the execution by isolating the two soldiers with those functions would have been unaffected if he had placed a larger squad between them. But their detachment from the squad makes a visible difference to it, which would not have been the case if the squad had been much bigger; and if smaller, would have made too much difference. Clay suggests that the frieze construction, together with centering and the use of vertical or horizontal banded structures, "allows Manet to evade compositional hierarchies." He is correct only if by hierarchy he means a single gradation of relative importance, for Manet does use composition to assign relative importance within a frieze of figures; very notably, here. (Clay, "Ointments, Makeup, Pollen," pp. 11–12.)

21 While Manet was working on the London painting, his friend and colleague Degas was making a painting that created confusion between a landscape and such a backdrop, therefore between figures and actors: his *Mlle Fiocre in the Ballet "La Source."* And we know that Degas was seeing Manet around this time; he made an etching of him with what may well be the reverse of the London canvas leaning against the wall in the background. See cat. notes for no. 72, *Edouard Manet Seated. Turned to the Right,* in Jean Sutherland Boggs et al., *Degas*, exh. cat. (New York: The Metropolitan Museum of Art, 1988), p. 128. The new engagement of the ground around the isolated soldier also suggests that Manet possibly

was thinking of the active figure-ground interactions beside the figure of Liberty in Delacroix's painting.

22 Michael Fried, *Absorption and Theatricality: Painting and Beholder in the Age of Diderot* (Chicago and London: The University of Chicago Press, 1980), pp. 177–78. See also Elizabeth A. Reid, "Realism and Manet," in Edouard Manet and the *Execution of Maximilian*, exh. cat. (Providence: Department of Art, Brown University, 1981), p. 75.

23 Fried, *Manet's Modernism,* p. 355.

24 A similar conflation may be seen in Matisse's *Bathers with a Turtle* of 1908, whose thus qualified absorption contrasts strongly with the violent theatricality of Picasso's *Les Demoiselles d'Avignon* of 1907, to which it responds. (See John Elderfield, "Moving Aphrodite: On the Genesis of *Bathers with a Turtle* by Henri Matisse," *Saint Louis Art Museum Bulletin* 22, no. 3 [Fall 1998]: 38–39, and nn. 88–93 on pp. 48–49 and p. 47, n. 64; and John Elderfield et al., *Matisse Picasso* [London: Tate Publishing, 2002], pp. 42–45.)

25 In the London painting, we cannot see their faces; in the Boston painting, it may be the illustrative means that hide them.

26 See cat. note for *Young Spartans,* no. 40, in Boggs et al., *Degas,* pp. 98–100.

27 This discussion develops that in Elderfield, "Moving Aphrodite," p. 25, n. 24 on p. 45. Quote from Paul de Man, *Blindness and Insight: Essays in the Rhetoric of Contemporary Criticism* (Minneapolis: University of Minnesota Press, 1983), p. 157. I shall claim that Manet actually represents "presentness" in his Maximilian compositions, e.g., by the figure of Miramón. However, it deserves noting here that Manet may be thought to operate within the Baudelairean example. As Clay observes: "The spirit of childhood: charm, passions, mischievousness—all of them traits conceded to Manet by his contemporaries" ("Ointments, Makeup, Pollen," p. 37).

28 These are reviewed by Anne Coffin Hanson, *Manet and the Modern Tradition* (New Haven and London:

Yale University Press, 1977), pp. 114–15, 169, and again by Jones, "Structure and Meaning in the *Execution* Series," p. 19, and nn. 65 and 66 on p. 102.

29 Wilson-Bareau suggests that Manet may have withheld the London painting in the hope that anticipated new press laws would allow the publication of politically sensitive material. If so, perhaps he embarked upon the lithograph with this event in mind—only, of course, to be disappointed, since he was refused permission to publish his lithograph. ("Manet and the Execution of Maximilian," p. 100.)

30 See Juliet Wilson-Bareau, ed., "Documents Relating to the 'Maximilian Affair,'" in Françoise Cachin and Charles S. Moffett, *Manet 1832–1883,* exh. cat. (New York: The Metropolitan Museum of Art ,1983), pp. 531–34.

31 It was a gift to Méry Laurent (see Tabarant, *Manet et ses oeuvres,* p. 141; and Hanson, *Manet and the Modern Tradition,* p. 114).

32 Reprinted in Wilson-Bareau, ed., "Documents Relating to the 'Maximilian Affair,'" p. 532.

33 Anne-Birgitte Fonsmark, "Manet og Kejser Maximilians Henrettelse om skitsen i Carlsberg Glyptotek," *Meddelelser fra Ny Carlsberg Glyptotek,* 1984, pp. 83–84.

34 This discussion expands on the analysis of the X-ray of the oil sketch in Wilson-Bareau, "Manet and The Execution of Maximilian," p., 60.

35 This confirms the frequent suggestion that Manet may have abandoned the London painting because he had brought the victims too far forward. See Fried, *Manet's Modernism,* p. 347.

36 Paul Abe Isaacs, "The Immobility of the Self in the Art of Edouard Manet: A Study with Special Emphasis on the Relationship of His Imagery to that of Gustave Flaubert and Stéphane Mallarmé," PhD. diss., Brown University, 1975, p. 117.

37 See Jones in "Structure and Meaning in the *Execution* Series," pp. 18–19, and Jean C. Harris, *Edouard Manet: Graphic Works; A Definitive Catalogue Raisonné* (New York: Collectors Editions, 1970), p. 153.

38 Ibid.

39 Harris, *Edouard Manet: Graphic Works,* p. 153; and Wilson, *Manet at Work,* p. 29.

40 See Appendix, *Le Figaro,* July 8, 1867, p. 184.

41 See Albert Boime, "New Light on Manet's *Execution of Maximilian,*" *Art Quarterly* 36, no. 3 (1973): 189; and House, "Manet's Maximilian: History Painting, Censorship and Ambiguity," pp. 100–101.

42 See Appendix, *La Liberté*, July 23, 1867, p. 187.

43 Letter to Baudelaire dated Thursday, September 14, 1865, in *Edouard Manet: Voyage en Espagne* (Caen: L'Echoppe, 1988). English translation in Juliet Wilson-Bareau, *Manet by Himself: Correspondence & Conversations; Paintings, Pastels, Prints & Drawings* (Edison, N.J.: Chartwell Books, 1991), p. 36.

44 This comparison is also mentioned by Jones, "Structure and Meaning in the *Execution* Series," p. 20.

45 See Wilson-Bareau, ed., "Documents Relating to the 'Maximilian Affair,'" p. 532.

46 Wilson-Bareau observes that the angle of the wall "suggests the confined space of a courtyard" (note and provenance for no. 105, *The Execution of Maximilian,* in Cachin and Moffett, *Manet 1832–1883,* p. 277).

47 See report in *La Chronique des arts et de la curiosité*, February 7, 1869, reproduced in Wilson-Bareau, ed., "Documents Relating to the 'Maximilian Affair,'" p. 532.

48 Wilson-Bareau, ed., "Documents Relating to the 'Maximilian Affair,'" pp. 531–34.

49 Ibid., p. 534.

50 Remarks by Zola under the heading "Coups d'épingle" ("Pinpricks"), in *La Tribune*, February 4, 1869, no. 35, reproduced in Wilson-Bareau, ed., "Documents Relating to the 'Maximilian Affair,'" pp. 531–32.

51 The observations made here on the basis of the X-ray expand those of Jones, "Structure and Meaning in the *Execution* Series," p. 18; and Wilson-Bareau, "Manet and The Execution of Maximilian," p. 60.

52 Fried, *Manet's Modernism,* p. 359.

53 Eric Darragon, *Manet* (Paris: Fayard,

1989), p. 266.

54 The handbill is illustrated in Wilson-Bareau, "Manet and The Execution of Maximilian," p. 70.

55 Remarks by Zola under the heading "Coups d'épingle" ("Pinpricks"), reproduced in Wilson-Bareau, ed., "Documents Relating to the 'Maximilian Affair,'" p. 532.

56 Wilson-Bareau, "Manet and The Execution of Maximilian," p. 60; and Fried, *Manet's Modernism,* p. 359.

57 There is a copy of the print at the Library of Congress. Paul Revere, *The Bloody Massacre perpetrated in King Street Boston on March 5th, 1770 . . . ,* handcolored etching, 1770. Prints and Photographs Division, Library of Congress, Washington, D.C.

58 Fried, *Manet's Modernism,* p. 359.

59 Ibid.

60 I thank Jack Flam for this comparison.

61 The oil sketch already makes it clear that the sword officer produced problems when created in a colored medium. The red of his trousers fills the gap between the dark gray trousers of the squad and the NCO while his red cap repeats that of the NCO: he assumes too prominent a place in the action, making his action seem its sole cause.

62 Fried, *Manet's Modernism,* p. 358.

63 See "List of Exhibitions," in Cachin and Moffett, *Manet 1832–1883,* p. 536.

64 Ibid. Quote from cat. note to no. 10 by Moffett, *The Spanish Singer* or *Guitarrero,* in Cachin and Moffett, *Manet 1832–1883,* p. 64.

65 Stéphane Mallarmé, "Médaillons et portraits: Edouard Manet," in *Oeuvres complètes,* ed. Henri Mondor and G. Jean-Aubry (Paris: Librairie Gallimard, 1956), p. 532. English translation in Clay, "Ointments, Makeup, Pollen," p. 31, n. 54.

66 Quoted in Clay, "Ointments, Makeup, Pollen," p. 31, n. 51. On Manet's speed of (or better, episodes of speed in) execution, see ibid., pp. 31–32.

67 Fried, *Manet's Modernism,* p. 296. This is a very simplified summary of Fried's highly nuanced argument.

68 Ibid., pp. 295–96; and Fried,

Absorption and Theatricality, pp. 177–78.

69 Théodore Pelloquet, *L'Exposition: Journal du Salon de 1863,* no. 22 (July 23, 1863), quoted by Fried in *Manet's Modernism,* p. 282, n. 44. I should add here that a posture or gesture caught in mid-movement, to comprise a pregnant or exemplary moment of action, is not, of course, the only way of depicting motion. In addition to thus implying it in a familiar pose, there are three other ways: depicting its physical effects; depicting its side effects; and depicting its appearance. See John Hyman, *The Objective Eye* (Chicago: The University of Chicago Press, 2006), p. 203.

70 Georges Bataille, *Manet,* trans. Austryn Wainhouse and James Emmons (New York: Skira, 1955), p. 67.

71 Ibid., p. 52.

72 Bataille draws the false inference that a painting, whose *text* it illustrates is effaced, should afford the anesthetized, apathetic *appearance* (and provoke a similar *reaction*) of the surface of an object that has been effaced of meaning. But it is the text and not the painting that has been negated—and there must be a visible difference between a painting's text and its surface, which will reveal properties that cannot be attributed to the text; therefore, neither to the effacement of the text. Bataille's "anesthetized" reading of the painting—"a tooth deadened by novocain"— (ibid., p. 67) seems to betray a greater tolerance for looking at violence than one would hope for.

73 Edmond Bazire, *Manet* (Paris: A. Quantin, 1884), p. 57; quoted by Hanson, *Manet and the Modern Tradition,* p. 116.

74 Part of what may be deemed prodigiously terrifying about the painting is its effect of absence of affect, drawn to our attention by the one (and, as we shall learn, misleading) exception of the figure of Mejía. This speaks, in part, of an anti-Romantic, Realist concern for objectivity akin to Flaubert's, who said that there was "nothing feebler than putting one's personal feelings into a work of art" (Gustave

Flaubert, *Correspondance,* vol.1 [Paris: Librairie de France, 1922], p. 428; quoted in Perutz, *Edouard Manet,* p. 57, n. 89). But it goes to something deeper and stranger than shunning of empathic appeal. Perutz is correct in speaking of certain of Manet's figures, for example the youth in *Luncheon in the Studio,* as having a quality comparable to what Walter Benjamin calls a "kind of mimesis of death," a "capacity to become rigid" which "manifests itself a hundredfold in Baudelaire's writings" (Walter Benjamin, *Charles Baudelaire: A Lyric Poet in the Era of High Capitalism,* trans. Harry Zohn [London: NLB, 1973], p. 38). Also reproduced in Perutz, *Edouard Manet,* p. 41, n. 100. In particular, the Mannheim painting reeks of death and rigidity, least of all, ironically, in the depicted incident and, most of all, in the alienating frozenness of the depiction, which allows inanimate spaces an equal voice to that of the nominally animate execution squad.

75 Kathryn L. Brush, "Manet's *Execution* and the Tradition of the *Histoire,*" in Edouard Manet and the *Execution of Maximilian,* exh. cat. (Providence: Department of Art, Brown University, 1981), pp. 45–46.

76 Fried, *Manet's Modernism,* p. 295.

77 Ibid., p. 357. Fried says that he can think of no other Western painting that so determinedly draws attention to this: perhaps Titian's *Bacchus and Ariadne* in Riley's account of this painting ("The Colour Connection, in conversation with Robert Kudielka" [1989], pp. 142–48). Titian's *Diana and Actaeon* (The National Gallery, London) also deserves comparison with Manet's painting for its very different appeal to the fiction of instantaneousness by showing Diana having bent the bow but not showing either the drawn bow-string or the arrow that strikes Actaeon who is already transforming into a deer and being attacked by Diana's hounds. I offer these comparisons not to suggest their influence on Manet, who to my knowledge is not recorded as having seen them. However, we do know that Manet was exposed to Vermeer's

paintings of momentarily suspended time, recently rediscovered by his acquaintance, Théophile Thoré (W. Bürger), in the 1866 issue of the *Gazette des Beaux-Arts* (see Perutz, *Edouard Manet*, p. 135, n. 201). While these do not, of course, present specific comparison with the Maximilian compositions, they are typically marked by an aloof effect of stilled movement joined to stopped time that implies that both will restart simultaneously. On the representation of smoke, that is so critical an index of temporality in this painting, see Postscript, p. 152.

78 Clay speaks of Manet "as though seeking to overcome in the texture the old distinction between form and background, comes to *produce* out of it a new surface by weaving, overflowing, and overlapping. In Manet—and soon in Matisse—the 'backgrounds' rise up, cross, create surfaces, and participate in the definition of the object" (Clay, "Ointments, Makeup, Pollen," p. 13). As Perutz points out: "From a comfortable viewing distance of about fifteen to twenty feet, we can only hope to encompass the picture in its entirety by looking at the center, that is, at this void, featureless but for the cast shadow that directs our gaze past the cap of the N.C.O. at the right to the equally insignificant area at the top right-hand corner. This is one of several deliberate misdirections" (*Edouard Manet*, p. 124).

79 Illogically, because the regularly stepped increase in length of the muskets does not conform to the spatial positions of the soldiers who hold them. In addition to the three visible muskets, there are two partly visible ones (very difficult to see in a reproduction) in spaces between the three others; to make matters even more confusing, these decrease in length from top to bottom.

80 For the clash of painted and scratched whites in this painting, see Clay, "Ointments, Makeup, Pollen," pp. 14–15, but with the surely odd conclusion that because the dispersion of light areas "contradicts [he means, distracts us from] the emotional concentration [of the event]," it follows that "the indifference to the execution

with which one taxes the artist is perhaps especially a matter of whites." To encourage a momentary looking-away is not necessarily to express indifference.

81 Suggested by Perutz in *Edouard Manet*, pp. 124–25.

82 The sword of the NCO is still much shorter than those of the other soldiers; that of one of the soldiers in the squad is still missing its handguard. Additionally, Manet has simplified the lower parts of the uniform jackets, painting out the lime green accents between the buttons, visible in London, in the jackets of all except the central soldier.

83 Fried, *Manet's Modernism*, p. 357.

84 As Perutz remarks, only Mejía does not confound the expectation of how a figure being executed might look, and, therefore, serves as a foil to the other two victims. (Perutz, *Edouard Manet*, p. 125.) For reasons that will emerge, this is especially ironic, and if Perutz is correct to add that Manet may have painted him thus to deflect the charge that he did not know how to render emotion, this representation of Mejía reacting to being struck by bullets is doubly ironic. (See below, pp. 134–35.)

85 Fried, arguing that Manet emptied his depiction of Maximilian and his generals of their absorption—more precisely, their absorption of its psychological depth— that such a text would be expected to show, states that the muted treatment of the victims, adumbrated by the portrait of Miramón in the London painting, "goes a long way toward neutralizing their status as the painting's expressive focus" (Fried, *Manet's Modernism*, p. 356). This is certain; we saw earlier how the arc of smoke reinforces the softness of their painting in this respect. However, he goes on to claim that Manet reinforces this neutralization by minimizing their gazes. Of that, I am not certain.

86 Bann suggests that what he calls "that wide-brimmed, mildly absurd Mexican hat" might be read "as a sign of Maximilian's determination to die as a *Mexican* emperor," which would identify him with the Mexicans (a few

wearing similar hats) looking at him from over the wall. Nonetheless, whether identified as Christ or a Mexican, "the man who is at the center of this little event is himself fundamentally *out of place*" (Stephen Bann, "The Odd Man Out: Historical Narrative and the Cinematic Image," *History and Theory* 26, no. 4 [December 1987]: 63–64).

87 On these hands, see Jones, "Structure and Meaning in the *Execution* Series," p. 18, n. 62. The direction of the muskets disproves Perutz's statement that already "a bullet is shattering the hand with which [Miramón] clasps the emperor, pink like that of the N.C.O." (Perutz, *Edouard Manet*, p. 125).

88 Reid, "Realism and Manet," p. 81.

89 Fried says that this painting is unusual in Manet's oeuvre in not doing this. (*Manet's Modernism*, p. 360). Therefore, this is as good a moment as any to affirm that this account most clearly parts way with Fried's in proposing that the painting contains motivators of perceptual movement and, therefore, both enrolls the viewer and thematizes the act (more precisely, the mobility of the acts) of viewing. For those who know Fried's interpretation, this must already be obvious from my discussion of perceptual distractions; it will become even more obvious in what follows, part of whose motivation was to find a place in my account for the witnesses of the execution rejected as regrettable by Fried (ibid.), a remaining challenge in the most authoritative interpretation in recent memory.

90 Wilson-Bareau, "Manet and The Execution of Maximilian," p. 60, caption for fig. 67.

91 Viewed at a distance, this issue is further complicated. As Perutz points out, from such a distance the gun barrels, "which fail to point where they should, appear to touch the victims" (Perutz, *Edouard Manet*, p. 125).

92 "To break up the subject and re-establish it on a different basis is not to neglect the subject; so it is in a sacrifice, which takes liberties with the victim and even kills it, but cannot be said to *neglect* it" (Bataille, *Manet*, p. 103).

93 It has thus especially attracted modernist admirers preoccupied with cultural aphemia and the consequent deprival of meaning, for example, Henri Matisse and Jasper Johns (see pp. 145–46; 150–51).

94 It is difficult to judge properly what Manet intended by the oil sketch, in this respect, because the supposed space beyond the wall is at least as dense, if not more dense and enclosing, as the wall itself, and it is only by reference to the Mannheim painting that one can propose that a landscape with figures is represented there.

95 Riley observes this of Titian's *Bacchus and Ariadne* in "The Colour Connection, in conversation with Robert Kudielka" (1989), p. 145.

96 Manet is unspecific as to how steep this slope is. Either the land slopes down to the same ground plane as that before the wall, in which case the witnesses have climbed onto something very high behind the wall, suggesting a pressing forward despite the difficulty of viewing. Or, logically but not visually impossible, the land ramps down from the distance to the line of the wall's cornice, adding weight to the forward thrust of the wall. In both readings, the space of the painting advances flatly toward us. Clay, in "Ointments, Makeup, Pollen," developing an observation by Françoise Cachin, speaks of a feeling of "inaccessible proximity" produced by certain of Manet's paintings (pp. 19–22).

97 Ibid., p. 20.

98 Wilson-Bareau, "Manet and The Execution of Maximilian," p. 62.

99 Bataille, *Manet*, pp. 51–52. Perutz observes that "the emotion that by right should belong to the still-living emperor and Miramón seems to have migrated to the dead, to the tombs and cypresses of the cemetery," and that the witnesses "are not there to express the outrage or sympathy reported by the newspapers but simply to gawk at the spectacle" (Perutz, *Edouard Manet*, p. 126).

100 A principal source of Fried's discomfort with the witnesses is that they show emotion and, therefore, are not sufficiently "indifferent." (Fried, *Manet's Modernism*, p. 360.)

101 Manet would enlarge this figure in the curious *Berthe Morisot with Fan* of 1872, who even more explicitly is the subject, not object, of viewing (see Nancy Locke, *Manet and the Family Romance* [Princeton and Oxford: Princeton University Press, 2001], p. 160). In the present instance, her (and her companions') ultimate derivation from Goya is important to their thematization of viewing: as Bann points out, Goya had stressed that his *Disasters of War* were witnessed (with titles like "I saw it" and "One can't look") ("The Odd Man Out: Historical Narrative and the Cinematic Image," p. 55); Manet, who said that he could only paint what he saw but in this case obviously did not, wants it to be known that he paints as if he and the viewers are witnesses. I suggest below that he also wants it to be known, by the unresponsiveness of these painted witnesses, that what we are witnessing is not quite what it seems.

102 Hence, they are not simply representatives of spectatordom, the role in which Fried, *Manet's Modernism*, p. 360, finds them redundant; they are representatives of its difficulties.

103 Bataille, *Manet*, p. 38, on *The Old Musician*.

104 Appendix, *Le Mémorial Diplomatique*, October 10, 1867, p. 191.

105 Bataille notes the one striking similarity between Manet's painting and the Goya that inspired it: "in both, painting accedes to 'definitive silence'" (*Manet*, p. 55).

106 Appendix, *Le Mémorial Diplomatique*, August 24, 1867, p. 190.

107 Appendix, *Le Mémorial Diplomatique*, October 10, 1867, p. 191.

108 Appendix, *L'Indépendance Belge*, July 21, 1867, p. 186.

109 Appendix, *Le Figaro*, July 8, 1867, p. 184–85.

110 Appendix, *L'Indépendance Belge*, July 21, 1867, p. 186.

111 Appendix, *Le Figaro*, July 8, 1867, p. 185.

112 Appendix, *Le Mémorial Diplomatique*, August 24, 1867, p. 190.

113 Appendix, *La Liberté*, July 20, 1867, p. 186.

"POSTSCRIPT"
pp. 141–53

1 Deborah Dorotinsky, "Los tipos sociales desde la austeridad del estudio," *Alquimia* (May–August 2004), p. 19. See also fig. 23 in this publication.

2 The Philadelphia painting may be confusable with but is not the source of the Aubert photograph, as close inspection will reveal.

3 Reproduced in Andrea Kettenmann, *Diego Rivera 1886–1957: A Revolutionary Spirit in Modern Art* (Cologne: Taschen, 2000), pp. 60–61.

4 Manet had the lithographic stone in his possession, of course, which showed him the composition in reversed form, but why or how he created this reverse tracing is unclear.

5 On the two lithographs, see Jean C. Harris, *Edouard Manet: Graphic Works; A Definitive Catalogue Raisonné*, rev. ed., Joel M. Smith, ed. (San Francisco: Alan Wofsy Fine Arts, 1990), no. 72, pp. 210–11, and Juliet Wilson-Bareau, cat. note for no. 125, *The Barricade*, in Françoise Cachin and Charles S. Moffett, *Manet 1832–1883*, exh. cat. (New York: The Metropolitan Museum of Art, 1983), pp. 326–28; on all three works, see Juliet Wilson-Bareau, "Manet and The Execution of Maximilian," in Wilson-Bareau et al., *Manet: The Execution of Maximilian; Painting, Politics and Censorship*, exh. cat. (London: National Gallery Publications in association with Princeton University Press, 1992), pp. 72–74.

6 Eric Darragon, *Manet* (Paris: Fayard, 1989), pp. 200–201.

7 His sardonic 1878 painting of the rue Mosnier on the Fête de la Paix on June 30, 1878, is discussed in Juliet Wilson-Bareau, *Manet, Monet, and the Gare Saint-Lazare*, exh. cat. (Washington, D.C.: National Gallery of Art, 1998), pp. 140–41; and in cat. no. 89, *The Rue Mosnier with Flags 1878*, in John House, *Landscapes of France: Impressionism and Its Rivals*, exh. cat. (London: Hayward Gallery, 1995), pp. 242–43. His two 1880–81 paintings of the escape of Henri Rochefort after imprisonment for his participation in the Commune are dis-

cussed by Françoise Cachin in the catalogue notes for no. 206, *Portrait of M. Henri Rochefort,* and no. 207, *The Escape of Rochefort,* in Cachin and Moffett, *Manet 1832–1883,* pp. 465–70; and Wilson-Bareau, "Manet and The Execution of Maximilian," pp. 75, 80.

8 See Cachin, cat. note for no. 208, *Portrait of M. Pertuiset, the Lion Hunter,* in Cachin and Moffett, *Manet 1832–1883,* pp. 471–74.

9 Péladan, "Le Salon d'Automne," *La Revue Hebdomadaire* (October 1905), p. 461. For this and subsequent references to responses to the 1905 Salon d'Automne, I am indebted to the archival research of Anna Swinbourne.

10 See, for example, René Wisner, "Le Salon d'Automne," *Ecrits pour l'art* (December 1905): 482; Camille Mauclair, "La peinture et la sculpture au Salon d'Automne," *L'Art Decoratif* (December 1905): 236. This point is made in Alistair Wright, *Matisse and the Subject of Modernism* (Princeton and Oxford: Princeton University Press, 2004), pp. 101–04.

11 Notably by Mauclair in "La peinture et la sculpture au Salon d'Automne," p. 240; and "Le Salon d'Automne," *Revue Bleue* (October 21, 1905): 522–23. Additionally, though, the critic for *Art et Décoration* (December 1905, p. 208) explicitly compares the two works, saying that the now Mannheim painting was a huge error, with its lead soldiers, as compared to the pathos, poignancy, sublimity (and so on) of the famous *esquisse.* But how did it come to be famous by 1905, the date of its first exhibition? Perhaps because it had been illustrated in Duret's 1902 book on Manet, or perhaps because Vollard, who had purchased it in 1899, may be assumed to have shown it to visitors to his gallery.

12 See Marilyn McCully, ed., *Picasso: The Early Years, 1892–1906,* exh. cat. (Washington, D.C.: National Gallery of Art, 1997), pp. 44–47, 204–05, 257, 300; and E.A. Carmean, Jr., *Picasso: The Saltimbanques* (Washington, D.C.: National Gallery of Art, 1980), pp. 22–23, 49.

13 See, for example, the story of Auguste Renoir's admiration of

Matisse's use of black, recounted in Jack Flam, *Matisse: The Man and His Art, 1869–1918* (Ithaca and New York: Cornell University Press, 1986), p. 469. For Matisse's own views on this subject, see "Noir" in the "Index des idées et des themes" in Dominique Fourcade, ed., *Henri Matisse: Ecrits et propos sur l'art* (Paris: Hermann, 1972), p. 355.

14 Edmond Duranty, "M. Manet et l'imagerie," *Paris-Journal,* May 5, 1870. Quoted by Beth Archer Brombert, *Edouard Manet: Rebel in a Frock Coat* (Boston: Little, Brown, 1996), p. xiv, p. 456, n. 3.

15 *Massacre in Korea* is stoutly defended, and the conditions of its creation and reception described, in the entry on this work by Paloma Esteban Leal, in *Picasso: Tradition and Avant-Garde,* exh. cat. (Madrid: Museo Nacional del Prado and Museo Nacional Centro de Arte Reina Sofía, 2006), pp. 284–91.

16 Michael Fried, *Manet's Modernism or, The Face of Painting in the 1860s* (Chicago and London: The University of Chicago Press, 1996), p. 357.

17 Vivien Perutz, *Edouard Manet* (Lewisburg: Bucknell University Press, and London and Toronto: Associated University Presses, 1993), p. 126.

18 The entire sequence is illustrated and discussed in Robert Storr, *Gerhard Richter: October 18, 1977* (New York: The Museum of Modern Art, 2000).

19 In putting it this way, I refer to T.S. Eliot's "Tradition and Individual Talent," to which Kitaj refers in this painting. ("Tradition and Individual Talent," in *The Sacred Wood: Essays on Poetry and Criticism* [London: Methuen, 1920], p. 58.)

20 Marco Livingstone, "Codes and Confessions," in Livingstone, ed., *R.B. Kitaj: An American in Europe,* exh. cat. (Oslo: Astrup Fearnley Museet for Moderne Kunst, 1998), p. 124. See also Livingstone, *Kitaj,* 3rd ed. (London: Phaidon, 1999), pp. 49–52.

21 I resist mentioning in the text that the cover image of my book, *The Language of the Body: Drawings by Pierre-Paul Prud'hon* (New York: Harry N. Abrams, 1996), an image of Prud'hon's *Head of Vengeance* of c.

1808 (Art Institute of Chicago), nestles between the legs of the companion soldier, identified below her shoulders as the artist's wife by the title of Pablo Picasso's 1911–12 *"Ma Jolie"* (The Museum of Modern Art, New York).

22 *Manet and His Critics* is the title of a book by George Heard Hamilton (New Haven: Yale University Press, 1954), who was also the translator of the typographical version of Marcel Duchamp's *The Bride Stripped Bare By Her Bachelors, Even; a typographic version by Richard Hamilton of Marcel Duchamp's Green Box* (London: Lund Humphries; New York: Wittenborn, 1960), which, as its title indicates, provided the title for Kitaj's painting.

23 See Livingstone, "Codes and Confessions," p. 124, and Eliot, "Tradition and Individual Talent."

24 This painting was created for an exhibition at The National Gallery, London, for which a group of contemporary artists were asked to respond to works in that collection. See Marco Livingstone, "Jasper Johns," in Richard Morphet, ed., *Encounters: New Art from Old* (London: National Gallery Company Limited, 2000), pp. 178–89; also, Fred Orton, "Suspensa Vix via Fit: Jasper Johns' catenary; the work of art and the art object; the everyday self and the extraordinary self," *Oxford Art Journal* 27, no. 1 (2004): 79–93; Scott Rothkopf, "Suspended Animation," in *Jasper Johns: Catenary,* exh. cat. (New York: Matthew Marks Gallery, and Göttingen: Steidl Publishers, 2005), pp. 16–17 and n. 33.

25 Georges Bataille, *Manet,* trans. Austryn Wainhouse and James Emmons (New York: Skira, 1955), p. 67.

26 Jorge Luis Borges, "The Secret Miracle," trans. Harriet de Onís, in Donald A. Yates and James E. Irby, eds., *Labyrinths: Selected Stories & Other Writings* (New York: New Directions, 1962), p. 93. I am indebted to Jack Flam for drawing to my attention the relevance of this story to Manet's project; observant readers may have sensed its influence on the closing paragraphs of chapter three.

27 I am indebted to Peter Galassi for his thoughts on the issues raised in these paragraphs.

28 May the repeated, similar poses of the squad be compared to a single figure moved into slightly different positions over the time of an exposure?

29 The Boston painting adumbrates the two-part division of smoke, but *below* the ends of the musket barrels and then drifting indiscriminately above. In the London painting, Manet conceives of the greater density of smoke around the ends of the barrels, but then spoils it by darkening the whole sky with smoke above the firing squad, although he does think of the clever (but ultimately redundant) indexical puffs of dark smoke coming from the firing mechanisms of the muskets. The lithograph has a wonderful white void that joins the two areas of smoke and the white shirts, articulating the boundaries of the smoke with a passionate graphic scribbling. The sketch proposes the solution that will be developed in the Mannheim painting, but in a curiously sticky way.

30 "Thirteen Ways of Looking at a Blackbird," stanza V in *Wallace Stevens: Collected Poetry and Prose* (New York: Alfred A. Knopf, 1997), p. 75.

31 "Manet is the first painter to have made an immediate translation of his sensation and thus give free rein to instinct. He was the first to act *through his reflexes* and thus to simplify the painter's technique . . . [He] was direct as possible" (Interview with E. Tériade, originally published as "Edouard Manet vu par Henri Matisse," in *L'Intransigeant*, January 25, 1932, p. 5; English translation in Jack Flam, *Matisse on Art* [Berkeley: University of California Press, 1995], p. 295, n. 2).

32 See Fried, *Manet's Modernism*, p. 357, where he speaks of how this painting's effect of strikingness—in its depiction of instantaneity and in the violence with which it confronted the beholder—is enhanced by the depiction of the execution at point-blank range, which replicates a typical viewing distance before a painting, making Maximilian and his generals metaphorical of Manet's art and the fusillade of the spectatorly aggression that it had provoked and received.

33 I discuss the fictive instantaneousness of the creation, the record, and the perception of a painting, raised in these paragraphs, in "Seeing Bonnard," in Sarah Whitfield and John Elderfield, *Bonnard,* exh. cat. (New York: The Museum of Modern Art, 1998), pp. 47–48.

34 See Walter Benjamin's description of a "kind of mimesis of death" in the work of Baudelaire. (Walter Benjamin, *Charles Baudelaire: A Lyric Poet in the Era of High Capitalism* [London: NLB, 1973], p. 38.)

35 This reference to the indexical quality of smoke is indebted to, and my discussion of smoke responds to, a fine and highly provocative passage in Stephen Bann, "The Odd Man Out: Historical Narrative and the Cinematic Image," *History and Theory* 26, no. 4 (December 1987): 57–60, during which he alludes to John Ruskin's observation that the introduction of the representation of sky in paintings at the end of the Middle Ages marks the shift from symbolic to imitative modes.

36 Readers who want a clue to answering this question might notice that the twelve photographs are arranged in a narrative sequence composed of three groups, each group being divided into two pairs of two: 1.1: Before; 1.2: Just prior to: 2.2: The moment; 2.3: Extended moments; 3.1: Just after; 3.2: Later. I am grateful for the advice of Susan Kismaric in developing a pool of images from which I selected these twelve.

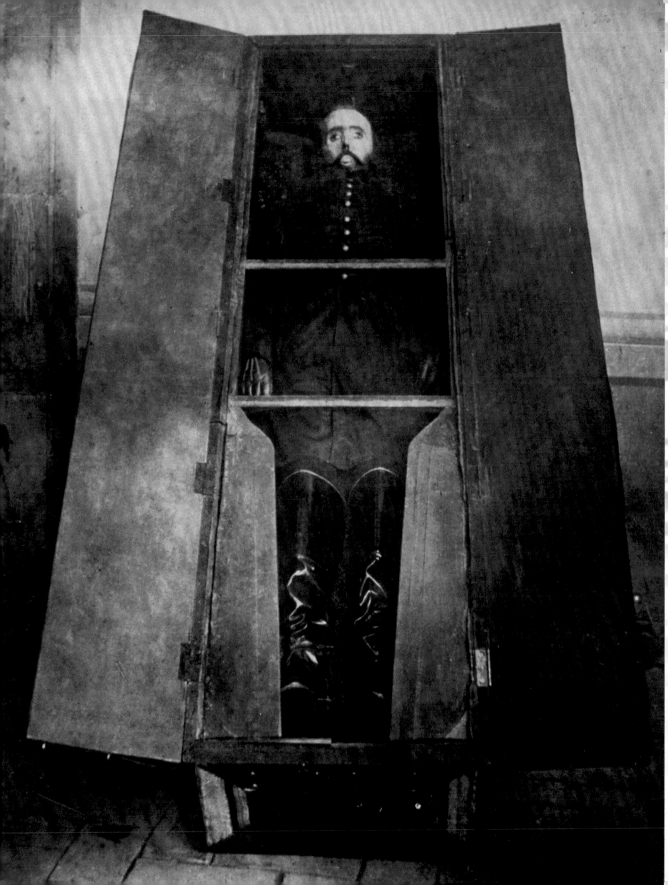

APPENDIX

BIBLIOGRAPHICAL NOTE

What follows offers a survey of accessible and useful studies, concentrating on the works that were most frequently consulted in the writing of this text. For the convenience of readers, the publications are divided into four sections; the final two, devoted to the Maximilian compositions, suggest how their discussion has evolved over the last half-century, the period of their serious study.

I. WORKS ON THE FRENCH INTERVENTION IN MEXICO

The historical literature on the French intervention in Mexico is enormous; it is surveyed in M. Quirarte's *Historiografía sobre el imperio de Maximiliano* (Mexico: Universidad Nacional Autónoma de México, Instituto de Investigaciones Históricas, 1970). Students and admirers of Manet's art will probably find sufficient the selective sources listed in Jasper Ridley's *Maximilian and Juárez* (London: Constable, 1993), an excellent popular account, which is to be recommended despite the author appearing not to have heard of Manet. The richly illustrated catalogue, *Testimonios Artísticos de un Episodio Fugaz (1864–1867)* (Mexico City: Instituto Nacional de Bellas Artes, 1995), offers a fascinating sense of the lives of Maximilian and Carlotta in Mexico, while Nancy Nichols Barker's "Monarchy in Mexico: Harebrained Scheme or Well-Considered Prospect?," *Journal of Modern History* 48, no. 1 (March 1976), pp. 51–68, provides well-argued and well-documented

answers to this critical question, and usefully supplements the same author's excellent *Distaff Diplomacy: The Empress Eugénie and the Foreign Policy of the Second Empire* (Austin and London: University of Texas Press, 1967). And there are good survey essays in the Brown University and National Gallery, London, catalogues (see section 3): Meredith J. Strang's "Napoleon III: The Fatal Foreign Policy," in the former, pp. 83–99, and Douglas Johnson's "The French Intervention in Mexico: A Historical Background," in the latter, pp. 15–33. The Bibliography in the London catalogue (pages 119–20) includes other useful sources.

2. WORKS OF REFERENCE ON MANET

The literature on Manet, although not as large as that on the French intervention, is still very extensive; the bibliographies in the Paris–New York 1983 catalogue (listed below), the 2003 Prado catalogue (also listed below), and in Nancy Locke, *Manet and the Family Romance* (Princeton and Oxford: Princeton University Press, 2001) are especially useful. For Manet's art, the first modern catalogue raisonné, Adolphe Tabarant's *Manet et ses oeuvres* (Paris: Gallimard, 1947), is now a historical document; the most recent are Denis Rouaurt and Daniel Wildenstein, *Edouard Manet: Catalogue raisonné*, 2 vols. (Lausanne: Bibliothèque

98 FRANÇOIS AUBERT
Maximilian in an Open Coffin. June 1867
Albumen silver print,
9 $^{7}/_{16}$ x 6 $^{13}/_{16}$" (24 x 17.3 cm)
Research Library, The Getty Research Institute, Los Angeles

des arts, 1975), and Jean C. Harris, *Edouard Manet: Graphic Works; A Definitive Catalogue Raisonné* (New York: Collectors Editions, 1970; rev. ed., San Francisco: Alan Wofsy Fine Arts, 1990). Among the many exhibition catalogues, *Manet 1832–1883* (Paris and New York, 1983), by Françoise Cachin, Charles S. Moffett, and Juliet Wilson-Bareau, is an indispensable resource, to be supplemented by *Manet en el Prado* (Madrid, 2003). In addition to the important discussion of Manet's working procedures in Ann Coffin Hanson's 1979 monograph (see section 4), there are two independent studies, one by Michael Wilson, *Manet at Work: An Exhibition to Mark the Centenary of the Death of Edouard Manet 1832–1883* (London: The National Gallery, 1983), and the other by Wilson-Bareau, *The Hidden Face of Manet* (London: The Burlington Magazine, 1986).

The early biographies, too, are historical documents, of continuing fascination. Edmond Bazire's *Manet* (Paris: A. Quantin, 1884), published the year after the artist's death, was the first biography, soon to be followed by the reminiscences of a childhood friend, Antonin Proust's *Edouard Manet: Souvenirs* (in *La Revue Blanche,* 1897; ed., Paris: A. Barthélemy, 1913; Caen: L'Echoppe, 1988), and those of an adult friend, Théodore Duret's *Edouard Manet et son oeuvre* (Paris: H. Floury, 1902 and 1906). Among modern biographies, the most recent, in French and English, are, respectively, Eric Darragon's *Manet* (Paris: Fayard, 1989) and Beth Archer Brombert's *Edouard Manet: Rebel in a Frock Coat* (Boston: Little, Brown, 1996); their titles tell reliably of their approach and tone.

3. MONOGRAPHIC STUDIES OF THE MAXIMILIAN COMPOSITIONS

The half-century following the first, 1905 exhibition in France of two of the paintings (see p. 17) saw a scatter of critical articles, among which the early study by Julius Meier-Graefe, *Edouard Manet* (Munich: Piper, 1912), stands out. And they were, of course, mentioned or discussed in the early biographies, catalogues, and general studies. However, it was not until 1954 that the art-historical literature that continues to the present truly began, with Nils Sandblad's *Manet: Three Studies in Artistic Conception* (Lund: C.W.K. Gleerup, 1954). This first examination of the significance of the historical events for Manet pioneered

investigation of his documentary sources, founding what became the majority camp in the study of these works. (The minority camp, engaged in their critical study, is mostly represented in general studies of the artist.) Subsequent articles of interest in this vein include the response to Sandblad by Martin Davies, "The Literature of Art: Recent Manet Literature," *Burlington Magazine,* 98 (May 1956), pp. 169–71, followed by his National Gallery, London, catalogue, *French School: Early 19th century, Impressionists, Post-Impressionists, etc.* (London: The National Gallery, 1970), pp. 94–98, and Albert Boime's "New Light on Manet's *Execution of Maximilian,*" *Art Quarterly* 36, no. 3 (Autumn 1973): 172–208, the first study to refer extensively to contemporaneous history paintings. However, the study that truly carried Sandblad's work to a new level, because allying it to critical art history, was the catalogue Edouard Manet and the *Execution of Maximilian,* produced by graduate students of Brown University under the supervision of Kermit Champa (Providence, R.I.: Bell Art Gallery, 1981). Especially important are the essays by Kathryn L. Brush ("Manet's *Execution* and the Tradition of the *Histoire,*" pp. 39–49), Pamela Jones ("Structure and Meaning in the *Execution* Series," pp. 10–21), and Elizabeth Reid ("Realism and Manet," pp. 69–82).

Subsequent documentary publications of great interest include Wilson-Bareau's compilation in the Paris–New York 1983 catalogue (see section 2) of "Documents Relating to the 'Maximilian Affair,'" pp. 531–34, and Anne-Birgitte Fonsmark's study of the Copenhagen sketch in *Meddelelser fra Ny Carlsberg Glyptotek* (Copenhagen, 1984), pp. 83–84. Then, building on the Brown catalogue, came what (prior to the present publication) was the only other extended monographic study, Wilson-Bareau et al., *Manet: The Execution of Maximilian; Painting, Politics and Censorship* (London: The National Gallery, 1992). In it, the author's "Manet and The Execution of Maximilian," pp. 35–85, valuably introduces new documentary research, while John House's "Manet's Maximilian: History Painting, Censorship and Ambiguity," pp. 87–111, extends Boime's approach in provocative ways. There was also a German version of this catalogue, Oskar Bätschmann, *Der Tod de Maximilian* (Frankfurt: Insel Verlag, 1993). Most recently, Theodore Reff's important *Manet's* Incident in a Bullfight (New York:

The Frick Collection, 2005), although on an allied subject, utterly alters our understanding of the extent and nature of Manet's response to events in Mexico and, therefore, of the context in which the Maximilian compositions were created.

4. CRITICAL STUDIES OF THE MAXIMILIAN COMPOSITIONS

As indicated above, with the principal exception of the essays in the Brown University catalogue, critical studies have tended to appear in general works on Manet. There have not been many of true importance. In 1955, the year following Sandblad's publication, there appeared the first extended, and influential such study in the "surrealist" author Georges Bataille's *Manet* (New York: Skira, 1955), pp. 50–55, 66–67, with its discussion of Manet's "indifference" and "obliteration" of meaning. But for many years thereafter, nothing appeared of comparable ambition, a lapse not to be blamed until the 1980s on the growth of social art history, which had little interest in these works. Anne Coffin Hanson's *Manet and the Modern Tradition* (New Haven and London: Yale University Press, 1979),

pp. 110–21, broke the drought with important discussions of Manet's technical procedures and conception of history painting with respect to these works. There were useful entries on some of them in the Paris–New York 1983 catalogue (see section 2), and two subsequent articles offer important insights. They are mentioned, passim, in Jean Clay's wide-ranging study of Manet's pictorial practice ("Ointments, Makeup, Pollen," *October* 27 [Winter 1983], pp. 3–44], and are discussed in the context of photography and film in Stephen Bann's "The Odd Man Out: Historical Narrative and the Cinematic Image," *History and Theory* 26, no. 4 (December 1987): 47–67. They are also examined at length, unsystematically but with insight, in Vivien Perutz's *Edouard Manet* (Lewisberg: Bucknell University Press, and London and Toronto: Associated University Presses, 1993). pp. 117–26. However, the most important extended argument about the meaning of these works since Bataille's, which it supersedes, is that of Michael Fried's *Manet's Modernism, or the Face of Painting in the 1860s* (Chicago: The University of Chicago Press, 1996), pp. 346–64.

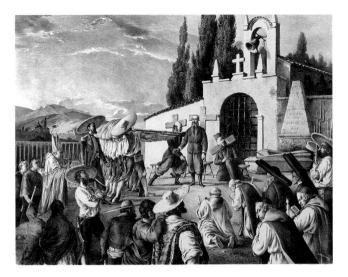

NEWSPAPER EXCERPTS

Anna Swinbourne

The events that occurred in Querétaro and atop the Cerro de las Campanas on June 19, 1867, generated a flood of accounts, both graphic (see figs. 99–101) and written. The following excerpts, from Parisian newspapers or those that circulated in Paris, begin with the first unofficial announcement of Maximilian's death on July 1 and conclude with what came to be regarded as the most accurate and reliable account, published on October 10. The reports are from a variety of sources—eyewitnesses, signed and anonymous letters, and various foreign publications—as borrowing and quoting from other newspapers were standard journalistic practice at the time. These reports are often contradictory. Some assert that the execution took place at seven o'clock in the morning; others place it hours later. Some state unequivocally that Maximilian was positioned at the center of the three condemned men; others contend he stood to one side. For those aspects of the event that are corroborated, such as the fact that Maximilian did not die instantly, the details are often told differently. The contradictions were published in rapid succession. On July 21, for instance, one newspaper printed an account stating that the victims were practically naked and forced to endure all kinds of abuses from soldiers and townspeople; the next day it printed a version in which the victims were dressed in bourgeois clothing and led to their death in front of a sobbing crowd. Even on the same day, August 24, one article stated that everyone in town attended the execution, and another from a different paper claimed that there were few spectators. In addition to contradiction, there is redundancy, both in terms of sourcing and information relayed. On July 22, *L'Indépendance Belge* and *La Liberté* borrowed from the same American newspaper, the *New Orleans Times*, but, curiously, in different ways. A day later, *La Liberté* again relayed details reported in New Orleans, this time melding the two articles printed the day before. As we read these accounts, two things become abundantly clear: first, the act of retelling significantly affects the narrative; and second, for those who were not present, it is impossible to know what happened there that day.

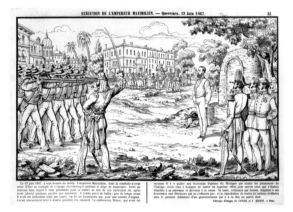

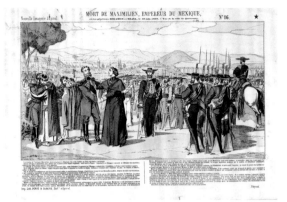

L'INDÉPENDANCE BELGE,

July 1, 1867

A dispatch from Vienna brings us painful news, . . . Emperor Maximilian was shot on June 19.

———————

L'INDÉPENDANCE BELGE,

July 2, 1867

The *Moniteur Universel* and most of the Paris newspapers are silent about our dispatch from Vienna announcing the execution of Emperor Maximilian. . . . We would like to be able to share these doubts, but new information we received today will not in any way permit us to do so.

———————

L'Etendard, July 3, 1867

A. Jourdier, "Dernières informations," p. 1

A gloomy piece of news is spreading throughout Paris. Emperor Maximilian was shot on the 19th in Mexico. Fortunately, we know that there are still some serious doubts

as to the authenticity of the dispatches that attribute this horrible assassination to the Juarists.

———————

LE MÉMORIAL DIPLOMATIQUE,

July 3, 1867

"Dernière heure," pp. 761–62

Specific information coming to us just as we go to press no longer leaves any doubt about the authenticity of the news of Emperor Maximilian's execution.

It is unfortunately true that two official dispatches were received in Vienna announcing that Emperor Maximilian was shot on June 19 by order of the Juarist government. This news will cause a painful emotion in Europe. . . .

It won't be long before we receive details about this sad event, which, we are certain, will ensure Emperor Maximilian his true place in history.

L'INDÉPENDANCE BELGE,

July 4, 1867

In a certain world in France, fortunately suspicious of preconceptions, horrible things are being said about the last moments of the unfortunate Maximilian. He was hung, mutilated, quartered. No fact confirms these abominable stories. All we know is that the execution took place on June 19th.

———————

LE FIGARO, July 4, 1867

D. G. d'Auvergne, "Emperor Maximilien," p. 1

Everyone knows how to picture this blond, blue-eyed German [Maximilian]. . . .

The emperor wore the uniform of Mexican generals to all receptions: black pants in long riding boots, a black frock coat with gold epaulets, the ribbon of *la Toison d'or* at his neck, and, lately, *le cordon de l'Aigle.*

Alphonse Duchenne,
"Courrier politique: Paris,
Le 3 Juillet 1867," p. 4

It was on June 19, two hours from Mexico—others say in Mexico itself—that Maximilian suffered the terrible sentence to which the war council had condemned him. . . .

It is no longer possible to maintain even the vaguest hope: two official dispatches transmitted from New York informed Emperor Franz Josef of his brother's tragic end.

———

L'Étendard, July 4, 1867
A. Jourdier, "Dernières informations: Mort de l'Empereur Maximilian," p. 1

Unfortunately, the grievous news appears to have been confirmed . . .

———

LE FIGARO, July 5, 1867
D. G. d'Auvergne, "L'Empereur Maximilian II," p. 1

When a lugubrious event such as this comes to horrify the world, the most sinister commentaries circulate just as soon from every corner. That's how awful details have already been provided on the torment of the unfortunate emperor.

We have already printed some of them: the one with the most credibility among those familiar with the country is the final outrage inflicted on the mutilated cadaver of the noble victim, who was apparently hung after the execution with a hideously refined depravity and cynicism.

LE FIGARO, July 7, 1867
D. G. d'Auvergne, "Les Exécutions au Mexique," p. 2
[Ed. note: The following text describes the general practice of executions in Mexico and does not relate specifically to Maximilian.]

The official torment, the kind parties prefer for each other, consists of shooting their political adversaries. The cord is reserved for thieves, Indians, poor people, and those particularly despised whom they wish to dishonor by killing.

In Mexico, they shoot at point-blank. The victim is seated on a stool, the soldiers stand four paces away. Rarely is death immediate; they make several attempts in order to kill the condemned person. . . .

When they shoot a man ordinarily, that is, with the required forms of expeditious justice, without being too quick to finish, they make a large black wooden cross with a plank on which he places his outstretched arms.

The people flock to these bloody spectacles, and, in the absence of any police, they press in so closely to the victim and the executioners that accidents are not rare.

If the wall where the last act of the drama unfolds is low enough to be scaled, it is often covered with ferociously curious onlookers, their legs dangling just a few centimeters from the poor man's head, waiting casually for the fatal shot. . . .

Generally, Mexicans die with a remarkable insouciance.

LE FIGARO, July 8, 1867
D. G. d'Auvergne, "Execution de Maximilien," pp. 1, 2

As we were going to press, we were sent the following article from the *New Orleans Picayun*, which borrows the following details about Emperor Maximilian's final moments from the *Esperanza de Querétaro* of June 20. We are immediately publishing this document, the sad importance of which escapes no one.

———

. . . It is necessary to explain the cause for the delay of thirty-four days that overexcited the opinion of our fellow citizens to such a high degree. The first mail that reached San-Luiz on the morning of May 19 bearing the news was only returned here with the orders of the president on the 22nd. The emperor was notified of his appearance before the war council. . . .

When seven o'clock struck, we heard the music of the procession, and Captain Gonzales entered the chapel with his blindfolds. . . .

At this moment the Franciscans passed by: the first two carried the cross and the holy water, the others held candles. Each of the three coffins was carried by a group of four Indians: the three black execution crosses with the benches followed behind. . . .

When we were at the top of the hill, Maximilian looked fixedly at the rising sun . . .

We had arrived near the large outer fortification wall of the cemetery: the bells slowly rang the death knell. Only the individuals in the retinue were present, because the crowd had been barred to keep them from scaling the walls.

The three benches with the plank crosses were placed against the wall, three firing squads, composed of five men, each with two noncomissioned officers, for the *coup de grâce*, stood three paces away from the condemned men.

When the rifles moved, the emperor thought they were going to shoot, and quickly approached his two companions and embraced them with a touching effusiveness.

Miramón, surprised, almost collapsed on the bench, where he remained; the Franciscans crossed his arms. Mejía returned Maximilian's embrace with broken words that no one heard; then, he crossed his arms over his chest, without sitting down.

The bishop, moving forward, said to Maximilian: "Sire, give all of Mexico, as personified by me, the kiss of reconciliation; may Your Majesty pardon everything at the supreme hour."

The emperor, internally agitated with visible emotion, silently allowed himself to be kissed. Then, raising his voice with force, cried out:

"Tell López that I forgive him for his betrayal; tell all of Mexico that I forgive it for its crime!"

Then, His Majesty shook the hand of the abbot Fischer, who, unable to speak, fell to the emperor's knees, kissing both his hands and covering them with tears.

Many people cried abundantly; Maximiliam gently disengaged his hands, and, taking a step forward, said ironically with a sad smile to the officer who was in charge of the execution:

"*A la disposicion de usted.*" ["At your disposition."]

At the signal of the sword,

when the rifles fired at his chest, he murmured a few words in German and detonations enveloped the spectators. Miramón rolled over, struck. Mejía remained standing, his arms flailing in the air; a bullet in the ear at point-blank, ultimately finished him off.

The emperor collapsed on the cross that was supporting his body. He was taken down immediately and placed in the coffin with the two generals. The burial of their remains took place immediately in the cemetery, and the bishop delivered the absolution.

————

[Ed. note: Le Figaro *is questioning the source for this article.]*

It would not be impossible, in Europe, after ten days of extensive detail, for the same text [articles] to be published by the *Esperanza de Querétaro* and the *Picayun* of New Orleans.

The article we have just reprinted could have been conveyed in this fashion: it contains 2,000 words, which at 300 francs per thirty words, would add up to 30,000 francs. *Le Figaro* did not pay for this transmission.

————

L'INDÉPENDANCE BELGE,
July 9, 1867

Several French newspapers have borrowed a very dramatic report on Emperor Maximilian's final moments from a newspaper, *Esperanza,* published in Querétaro . . . This publication is obviously apocryphal, as the latest mail from Mexico bears the date of June 13 and Emperor Maximilian was not executed until

six days later. Only the next mail coach will bring us the first details of the drama of Querétaro.

————

LE MÉMORIAL DIPLOMATIQUE,
July 10, 1867
[Reprint of article from *Moniteur universel* of July 7]
. . . We still do not know the details of the regicide of June 19 . . .

————

LE MÉMORIAL DIPLOMATIQUE,
July 20, 1867
[details reported in *L'Indépendance Belge,* July 17, 1867, and *Le Figaro,* July 18, 1867]
Alphonse Duchenne, "Courrier politique: Paris, 17 Juillet," p. 1
From the *Express* of London, we borrowed the first details to come to Europe regarding the odious crime committed on June 19 in Querétaro.

[in the English paper]:
New York, July 4
. . . the following details on the execution of Emperor Maximilian:

. . . their execution was suspended by Juárez's order until the 19th, and it was that day that they shot all three [Maximilian, Miramón, Mejía] at seven o'clock in the morning . . . Maximilian was shot from the front. His last words were: "Poor Charlotte!"

Miramón and Mejía were turned around, then shot in the back. . . .

Letters from Juárez, which we received here in the general quarter and which your comissioner had the privilege of reading, say that . . . it

was announced that the execution positively took place on June 19 at 11 o'clock in the morning.

LA LIBERTÉ, July 20, 1867
"Les Nouvelles du Mexique"
[A letter from Mexico contains the following account]:

A few moments before his execution, Emperor Maximilian asked the officer who was guarding him for permission to speak to the soldiers who had to shoot him. The commanding officer, having granted this request, called the soldiers in. As soon as the soldiers were present, the emperor pulled out a few pieces of gold, which he distributed, addressing the soldiers with the following words: "Here, these pieces of gold are the reward for a favor. Aim at me well; do not tremble in the presence of the one who yesterday was your emperor." Then he pulled out a silver engraved cigar case, embellished with gold and fine stones; he distributed the cigars, and, heading toward a soldier who seemed more downtrodden than the others, said to him: "Take this object; keep it as a souvenir; it belonged to a viceroy happier than I."

L'INDÉPENDANCE BELGE,
July 21, 1867

We excerpt the following details on the final moments and execution of Maximilian from a correspondence from Matamoros of June 26 published by the Morning Post*:*

The health of the prisoners was very poor. All three suffered from various ailments. For a long time, Mejía was the victim of a disease that was slowly killing him. Miramón was still weak as a result of his injury and an attack of fever. Maximilian had not yet recovered from the illness that had placed him in a weakened state immediately after the fall of Querétaro. . . .

The prisoners were led to their death with bare heads and almost no clothes, their guardians having been authorized to strip them. They were led through a crowd of yelling soldiers and the dregs of the populace assailing them with insulting epithets and, if we are to believe one of the accounts, threw garbage at their heads. . . .

A shallow ditch had been dug for the victims. The condemned men were brought to the edge of this ditch. The method of Mexican executions requires that traitors be shot in the back. Miramón and Mejía were killed in this ignominious fashion. Maximilian received the mortal blow looking his executioners in the face. It was noticed that he did not change color until the last moment. The cadavers were buried where they fell, without ceremony or religious prayer.

The *Times* of New Orleans received a special dispatch from Houston (Texas), which offers a few new details on the death. . . .

None of the prisoners were bound; nor were they blindfolded; basically, they were not subjected to any undignified treatment. . . .

Five bullets entered his [Maximilian's] chest, but he did not die immediately; two soldiers delivered the *coup de grace.*

L'INDÉPENDANCE BELGE,
July 22, 1867

Here is the report that the New Orleans Times *published about Maximilian's execution; it is quite different from the one published in the* Morning Post *from its correspondent in Matamoros, whose previous letter was, moreover, inaccurate in many respects. We will offer this second version since we have offered the first:*

On the 19th, at six o'clock in the morning, the troops of Escobedo approached the town for the execution of Maximilian and his generals, while the people of Querétaro came by the thousands toward the same point to attend the last drama in the life of the men they loved.

As the clock struck seven, the bells rang and announced that the prisoners had just left their prison and were on the way to the execution. A few minutes later they appeared . . . Just as they were approaching the execution site, convulsive sobs burst from the crowd. The cars stopped, and the prisoners got out. There was barely a dry eye . . .

The prisoners were dressed in bourgeois clothing

The guard advanced. The prisoners were standing in front of them. The emperor called the sergeant and, pulling a handful of twenty-dollar coins from his pocket, gave them to him, asking him to share them with the soldiers in the company after the execution; then he asked that he be shot in the heart. Immediately afterward, the officers gave the signal, a detonation was heard, and the prisoners fell. . . .

The corpses were then taken away by their respective friends and the troops returned to their barracks, while the thousands of people, retained as though by a supernatural force, remained in place.

———

LA LIBERTÉ, July 22, 1867
"Les Nouvelles du Mexique"

Mail from America brings us the first details of the epilogue of the Mexican drama. First of all, according to the *Times* of New Orleans, the account of Maximilian's death is as follows:

None of the prisoners were tied up or blindfolded, nor were they demeaned. Before being shot, Maximilian recapitulated the causes that had brought him to Mexico; he denied the authority of the martial court that condemned him and expressed the hope that his death would put an end to the bloodshed in Mexico.

One moment before being led to the place of execution, he called the sergeant of the guard, and gave him a handful of gold, asking him to instruct his men to aim at his heart. His last words were: "Poor Charlotte!" Five bullets hit him right in the middle of his chest but did not kill him right away; two soldiers had to break rank and shoot him in the side in order to finish him off.

Keen discontent and profound pain were manifested by the witnesses of this sad scene.

Miramón read a note in which he said the only regret he felt about dying was to see power remain in the hands of the liberals and to think that they might stigmatize his children as the children of a traitor.

Mejía did not give any sort of speech.

———

Le Courrier des Etats-Unis *also offers a version of the shooting at Querétaro. . . .*

We do not know any more about the execution than what was transmitted by telegraph. It was only a few seconds before the order to fire was given that Maximilian cried: "Poor Charlotte!" He did not die right away, and, in his brief agony, this exclamation passed over his lips several times.

———

LE FIGARO, July 22, 1867
Alphonse Duchenne, "Courrier politique: Paris, 21 Juillet," p. 2

Le Courrier des Etats-Unis brings us new details on the death of Maximilian and the circumstances that precipitated it: this information is still far from complete but sheds some bright light on the facts we already know. . . .

Regarding the execution, the details are still missing. All they say is that the unfortunate victim did not die immediately.

The bullets that went through his chest did not kill him. Two soldiers had to break rank and fire at him in order to finish him off.

———

LE FIGARO, July 23, 1867,
"Courrier politique: Paris, 22 Juillet," p. 3

It is impossible, as one can see, to make these two accounts tally; we must therefore not accord total faith to either of them and prudently wait for more reliable information.

The truth will soon be revealed and verified.

Until then, it is the fictional account and not the history of Maximilian's last moments that we will be exposed to reading.

———

LA LIBERTÉ, July 23, 1867
F. A., "Lettres d'Amerique: New York, 11 juillet, 1867"

Yesterday, by way of New Orleans, we received a few very interesting details on the last moments of Emperor Maximilian, Miramón, and Mejía. These details in a letter from San-Luis-Potosi are formulated in the following way:

. . . When the captives reached the execution site, convulsive sobs were heard from the middle of the crowd. The cars came to a stop. All the spectators were crying, and the condemned men set foot on the ground. The crowd greeted Maximilan as he got out of the car. With grace and perfect ease and a spring in his step, the emperor approached the fatal site. The prisoners were dressed simply; their hands were not tied, and their eyes were not blindfolded.

Having taken their positions in the designated places, the emperor addressed a few words to the spectators, which he pronounced in a clear, young voice, but without bravado. . . .

Miramón had just spoken, so the firing squad advanced. The prisoners stood side by side, and faced the soldiers. Maximilian called the sergeant to him and pulled out a few twenty dollar gold pieces that he gave . . . to the officer, asking him to distribute them among his men,

102 NORIEGA
Site of Execution of
Emperor Maximilian. 1867
Albumen silver print,
4 $^7/_{16}$ x 5 $^5/_8$" (11.4 x 14.2 cm)
The Metropolitan Museum of Art,
New York. Gilman Collection,
Museum Purchase, 2005
(2005.100.580.3)

whom he enjoined to aim at his heart. An instant later, the signal was given: a detonation was heard, and the condemned men fell. The emperor was still breathing, and he could be seen shuddering, though five bullets had struck his chest.

Two soldiers were then taken out of line to deliver the *coup de grace*. Miramón and Mejía were already dead. Each had four bullets in the chest. Once the execution was over, the doctor in charge of embalming Maximilian's body covered his remains with a bedsheet. Then the cadavers were taken away. Thousands of spectators stayed at the site for a long time, as they could not convince themselves of the reality of the somber drama they had just seen take place.

LE MÉMORIAL DIPLOMATIQUE,
July 27, 1867
P. Boutet, "Mexique"

. . . But from now on the truth can no longer be concealed, in the presence of all the information emanating from credible sources, eyewitnesses, and residents of Mexico who are in a position to be more accurately informed.

L'INDÉPENDANCE BELGE,
July 31, 1867
[by] "correspondent particulier de L'indépendance,"
Mexico, June 28

The execution took place on the platform on top of the Cerro de la Campanas (fig. 102); four men were obliged to carry him [Maximilian] there on a chair. Miramón and Mejía walked on either side of him.

Once in the middle of the square formed by the soldiers, the captain commanding the company in charge of the execution approached him and asked him not to hold it against him for the painful duty he was charged with fulfilling. The emperor embraced him. This scene moved everyone. Many of the soldiers cried.

Miramón and Mejía, condemned as traitors, would be shot in the back, Maximilian in the front. . . . They also allowed him [Maximilian] to die between his generals, holding their hands. Miramón, back turned, was on his right, Mejía on his left. The emperor, taller than they, towered over both. He was dressed in black from head to toe, his buttoned suit had an engraved silver plate on the left side; a Mexican hat with a large, unfolded brim shaded his head.

The soldiers fired, and the smoke dissipated; then we saw that the emperor had fallen backward, the two generals forward . . . The sergeant who had to finish off the prince had to step over the body in order to complete his sad mission.

He shot him in the head, which stopped his movements, though his legs continued to twitch. As no other man had his rifle loaded, the sergeant, his shot released, was obliged to reload his weapon; but he was so upset that he had to do it several times and, unable to put the rod in place, as his hands were trembling so, he let it fall to the ground in order to fire the second shot. Then everything was over.

———

LE MÉMORIAL DIPLOMATIQUE, July 31, 1867
P. Boutet, "Mexique," p. 895

New York newspapers of July 16th contain new details on the judgment and execution of Emperor Maximilian. . . .

When Maximilian came out of the convent that served as his prison, he cried, "What a beautiful sky! That's what I wanted on the day of my death!"

The three condemned men were dressed with scrupulous care. The commanding officer of the firing squad asked Maximilian's forgiveness, telling him that he did not approve of the sentence, but that he was a soldier and had to obey the orders he was given. Maximilian responded: "A soldier must always carry out his orders. I thank you with all my heart for your kind sentiments, but I beseech you to follow your orders." The emperor, according to certain accounts, placed Miramón in the center; according to others, it was Maximilian who was in the middle, with Miramón and Mejía on either side. . . .

LE FIGARO, August 3, 1867
Francis Magnant, "Paris vu jour le jour," p. 2

Light is being cast on the Mexican tragedy. Two letters, one addressed to *La Liberté*, the other to *Indépendance Belge*, contain distressing details regarding the final moments of Maximilian's death. The resemblance between the two versions offers a certain authenticity.

———

The emperor's captivity was very difficult, says *La Liberté*. Everything had been stolen from him, and the unhappy prince had only the effects that he carried on him. In order to wash his shirt, he was obliged to keep his frock coat buttoned. . . .

———

According to the *Indépendance Belge*, the unhappy emperor, exhausted by dysentery, had to be carried on a chair to the execution site. He was allowed to die between his two generals, holding their hands. Miramón, his back turned, was on the right, Mejía on his left; the emperor, taller than they were, towered over both of them. He was dressed in black from head to toe. His buttoned suit bore an engraved silver plaque on the left-hand side; a Mexican hat with a large, unfolded brim shaded his head. After the soldiers fired and the smoke dissipated, we saw that the emperor had fallen backwards, the two generals forward. Only Mejía was no longer moving. . . .

Poor Maximilian. Poor, golden-haired prince, as his flatterers and advisers said.

LE FIGARO, August 11, 1867
Albert Wolff, "Gazette du Mexique," p. 1

[From a letter, signed "X . . . "]
I'm sending you photographs taken at Querétaro after the execution. That is, pictures of Maximilian's servant's waistcoat and frock coat, which the emperor, whose clothing was stolen, wore at the execution, as well as portraits of the firing squad that shot Maximilian. I acquired these photographs from the army's chief doctor who embalmed Maximilian or rather who stuffed him, for he gave him two large, black glass eyes, since he had no blue ones. These photographs were taken in secret. . . .

———

[Four photographs were included, one of which is described below.]
The second [photo] shows us the firing squad for the emperor's execution. It is composed of six soldiers, a corporal, and an officer.

The soldiers have hideous, sinister faces. Their uniform resembles the French uniform: the kepi and the tunic seem to be made of gray cloth, the white leather belt, the pants, which descend to the feet, are of darker material.

The corporal, the one who killed Maximilian, is a very handsome boy; he has a sweet face that contrasts sharply with the lugubrious task he was assigned.

The most curious of the seven is the commanding officer of the firing squad; he is not even eighteen.

103 NORIEGA
Emperor Maximilian's
Death Carriage. 1867
Albumen silver print, 4 $^{7}/_{16}$ x 5 $^{5}/_{8}$"
(11.4 x 14.2 cm)
The Metropolitan Museum of Art,
New York. Gilman Collection,
Museum Purchase, 2005
(2005.100.580.2)

104 FRANÇOIS AUBERT
Maximilian's Coffin. 1867
Photograph, 4 $^{5}/_{16}$ x 2 $^{13}/_{16}$"
(10.9 x 7.1 cm)
Fototeca Nacional, SINAFO, Instituto
Nacional de Antropología e Historia,
Mexico

LE MÉMORIAL DIPLOMATIQUE,
August 24, 1867
P. Boutet, "Mexique," p. 991

The *Gazette officielle de Vienne* has published an account of Emperor Maximilian's death, which is said to come from a witness of the execution.

———

When on Wednesday, at six o'clock in the morning, the condemned men came out of the convent of the Capuchins, Emperor Maximilian appeared at the threshold. . . . They were all dressed in black. Each one climbed into his car with a priest. These cars, escorted by four thousand troops, headed toward Cerro de la Campanas, a hill outside the town of Querétaro. . . .

The condemned men descended from the cars at the spot where they were to be executed. The emperor shook off the dust that covered his clothing: his air was resolute; he carried his head high.

He inquired about the soldiers in charge of shooting him; he gave them each an ounce, asking them to aim at his chest. . . .

After this, the emperor approached the generals Miramón and Mejía, and embraced them effusively, saying: "We will see each other again in the next world." The emperor, who was in the middle, turned to Miramón: "General, sovereigns also admire the brave, and, before dying, I want to give you the place of honor . . ."

The emperor moved forward a few steps and pronounced these words in a clear voice with remarkable tranquility: "Mexicans! Men of my blood and my origin, men animated by the same feelings as mine, are destined by Providence to forge the happiness of the people or become martyrs. When I came to you, I did not have any ulterior motive. I came after being called by well-intentioned Mexicans, by those who today sacrifice themselves for my adopted country. As I prepare to leave this world, I take with me the consolation of having done only good, to the best of my abilities, and of not being abandoned by my loved ones and faithful generals. Mexicans! May my blood be the last shed, and may my unfortunate adopted country one day raise itself up!"

After these words, the emperor moved back a few steps, placed one foot forward, looked up at the sky, pointed to his chest, and calmly waited for death. . . .

Every heart was moved, tears were seen in many eyes. There was not one inhabitant of Querétaro who did not attend the execution; the streets were deserted, homes shuttered.

The *Nouvelle Presse Libre* of Vienna extracted the following passages from a letter from an Austrian doctor residing in Mexico:

. . . June 19th at 9:00 o'clock in the morning, the three condemned men were led in a hackney carriage to the execution site, where the troops already formed an immense square. There were few spectators, because in spite of the misery and suffering they had experienced during the siege, the inhabitants had learned to love the emperor too much to want to witness his execution. . . .

[H]e fell backward, pierced by six bullets in the chest and abdomen.

LE MÉMORIAL DIPLOMATIQUE,
October 10, 1867
"Mexique," p. 1122

Various, more or less accurate, accounts of Emperor Maximilian's execution have been published; but the following seems to be the most authentic and most detailed yet to appear. This is the result of the testimonies of Tudos, the emperor's faithful Hungarian valet, who was an eyewitness to the scene; and it is corroborated by the account of the priests who helped Maximilian, and the officer in charge of the prison gate.

At seven o'clock in the morning, on June 19th, His Majesty left the room where he had been confined in the convent of the Capuchins. . . . On the road, people openly demonstrated their sympathy and indignation. No man from the upper classes made an appearance. The crowd was principally composed of poor Indians and ladies manifesting their sympathies fearlessly . . .

When they arrived at the foot of Cerro, the carriage (fig. 103) stopped. . . . The emperor then had to walk about a hundred steps up the hill. . . . For each prisoner, four soldiers had been detached, plus one reserve soldier; they stood five paces from the prisoners, three paces from each other. They [the prisoners] were not positioned by the officers, but took their places haphazardly; the emperor found himself on the right, Miramón in the middle, and Mejía on the left, facing Querétaro.

When everything was ready, the emperor took off his hat and gave it to Tudos. . . .

Behind the prisoners, higher on the hill, were the people, almost all of them poor Indians . . .

His Majesty then placed his hand on his chest to indicate to the soldiers where they should shoot, and opened his arms to receive the shots. The signal was given, the four men fired. The emperor looked up toward the sky and fell slowly, in a seated position. The four bullets struck him; three in the lower part of his vest on the left side, one very high up on the right side. He moved his eyes and arms, and looked at Tudos, who was only three steps away from him, as though he wished to speak to him; but he was incapable of articulating anything. One of the priests sprinkled him with holy water. The reserve soldier then moved forward and shot him with the fifth bullet; but it only pierced the right lung. The mouth of the gun was so close that the vest caught on fire, and Tudos had to throw water on it to extinguish the flames.

In his death throes, the emperor pulled convulsively at his vest, as though to open it, and tore it down to the fifth button. He continued to writhe; a sixth soldier advanced, but his rifle misfired. General Diaz then arrived on horseback and told them to hurry up and finish; a soldier moved forward once again, fired, and once again the rifle misfired. There were no more men with loaded guns and a few moments were wasted looking for one; finally, one was found, he approached at point-blank and fired; this time the bullet went through the emperor's heart and put an end to his suffering; he cast a convulsive glance, let out a sigh, and fell dead. . . .

Four porters then brought a sort of makeshift coffin (fig. 104), too short for his body, which was thrown in, legs dangling over the edge, and in this way he was brought back to Querétaro, accompanied by several officers; he was nevertheless followed by a large number of poor Indians crying bitterly. These poor people promptly gathered in their handkerchiefs each drop of blood that fell to the ground.

Mejía died after the emperor; seven bullets were required to kill him. Miramón was the only one of the three to die immediately. All three were shot at the same time. It was the emperor's personal wish that, in case of a death sentence, they would be executed together.

ACKNOWLEDGMENTS

This publication and the exhibition that it accompanies could never have been possible without the support of a great number of individuals and institutions. I am deeply grateful to all of them for aiding the creation of a project whose circumscribed aims were both precise and ambitious.

As explained in Glenn Lowry's Foreword, the exhibition evolved from discussions in Madrid of ways to commemorate the twenty-fifth anniversary of the arrival of *Guernica* in Spain after its long-term loan by Picasso to The Museum of Modern Art until democracy was restored to that nation. Although this present exhibition did not require asking the assistance of the Prado and the Reina Sofia museums, it would not have taken place without their initiative. Therefore, I want to thank Rodrigo Uría, Miguel Zugaza, and Gabriele Finaldi of the Museo del Prado, and Ana Martinez de Aguilar and María García Yelo of the Reina Sofia for hosting the discussions that led to the conclusion that The Museum of Modern Art and the Städtische Kunsthalle, Mannheim, would organize exhibitions on this occasion. And I want particularly to thank Rolf Lauter, the director of the Städtische Kunsthalle, since it was his agreement to loan the Mannheim painting to New York that created the opportunity to attempt to bring all the Maximilian compositions to The Museum of Modern Art.

However, the exhibition could not have been realized without the generous cooperation of the custodians of all of Manet's paintings of the execution of Maximilian. I should, therefore, especially like to thank, in addition to Rolf Lauter: Malcolm Rogers and George Shackelford of the Museum of Fine Arts, Boston; Charles Saumarez Smith, David Jaffé, and Christopher Riopelle of The National Gallery, London; and Flemming Friborg of the Ny Carlsberg Glyptotek, Copenhagen. Manet's lithograph of this subject was kindly loaned to the exhibition by The Metropolitan Museum of Art, New York, which also loaned two additional, important paintings by Manet and other prints and photographs. I am deeply grateful to Philippe de Montebello, Gary Tinterow, George R. Goldner, Colta Ives, and Malcolm Daniel for making these loans possible.

The National Gallery of Art, Washington, D.C., and the Art Institute of Chicago also lent important paintings by Manet, for which thanks are due to Earl A. Powell III and Philip Conisbee and to James Cuno and Douglas Druick, respectively. Paintings by Mexican artists of the execution and the execution squad were loaned by the Philadelphia Museum of Art, thanks to Anne d'Harnoncourt and Joseph J. Rishel, and the Museo de las Intervenciones in Mexico City, thanks to Alfredo Hernández Murillo. I also want to thank, for the loan of often delicate photographs and works on paper, Klaus Schroeder and Heinz Widauer of the Albertina Museum; Johanna Rachinger and Eva Farnberger of the Austrian National Library; Jean-Noël Jeanneney and Jocelyn Bouquillard of the Bibliothèque Nationale de France; László Baán of the Budapest Museum of Fine Arts; Michael T. Kelly and Kari Schleher of the Center for Southwest Research at the University of New Mexico; Salvador Rueda Smither of the Fototeca Nacional in Mexico; Wim de Witt and Tracey Schuster of the Getty Research Institute for the History of Art

and The Humanities; Mitchell A. Codding, Patrick Lenaghan, John O'Neill, and Susan Rosenstein of The Hispanic Society of America; Luciano Cedillo Albarez, Sergio Raúl Arroyo, and Esther Azevedo of the Instituto Nacional de Antropologia e Historia, Mexico; Michel Colardelle and Gérard Guillot-Chene of the Musée National des Arts et Traditions Populaires, Paris; Juan Carlos Valdez and Victor Ruiz of the Museo Nacional de História, Castillo de Chapultepec, Mexico; David Ferriero of The New York Public Library; Piet de Gryse and Richard Boijen of the Royal Museum of the Armed Forces and of Military History, Brussels; and my colleagues in the Museum's Department of Photography, Peter Galassi and Susan Kismaric, who also contributed their advice on the choice of photographs for the Postscript to this book.

In the Museum's Department of Painting and Sculpture, I have been extremely fortunate in the collaboration of Anna Swinbourne, who administered the curatorial aspects of the project, undertook essential research, notably in the preparation of the Appendix, and helped to trace critical loans. She was aided by Jennifer Field, who similarly assembled research and documentation as well as providing invaluable assistance in the preparation of the endnotes. Both made important, substantial contributions to the scholarship on this subject, to the enormous benefit of the exhibition and the catalogue. They join me in thanking Delphine Huisinga and Galini Notti for their remarkable research and assistance with the exhibition catalogue, as well as Nora Lawrence for her Spanish translations. I am also grateful to the many people who went out of their way to provide us with advice and support to the great benefit of the project: Mary Bartow, Bertha Cea, Judith Tolnick Champa, Rita Eder, Carol Epstein, Charles Isaacs, Peter Kurz, Charles S. Moffett, Diana Negroponte, Fausto Ramirez, Rosa Estela Reyes, and Alice Whelihan.

This publication was made possible by the sensitive editorial work of Joanne Greenspun, the inspired design of Amanda Washburn, and the accelerated but nonetheless scrupulous production of Marc Sapir and Christina Grillo. I would also like to thank Jeanine Herman for her translations of French texts. To them, and to Christopher Hudson, go our deepest thanks. So many other people at The Museum of Modern Art helped in some way on the project that it is impossible to name them all. However, we do want to mention, in the areas of Exhibitions and Registration, Jennifer Russell, Maria DeMarco Beardsley, Ramona Bannayan, Randolph Black, Jennifer Wolfe, and Kerry McGinnity; in Conservation, James Coddington, LeeAnn Daffner, and especially Anny Aviram, who put us in touch with colleagues in Mexico City; Jerry Neuner and the staff in Exhibition Design and Production; and the many preparators and technicians who made the installation of the exhibition possible. And I wish additionally to thank, in the Department of Painting and Sculpture, Sharon Dec and Lauren Mahony, for their continuing support, as well as all my colleagues in the department for their forbearance as this project assumed more and more of my time. Finally, within the Museum, I owe very particular thanks to Glenn Lowry for saying to me in Madrid that the ball was now in my court and that I should do what I wanted to do, and for his advice, encouragement, and unswerving support as the project advanced through its vicissitudes to its realization.

I am pleased to be able to acknowledge that two friends read the penultimate version of the text of this book and offered extremely helpful comments: Jack Flam, with whom I have benefited from many conversations on painting over the years, and Michael Fried, whose own writings on Manet have been deeply influential on what appears here. And, last but not least, I have been fortunate in that Jeanne Collins's notion of connubial felicity extended to visiting Querétaro with me and endlessly discussing this project, and that, thanks to Sid and Mercedes Bass, the American Academy in Rome welcomed me as its first affiliate fellow from The Museum of Modern Art, which allowed this book to be completed, just in time.

John Elderfield
June 2006

PHOTOGRAPH CREDITS

Photographs of works of art reproduced in this volume have been provided in most cases by the owners or custodians of the works, who are identified in the captions. Individual works of art appearing here may be protected by copyright in the United States of America or elsewhere, and may thus not be reproduced in any form without the permission of the copyright owners. The following copyright and/or other photograph credits appear at the request of the owners of individual works.

INDEX

An asterisk preceding the title of a work indicates that it is included in the exhibition. Works in the exhibition that are not reproduced in this publication are listed at the end of this Index.

engraving after Francisco
Goya 74 (fig. 25)

Z

WORKS IN THE EXHIBITION
THAT ARE NOT REPRODUCED
IN THIS CATALOGUE

François Aubert
*Emperor Maximilian in His
Coffin.* 1867
Albumen silver print, 8 7/8 x 6 1/2"
(22.5 x 16.5 cm)
The Museum of Modern Art,
New York. Gift of Harriette and
Noel Levine

François Aubert
*Emperor Maximilian's Execution
Squad Standing at Ease.* 1867
Albumen silver print, 4 7/16 x
5 9/16" (11.4 x 14.2 cm)
The Metropolitan Museum of
Art, New York. Gilman Collection,
Museum Purchase, 2005
(2005.100.580.1)

François Aubert
*View from the Cerro de las
Campanas.* 1867
Albumen silver print, 6 3/8 x
8 11/16" (16.2 x 22 cm)
Research Library, The Getty
Research Institute, Los Angeles
(96.R.141)

François Aubert
*The Shooting of Emperor
Maximilian, Miramón and Mejía,
June 19, 1867.* n.d.
Graphite pencil, 5 7/8 x 10 9/16"
(15 x 26.8 cm)
Collection of the Royal Army
Museum, Brussels

Adrien Cordiglia
*Commemorative Picture of
the Execution of Emperor
Maximilian.* 1867
Photograph *carte de visite*,
2 3/16 x 3 5/8" (5.6 x 9.2 cm)
Center for Southwest Research,
University Libraries, University of
New Mexico, Albuquerque.
Mexican *Cartes de Visite* Album
(986-025-0011)

Francisco de Goya y Lucientes
*With or Without Reason (Con
razon ó sin ella).* Plate 2 from
Disasters of War. 1810–20
Etching, aquatint, burnishing,
drypoint, and burin, 6 1/4 x 8 1/8"
(15.9 x 20.6 cm)
The Metropolitan Museum of
Art, New York. Purchase, Rogers
Fund and Jacob H. Schiff
Bequest, 1922 [22.60.25(2)]

Marshal Hat of Emperor Maximilian
Photograph, sheet: 5 1/8 x 7 7/8"
(13 x 19.9 cm); image: 4 3/4 x 7"
(12 x 18 cm)
Austrian National Library, Vienna.
Picture Archive, 126.686 C

Read, Brooks & Co., London
*The Brutal Assassination of the
Emperor Maximilian, and His
Two Generals Miramón and
Mejía Before Querétaro on 19th
of June 1867, by the order of
the blood-thirsty Juárez.* 1867(?)
Lithograph, with additional tint
stone, sheet: 12 3/4 x 18 1/4"
(32.4 x 46.4 cm); image: 10 x
17 3/16" (35.4 x 43.6 cm)
Print Collection, Miriam and Ira
D. Wallach Division of Art, Prints
and Photographs, The New York
Public Library. Astor, Lenox and
Tilden Foundations